MARY TREGEAR

CHINESE ART

with 162 illustrations, 20 in colour

THAMES AND HUDSON

Frontispiece. Gilt bronze Buddhist altarpiece. The standing Buddha in teaching *mudra* is flanked by Bodhisattvas and monks, and surrounded by flying *apsaras*. Such pieces were cast in sections and fitted together. Wei style. 6th century AD. (See p. 89)

ISBN 0-500-20178-1

Printed and bound in Slovenia by Mladinska Knjiga

Contents

Introduction

The arts of a culture, however remote that culture may be from our own, are primarily to be enjoyed for their own sake. However, as expressions of a particular culture, they often reflect a unique aesthetic standpoint which we must seek to understand if we are to deepen our initial response to the arts in question. In attempting to trace such a standpoint, this short survey of the Chinese visual arts can but open the subject a little, for the visual arts have played several distinctive roles in China whose importance has varied with developments in Chinese culture itself.

In earliest times in China, Neolithic man's visual sense is revealed to us only in the shape and decoration of his pottery. Already familiar with the properties of clay, potters were inventing shapes which became established as part of a long heritage. Their decorative schemata, although distinctive to the period, show the sensitivity and judgment of scale which were to characterize Chinese decoration in succeeding centuries.

There followed a period of great hieratic art in the service of a Bronze Age culture of considerable duration and stature. This art was largely expressed in the form of cast bronze vessels and jade carvings. The shapes and decoration, marvellous in their own right, provide a vivid insight into a society for which symbols of ritual were the chief means of expression. With a loosening of theocratic controls, the hieratic symbols were adapted to serve a status-conscious feudal culture. The once-potent motifs on bronze vessels increasingly became avowedly decorative, and new techniques were developed to emphasize richness.

In the absence of any graphic expression, the works of craftsmen in metal, jade, lacquer and clay constitute our only indication of the nature of artistic life in late Bronze Age China. At the same time, in a visual culture still dominated by artefacts, calligraphy had already played an integral part in the form of cast inscriptions. Styles of writing developed and gradually, as longer inscriptions were cast into bronzes or cut into stone and bone, ideas of spatial composition emerged.

With the introduction of brush, ink and paper, calligraphers and painters took over the expressive arts. Calligraphers were the first to turn their attention to and develop a sophisticated brushwork, and with it criteria for compositional judgment. Painters took from them the skills of brush and ink

and at first used them to express narrative themes of myth and history. Later, painters explored a more poetic and allusive form of expression in landscape painting and more decorative compositions in bird and flower painting. The development of an expressive, graphic art by painters and calligraphers completely superseded all other artistic endeavours in esteem, and painting and calligraphy became the dominant visual arts in what was a pre-eminently literary culture.

In all its diverse forms – narrative, decorative and romantic – expressive painting was pursued both by professional painters and by scholar-painters (the so-called *literati*). This distinction between professional painters and scholar-painters is more than one of status. The professional painters, trained as portrait painters and decorative artists, produced a wide range of work intended for private houses, palaces and temples, and worked in ateliers. Their names are very rarely recorded and their work was not collected or preserved. The scholar, a member of the exclusive, educated class, rose within the examination system to official rank in the administration of the country. Part of his education was in calligraphy and often also in painting. Painting always ranked high among the cultural concerns of this group and many scholars were full-time or part-time painters. By tradition they did not sell their works, which were shown and given to friends. The scholar-painters were often at pains not to be confused with the professional painters and they even affected a gaucherie of brush style to emphasize the gap between themselves and the latter. The paintings which were avidly collected by connoisseurs are largely the works of scholar-painters.

In a complex milieu dominated by literature and painting, the scholar-painter evolved an ascetic form of ink painting which he supplemented with rich and rare crafts to provide colour and form. From a very early period there was a tradition of collecting and ardent connoisseurship by scholars, and the many and varied crafts of China came to occupy a place not far from the centre of 'high' artistic concern in the eyes of the cultured man, forming an integral part of his visual culture. Bronze and other metalwork, jade carving and pottery formed the major complement to painting. Sculpture, introduced with Buddhism, played a much lesser role; it was only rarely pursued by Chinese artists and patrons for other than Buddhist or ceremonial settings.

In summary, the Chinese visual arts gradually evolved in response to Neolithic, theocratic and feudal society to find · their most distinctive expression in painting, an art closely linked to a strong literary tradition, and further surrounded and extended by a rich tradition of decorative and applied arts.

Neolithic Period

c. 5th millennium—18th century BC

This is of necessity a wide date. Current archaeological work is extending the period backwards in time. The relative dating of the many groups of distinctive settlements in this period is also not definitive.

Shang Dynasty

1766–1111 BC

It seems clear from archaeological investigations to the present that the major Shang settlements were in the Yellow River Valley area and that the longest established Shang capital was at Anyang (1384–1111 BC). However, the long time span sees an enlargement of the territory of the Shang state and the spread of Shang influence over a very wide area, as is shown by finds in the south-west.

Chou Dynasty

1111–221 BC

Western Chou	1111–771
Spring and Autumn Annals	
(Eastern Chou)	771–481
Warring States	481–221

As can be seen from the subdivisions, this was not a settled period. The title Spring and Autumn Annals for the period 771–481 BC is a literal translation of the title of the official history of the period; such histories exist in unbroken series from the Han Dynasty onwards. The division between Western and Eastern Chou marks the move of the capital from Ch'angan to Loyang. The proliferation of states, a result of the organization of the Chou Dynasty, led to a period of eventual disintegration, graphically called Warring States, in which one of the dominant states was the Ch'u.

Ch'in Dynasty

221–206 BC

A short period dominated by the first Emperor, Shih Huang-ti ('First Yellow Emperor'), who unified the country. In the course of this unification he established an internal communication system, started the Great Wall, as we know it today, as a means of defence against the nomads of the north, and suppressed the scholars and the Classics as divisive influences. In many ways the Ch'in Dynasty created the conditions which allowed the Han Dynasty to prosper.

Han Dynasty

206 BC—AD 221

Western Han	206 BC—AD 12
Hsin	12–23
Eastern Han	25–221

One of the major dynasties. A period of great geographical expansion in which Chinese influence spread west into Central Asia, north to Korea, and south towards the Malaysian peninsula. The division between Western and Eastern Han again marks the move of the capital from Ch'angan to Loyang. The short break, AD 12–23, marks a usurping reign. Buddhism was introduced to China during the Han Dynasty.

9

Northern and Southern Dynasties

219–580

Northern:
Northern Wei 386–532
Western Wei 535–554
Southern:
Western Chin 219–316
Eastern Chin 317–419

In the north, the Toba Turkic Wei people established a state. The first capital was at Lanchow, near Tun Huang, and the second capital at Ta T'ung; both of these are Northern Wei capitals. When the capital was moved south to Ch'angan, the state took the title of Western Wei.

Sui Dynasty

581–618

Another short period of unification.

T'ang Dynasty

618–906

Another expansionist dynasty. A period of enormous vitality, especially in the seventh and eighth centuries. T'ang boundaries extended into Asia and north China became a cosmopolitan society. Culturally this is a rich period in music, literature and the visual arts.

Five Dynasties

907–960

Following a recurrent pattern, the organization of the huge country broke down in this period, and many states emerged in uneasy independence.

Liao Dynasty

907–1125

A state to the north of the Manchu border which is often included as a Chinese dynasty. It is culturally interest-ing as a link between Korea and north China.

Sung Dynasty

960–1279

Northern Sung 960–1127
Southern Sung 1128–1279
(Chin 1115–1234)

At first, with the capital at Kaifeng, this was a period of great aesthetic richness. An invasion from the north-west defeated the state, but although the Chin Turkic invaders set up their own capital at Peking, the Chinese court fled south and established the Southern Sung state with its capital at Hangchow in 1128.

Yüan Dynasty

1260–1368

The divided country was overrun once again from the north-west and unified by the Mongols of Genghis Khan. The ensuing Yüan Dynasty was one of the two foreign dynasties in the history of China and ruled for less than one hundred years, with its capital at Peking.

Ming Dynasty

1368–1644

Reign titles:
Hung Wu 1368–1398
Chien Wen 1399–1402
Yung Lo 1403–1424
Hsuan Te 1426–1435
Cheng T'ung 1436–1449
Ching T'ai 1450–1457
T'ien Shun 1457–1464
Ch'eng Hua 1465–1487
Hung Chih 1488–1505
Cheng Te 1506–1521
Chia Ching 1522–1566
Lung Ch'ing 1567–1572
Wan Li 1573–1619
T'ai Ch'ang 1620
T'ien Ch'i 1621–1627
Ch'ung Cheng 1628–1643

This began as a triumphant return to native rule. Peking was established as the capital, inheriting the palace sites of both Chin and Yüan. The Forbidden City site was laid out and at least partly developed as the home of the immediate Imperial family and the administrative centre of the country. It had long been the custom for Chinese emperors to give a name to their reign, sometimes more than one. In the Ming Dynasty, which had sixteen reigns, the reign title was often inscribed on ceramics or lacquer to identify and date the piece. The name was not that of the person of the emperor, but of his reign period; the emperor had his own personal and official names.

Ch'ing Dynasty

1644–1911

Reign titles:
Shun Chih	1644–1661
K'ang Hsi	1662–1722
Yung Cheng	1723–1735
Ch'ien Lung	1736–1795
Chia Ch'ing	1796–1820
Tao Kuang	1821–1850
Hsien Feng	1851–1861
T'ung Chih	1862–1874
Kuang Hsu	1875–1908
Hsuan T'ung	1909–1912

Again a foreign dynasty. This time the invaders were Manchu coming south through the north-east corridor. They also set up their capital in Peking and rebuilt the Forbidden City, which had suffered much in the disorders at the fall of the Ming. The Ch'ing Dynasty had a total of ten reigns, of which three – K'ang Hsi, Yung Cheng and Ch'ien Lung – were the most distinguished and provided the major cultural activity of the period.

The Republic of China

1912–1949

The People's Republic of China

1949 to the present

Neolithic Crafts
c. 5th millennium–18th century BC

1 In the subcontinent of China there were Neolithic peoples settled over a wide area, along the valleys of the Yellow River and its tributaries, on the marshy plains of present-day Shantung, and southward along the coast to the Yangtse and beyond. At least from the fifth millennium BC these diverse peoples inhabited villages, tilled the land, hunted and fished. Very early on they domesticated the pig and the dog, and made pots and simple stone and bone implements. Their visual taste can now be judged only from the shapes and decoration of their pottery. As far as we know, no wall paintings or carvings from the Neolithic period exist, and it seems that the artists of these communities were the potters. They made coiled, slab and modelled pots in a low-fired earthenware, in an ever increasing variety of shapes. In most Neolithic communities two qualities of pot were made. The everyday, cord-impressed grey ware is ubiquitous; but pots of finer technique and decoration are also found. The earlier pots of the Shensi region (fifth to fourth millennia BC), and those of the north-westerly communities (third to second millennia BC), were smoothed, burnished and painted in slip colours of black, red and white; to the east and south the contemporary Black Pottery people made undecorated wares in exotic shapes.

A picture, as yet incomplete, of the long period from *c.* 4000 BC to *c.* 1700 BC shows early settlements in the central Yellow River Basin and in the Wei River Valley. The most completely preserved site of the Yellow River Neolithic peoples is at Pan P'o, near present-day Sian, where a large riverside village has been excavated and preserved. Inhabited, probably in two phases, over a long period (*c.* 4000–3000 BC), the Pan P'o site comprises a spreading settlement, with a defined dwelling area consisting of small round
2, 3 houses and a community house, a burial area away from the village, and a potters' area with simple up-draught kilns. The Pan P'o potters used the distinctive decorative motifs which have earned this whole culture (originally identified at the Yang Shao site) the title of 'Painted Pottery'. Probably of a symbolic significance which can only be guessed at today, the
4 fish and the human head with three-pointed 'halo' motifs of Pan P'o move slowly towards abstraction. This movement from representation to abstraction is repeated in much of the other Painted Pottery decoration of north China. It can be seen, for instance, in the flower motifs of Honan. Here

1 Single shouldered polished stone axe head. Designed to be mounted on a wooden handle and used either for chopping or as a chisel. From Ho-yin, Honan. Neolithic period.

the sinuous movement of the motif complements the profile of the pot in a way which makes it clear that it was deliberately chosen by the decorator. The potters of the Chinese subcontinent have retained their concern for unity of shape and decoration, and in this sense the pottery of the Neolithic period should be regarded as part of a long tradition which has continued in China up to the present day.

Perhaps the most dramatic creations of the Painted Pottery decorators were the pots of the later western Neolithic settlements of the T'ao River in Kansu. Here a Neolithic culture related to the Wei River settlements survived even into historic times. The finds from Pan Shan, Ma Ch'ang and Hsin Tien all show elaborate and rich decoration in the traditional black, red, and occasionally white, line-drawn decoration. Swirling and geometric motifs exist alongside representational animal motifs. The progression from representation to abstraction seems to be complex and uneven. The colours are drawn in thick and thin lines, and space-filling motifs and solid colour are also used. It is thought that these pots were painted with the frayed stump of a piece of wood or bamboo, the brush being a later invention.

5, 6

37

The similarities between the Kansu decoration and other Neolithic decoration in Western Asia raise questions about the origins of the Kansu culture: did its source perhaps lie across the Central Asian desert? Recent scholarship in China favours its native origin, partly on the grounds of the later date (c. 3500–1700 BC) of the sites of north-westerly China. The archaeological sites of central China being all considerably earlier in date (c. 5200–3500 BC), the movement of culture seems to be from the centre towards the north-west. The whole question of the sequence of Neolithic cultures in China is gradually becoming clearer, and it is now possible to place the Painted Pottery decorators of the central Yellow River as earlier than the Black Pottery people (c. 3500–2000 BC) of the Shantung and the south-easterly area. Although the Painted Pottery and Black Pottery peoples appear in some places to have been contemporary, there seems to exist no evidence in support of the theory that one derived from the other.

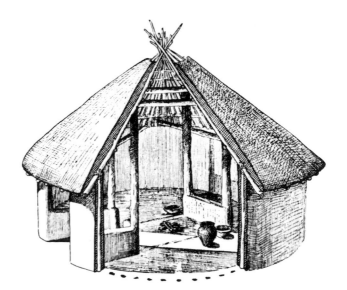

2 Reconstruction of a circular hut of the type excavated at Pan P'o, Shensi. The huts were constructed on a system of posts, for which the holes have been found. It is thought that the walls and roofs were of wattle and thatch.

3 Excavation of a circular hut foundation at Pan P'o. Subsidiary pits seem to indicate craft activity, such as pottery, close to the dwelling houses.

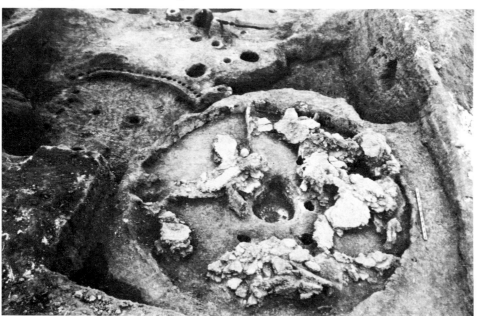

4 Buff earthenware basin with dark slip-painted decoration. A human face, with three-pointed 'halo', is associated with a geometric shape, an abstraction of two confronted fish. From Pan P'o, Shensi. 5th–4th millennium BC.

5 Large burial urn of burnished red earthenware, painted in black and purple slip in swirling designs. Pan Shan type, from Kansu. 3rd millennium BC.

The Black Pottery people, first identified at the Ch'eng Tzu Yai site in Shantung, populated a large area spreading from the east coast into the loess area of fertile wind-blown soil of the central Yellow River Basin. Like the Painted Pottery people, they lived in villages with defined craft and burial areas. Although the media of their crafts were principally bone, stone and pottery, it seems, from burial imprints (where the surrounding earth has taken up the imprint of an object which has disappeared in burial), that these early people also made baskets of some distinction and probably wove simple cloth. The archaeological evidence, however, does not allow any judgment of the artistic quality of this craft work. Once again, the potters seem to have been the only artists as far as we know. They made at least two qualities of pots. The everyday, cord-impressed wares, which are very similar to those of their western neighbours, are grey and potted in a variety of cooking and storage shapes. The special quality wares are distinguished by an absence of decoration; they are made in a paper-thin, brittle, fine-grained earthenware, potted in a wide range of intricate and often multi-sectioned shapes, and baked either black or red and burnished. Whereas the Painted

6 (*below*) Footed *tazza* of burnished red earthenware, painted in black slip in waving and swirling designs. From Lanchow, Kansu. Late 3rd millennium BC.

7 (*right*) Tall beaker of thin burnished black pottery. A shape which is unique to the eastern area of the Black Pottery culture. From Wei Fang, Shantung. 3rd or early 2nd millennium BC.

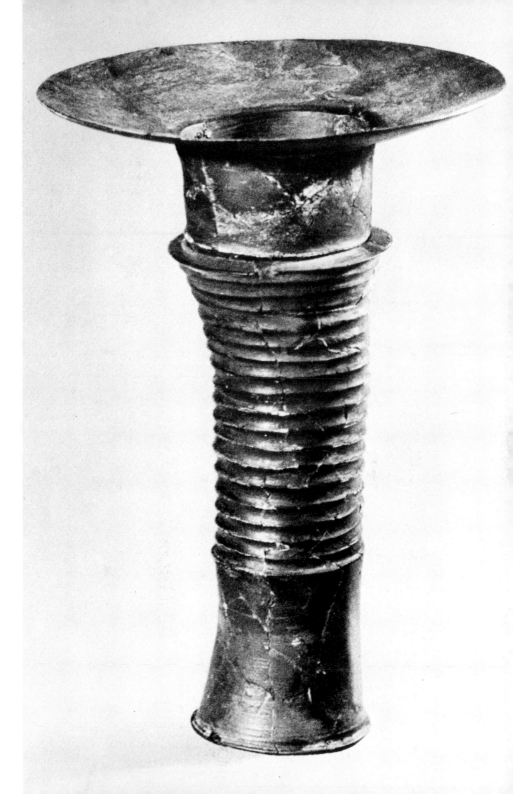

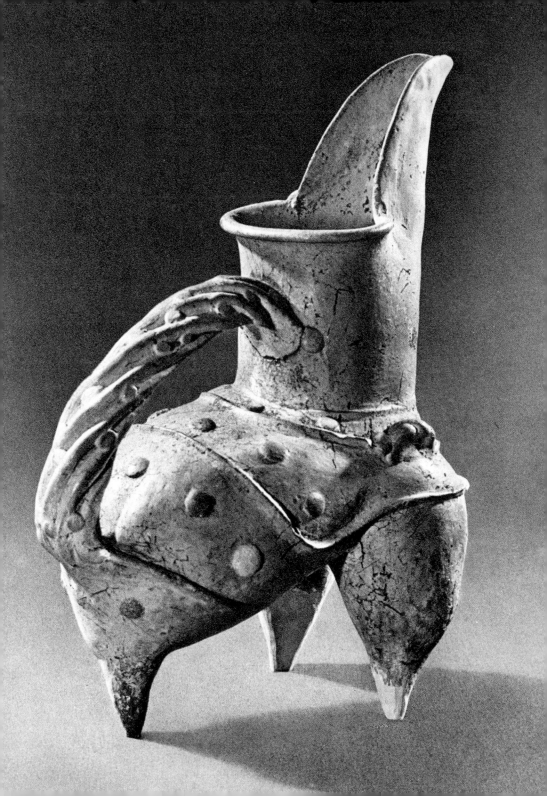

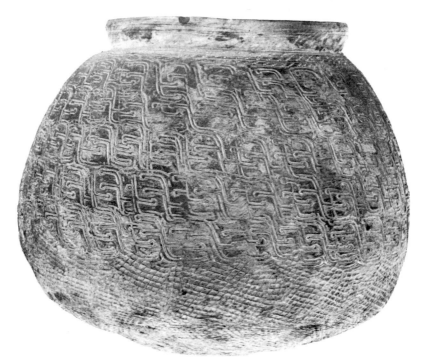

8 *(left)* White pottery tripod jug. Another shape peculiar to the east, which seems to be a replica of a vessel made in another material. The bag-leg tripod shape is carried through into the Bronze Age. From Wei Fang, Shantung. 3rd or early 2nd millennium B C.

9 *(above)* Impressed 'double F' decorated round-based jar. The unglazed mottled buff body is relatively high-fired and the decoration is stamped with a die; the walls are much distorted. From Wu Hua, Kwangtung. Late Neolithic or Bronze Age period.

Pottery people had used a restricted range of bowl and jar shapes for their more elaborate wares, the Black Pottery people extended the range to include spouted jugs with handles, tall beakers, straight-sided pots and tall stemmed cups. A variety of methods was required in the making of these pieces, which seem, in some cases, to suggest even a replica of a vessel made originally in another material. The three-legged jug with the 'studs' at the fixing of the handle and to each side of the lip is perhaps such a case. This kind of imaginative potting moves right away from the pottery decorators' art; here the potter is concerned solely with form and profile. This concentration on invention of form seems to be accentuated by the use of an impractical and fragile material; for these vessels could have been of ritual or decorative

7

8

use only. No comparable artist-potter tradition was attained again in China for several centuries.

Contemporary with the Black Pottery people, and outlasting them in the more remote areas, was a group of people who appear to have made their home on or near water. They lived around the mouth of the Yangtse, down the coast and along the river valleys. Again, pottery constitutes their only claim to artistic production. They made squat jars and dishes of very simple shape. In the grander pieces they used a noticeably harder, higher-fired ware. The surface decoration of these pieces is carried out in impressed geometric motifs covering the wall of the pot, creating a surface texture and richness which is something entirely new. The clay, and the firing used, produced a surface which, while not a true glaze, is smooth and needs no burnishing. From the point of view of ceramic technology this southern culture is of great significance in the consideration of later styles, for it was in the higher-fired wares that Chinese potters were to achieve their finest productions.

There is no doubt that even at this very early period, before the advent of metal and higher civilization to China, there existed a richness and variety of artistic expression. Although there is little evidence to suggest a direct relationship between any one of these Neolithic cultures and the Bronze Age people who followed, there are enough links, particularly between the Black Pottery people and the people of the Yangtse Delta, to hint at technological and artistic continuities amongst the craftsmen.

Hieratic Art and the Bronze Age
18th–12th centuries BC

As the Shang Dynasty (1766–1111 BC) gained control of a large area of north China, technological and cultural changes demanded innovation of the artist-craftsmen. The date and nature of the introduction of bronze and bronze casting techniques to China is not yet documented in archaeological studies. It is assumed to coincide with the rise of the Shang Dynasty. The date given for the start of the dynasty is computed from written records, but the earliest sites have not yet been identified archaeologically. In the face of these unresolved problems, theories have been proposed outlining possible solutions. As the Bronze Age came relatively late to China, Western-trained archaeologists have been tempted to trace its source outside China, adopting a theory of cultural drift. The supposition of a movement of peoples from Central Asia, entering China from the north-west through the Kansu corridor, is not acceptable, however, partly because of the extended Neolithic culture of those areas (including Kansu) in which Painted Pottery settlements continued to the end of the Shang period, with no signs of Shang state culture. Some scholars have given weight to a possible influence from the far north, where there was a bronze-casting tradition in the Lake Baikal area; here again the route of entry proposed is through the north-east corridor. However, there is today a growing body of evidence to support the theory of a spontaneous development of Bronze Age culture in China, a development dependent on technology from the south-east.

Whichever theory may emerge as correct, it is clear that the Chinese craftsmen made an entirely individual contribution to bronze technology, using an alloy which is peculiar to China and a technique of casting by multiple-piece moulds which they brought to an unusual complexity. Bronze is a variable alloy of copper and tin, of which the major component is copper. To this alloy the Chinese metal-workers added lead. The reason for the addition of lead is not evident, but it may have been to improve the pouring quality of the molten alloy. The addition of lead imparts a greyness to the sheen which is typical of most Chinese bronzes. The use of this unusual alloy seems to indicate a native understanding of smelting of metallic oxides. As all the constituents of the alloy must be prepared separately, there is no question of a mixed ore being found naturally; the scattered presence of copper and tin, and the relative concentration of lead in the remote south-

west of China, also point to a knowledge of the materials required and systematic collection of these materials from a wide area. Furthermore, the method of forming the objects is quite distinctive. There is no evidence that metal was ever prepared by beating and, thus far, no copper vessels have been found. The Chinese either adopted or themselves arrived at the technique of casting from the start. As mentioned above, the method favoured was by piece mould. The original model was probably constructed in clay; from this model, clay moulds were made in multiple sections which could be reassembled and keyed together to produce the final mould into which the molten bronze was poured for casting. The Chinese undoubtedly also used the 'lost wax' or *cire perdue* method by which the matrix is made in wax; here the matrix is coated with clay, the wax melted out, and the molten bronze poured into the resulting clay mould. In the process matrix and mould are both lost, but this is the only method by which intricate undercut and pierced work can be cast. At present it is thought that the Chinese craftsmen used the 'lost wax' method only in later times and then only when the nature of the piece required it.

The Shang rulers possibly came from a tribe inhabiting the central Yellow River Valley area. At the head of the Shang state was a god-king whose control was exercised through ritual, oracle-taking and warfare. It is clear from archaeological evidence that ritual lay at the heart of Shang society: it permeated most aspects of life for the ruling caste and it naturally required the service of the arts. The Shang craftsmen and designers adapted themselves to the special requirements of the theocratic regime and to the new material at their disposal, creating a style to express an unmistakable code of ideas, coherent and compelling, but not completely comprehensible today. Most of our information about Shang culture is derived from excavations of capital cities and of the elaborate pit-burials of the rulers, whose equipment and regalia were buried with them for future use in an after-life. There is no evidence of artistic activity, not even of folk pottery, for other than the rulers.

The oldest Shang city site (sixteenth century BC) is at Cheng Chow, where the early capital of Ao was sited. Here a simple walled city was found with differentiated craft areas for bronze casting, stone carving and pottery. A large central house, perhaps a palace, dominates the dwelling section and the whole lay-out is orientated north to south. The bronze objects found here were in the early Shang style, frail and relatively poorly cast, but complex in form. The extensive burial site at Hsiao T'un, Anyang (*c.* 1384–1111 BC), was first excavated in China in 1927. This mid-Shang Imperial burial ground, in use over many centuries, is the source for the majority of the finds of the period. The excavations, continuing today, have so far revealed no dwelling

10, 11

areas and no city wall, but an extensive bronze foundry site and craft areas, a ceremonial hall and a series of rich burial sites. It has consequently been postulated that this is not a dwelling site, but may have been the royal burial site for another capital city. While this remains an attractive idea, it raises the question of the identity of the site of the later Shang capital, for the Shang was a tightly controlled state whose capital would have been of great importance, and no other city has been recorded. However, from present-day excavations it is becoming clear that the Shang, from the fourteenth to twelfth centuries BC, extended their influence over a wide area of China. Shang finds in Yunnan, in the far south-west, are the latest in a series which changes the traditional picture of this dynasty as a geographically compact one.

There exist numerous examples of the ritual possessions of the king and those of his personal household. The most durable buried objects were of bronze and jade, but we know that, like the Neolithic peoples whom they had conquered, the Shang also used painted and carved wooden beams in architecture, and wove textiles and baskets – all of which is evidenced only by burial imprints. Stone carving is very rare. Bronze was the new material on which craftsmen lavished such skill that by the fourteenth century BC they were producing hauntingly grand vessels.

As we have seen, the Neolithic potters of the east had already experimented with vessels of complex shape, and although there is no evidence that they were familiar with casting techniques, either they, with their skill in handling clay, or their neighbours further south, with their technique of producing a higher-fired impressed ware, may have mastered the craft of making first the model and then a mould in sections. As art objects the Shang vessels have such distinction that one easily overlooks the technical skill required in their construction, in admiration of the richness of their shapes and decoration. The shapes, which seem to have been demanded for ritual usage, are derived in many instances from the Black Pottery vessels, but in metal these shapes take on a monumental character. The Shang vessels are not large but they are so proportioned and decorated as to demand attention. The shapes were named and classified and, by the fourteenth century BC, had become 'classic'; the decoration of the surface, cast into the vessel with very little added tooling, shows an ever-growing richness.

The development of hieratic motifs is so impressive that it cannot rightly be called 'decoration' any longer. It amounts rather to an expressive art and it is one of the great achievements of the Shang designers. The seventeenth-century BC bronze vessels, from the site at Cheng Chow, while clearly not the earliest experiments of the Shang bronze caster, show a simple form of thread and low relief decoration, laid in a band around the body of the piece.

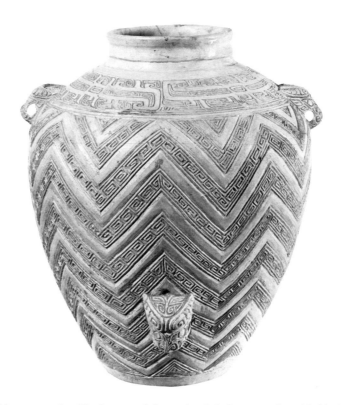

10 White pottery jar. The impressed decoration is in bronze style, with *k'uei* round the shoulder and horned mask cartouches. The body is of a pure white clay of very high Kaolin content. From Anyang, Honan. 14th–13th century BC.

This style quickly developed to embrace an elaborate relief treatment of the whole of the surface of the vessel. It is, however, typical of Shang decoration that it is designed to be arranged in horizontal zones around the vessel. The scale of the decoration, as it becomes more and more complex, is finely judged. The use of thread relief gives way to a shallow relief, set off against a background itself covered all over with a squared whorl known as *lei-wen* or 'thunder spiral'. Precision of line, indeed slight undercutting to achieve a clean line even in this background motif, is a characteristic feature of the fourteenth-century BC pieces.

The basic motifs for the decoration are animal. There is a dichotomy of themes apparently operating contemporaneously: the so-called 'realistic'

24

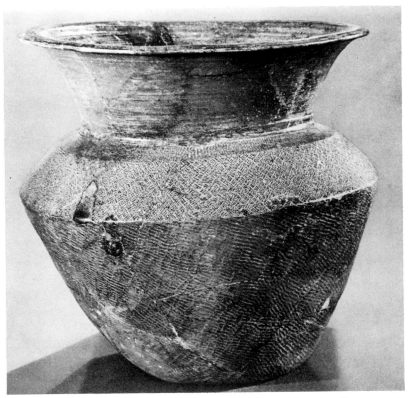

11 Impressed stoneware jar with wide flaring lip and angled shoulder. The geometric impress motif is covered by a high-fired glaze. The earliest example of glazed stoneware. From Cheng Chow, Honan. 16th 15th century BC.

style, by which is meant the use of representational masks and features of non-mythical subjects – human faces, deer and elephant heads – contrasts with the equally vivid representation of mythical animals. These two themes sometimes appear on the same object, resulting in a rather weird effect, which, however, seems to evoke the original symbolism more strikingly than on those objects in which one style or the other is used alone. There seems no reason to suppose a significant transition from one style to the other. As the vessels with which we are concerned were all meant for ritual use, it is probable that there is a meaning in the decoration. It is thought that the readily recognizable representations refer to the animals associated with the sacrifice for which the vessel was prepared. The question of the mythical

15

18

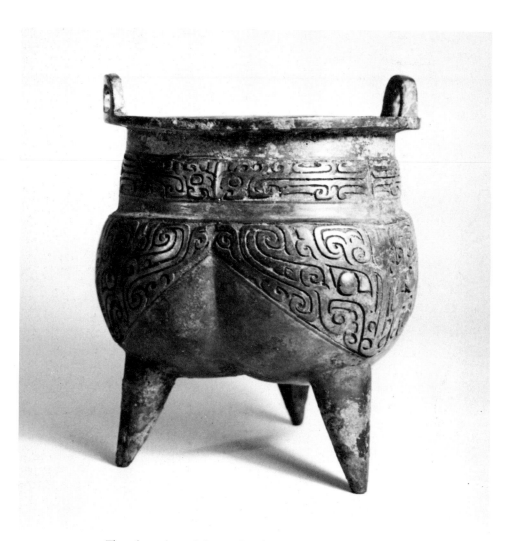

12 Three-legged vessel, *li-ting*. Cast bronze. This shape is a cooking vessel; it retains the hollow legs of earlier pottery (see Pl. 8). Decoration is composed of *k'uei* in flat raised relief. 14th century BC.

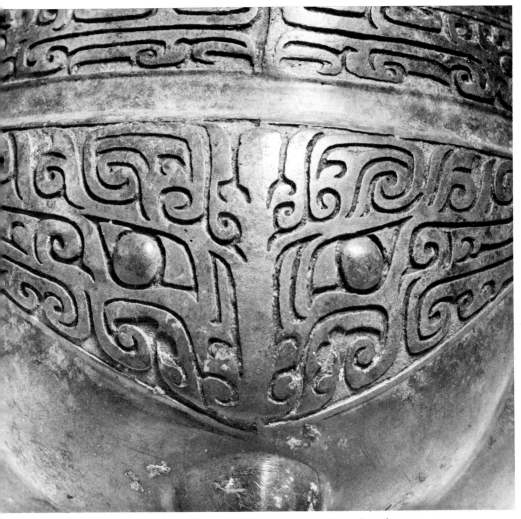

13 Detail of Pl. 12, showing confronted *k'uei* forming a *t'ao-t'ieh* mask.

motifs is more difficult. The all-pervading *t'ao-t'ieh* mask, with its protruding eyes and ferocious upper jaw, must represent something important in terms of the rituals, which we know were much concerned with blood sacrifices; it has been thought to be a symbol of gluttony or simply a terror mask. Even less easily interpreted are the small *k'uei*, loosely translated as 'dragons', small two-legged animals with a clearly visible snout, ears and a short curved tail. *K'uei* constitute the chief element in the main zone of decoration, sometimes forming a band running head to tail, or soon dismembered to create a continuous abstract design; later the *t'ao-t'ieh* mask itself may be built up of *k'uei* whole and dismembered. The lesser zones of decoration contain geometric or animal motifs such as that of the cicada, a creature full of significance throughout Chinese culture for its habit of burrowing away during part of its life-cycle to appear as a beautiful singing insect from out of the earth, a ready symbol of life after burial.

12, 13

The vessels on which this kind of relief decoration appear are also interesting for their form. The three-legged vessels, used for heating wine or for cooking food as they stand in the embers, are the very elegant heirs to the crude grey pottery or Black Pottery three-legged vessels of the Neolithic period. But in the bronze version the legs are lengthened, cast separately and brazed on. The *chüeh* and *ku*, for presenting heated wine, are very early shapes soon to die out, but the *ting* (cauldron) and *hsien* (steamer) survived for many centuries. Of the storage vessels for liquid and solid foods alike, the *kuei* is perhaps the most persistent shape, and the *yu* (bucket), with its swinging handle, an exceptionally beautiful one. It is typical of China that these vessels should early on be categorized, named and recorded. From the mid-Shang period onwards, it became customary for inscriptions to be cast into the vessel, often recording the occasion of the making of the vessel (when it is named), for whom it was made and for what reason. The inscriptions are short, consisting of a few characters of a simple pictorial script.

12, 13
8
38, 14
15, 27
16–18
25, 26
19, 20

14 (*right*) High-footed goblet, *ku*. Cast bronze. This trumpet-mouthed shape is a wine-drinking vessel; the hollow foot reaches up to the central zone. The rising blades are of cicada motif. 14th–13th century BC.

15 (*overleaf, left*) Four-legged vessel, *ting*. Cast bronze. The human mask motif may refer to human sacrifice, but this vessel bears an inscription 'large grain'. The simplification of the surrounds and the enlarged flanges point to a late Shang date. From Ning-hsiang, Honan. 14th–12th century BC.

16, 17 (*overleaf, above and below right*) Food storage vessel, *kuei*. Cast bronze. The reduced *t'ao-t'ieh* mask separates two confronted snouted animals and is surmounted by a feline cartouche. The decoration of the main motif in simple relief is surrounded by *lei-wen* in many forms (see detail). 12th–11th century BC.

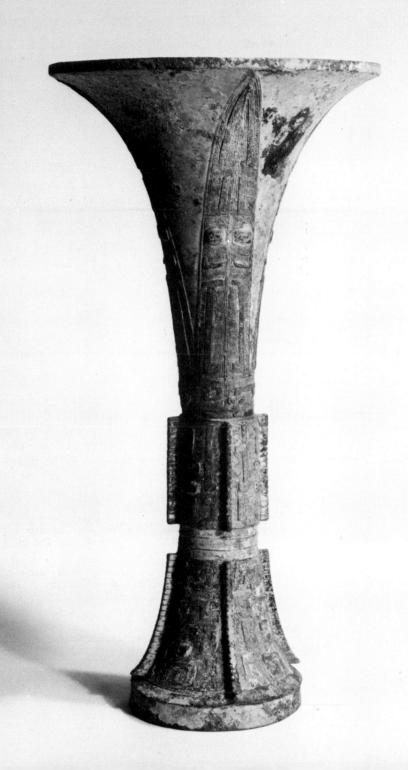

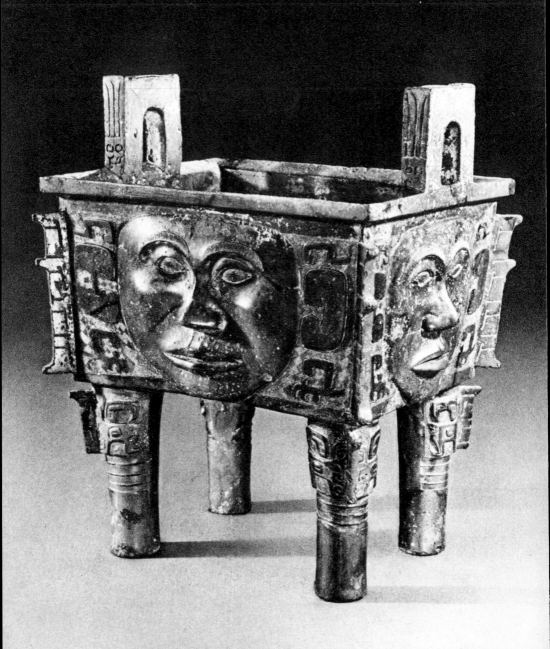

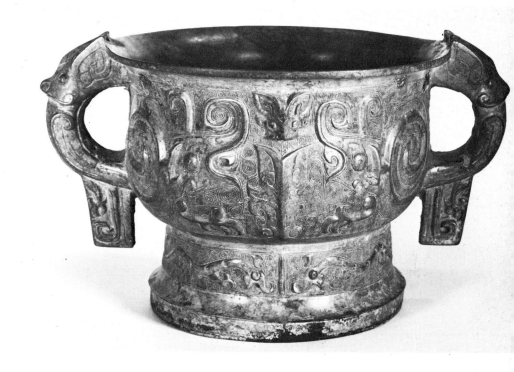

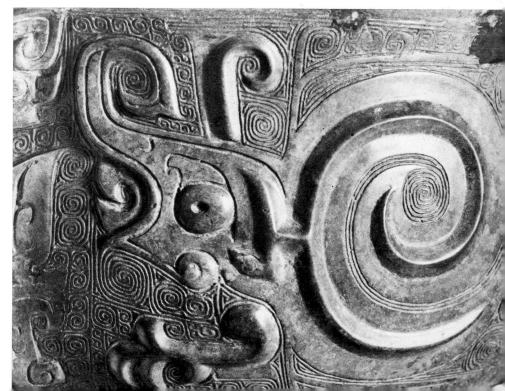

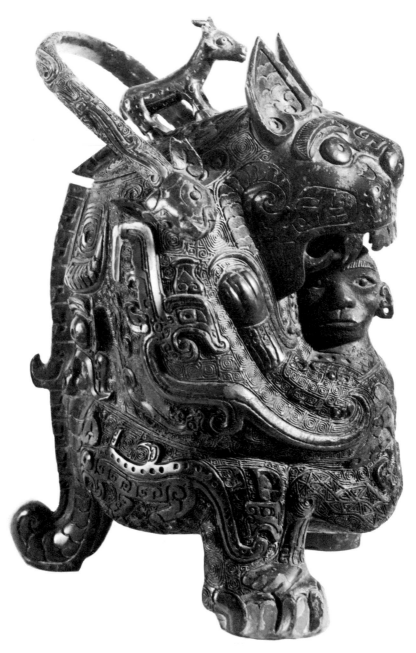

32

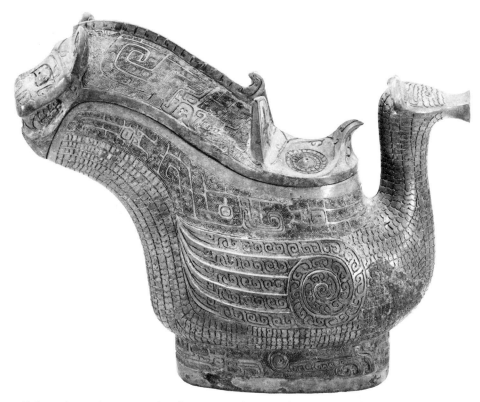

18 (*left*) Bucket with swinging handle, *yu*. Cast bronze. The monster with terrified human being embodies much of the late Shang style. The elaborate surface decoration includes *k'uei*, felines and serpents; a small deer forms the knob. Much use is made of *lei-wen* to enrich the surface. 11th century BC.

19 (*above*) Wine storage and pouring vessel, *kuang*. Cast bronze. This is a fine zoomorphic example in the form of a duck, with a monster mask on the tail and an owl on the shoulder. The surface is enriched with *k'uei* and a scale motif. 12th century BC.

A more continuous script is used in the oracle bone inscriptions. The 21 oracle bones were prepared for divination, following the tradition of the Black Pottery people, by cutting shallow indentations in the concave side of the bone at regular intervals. If a hot point is applied to one side of an indentation, this will crack the bone vertically and laterally. The angle formed by these two cracks provides relevant indication of the answer to the question asked in the oracle. In the Shang Dynasty the question was incised into the bone beside such a crack; this was often dated and the name of the

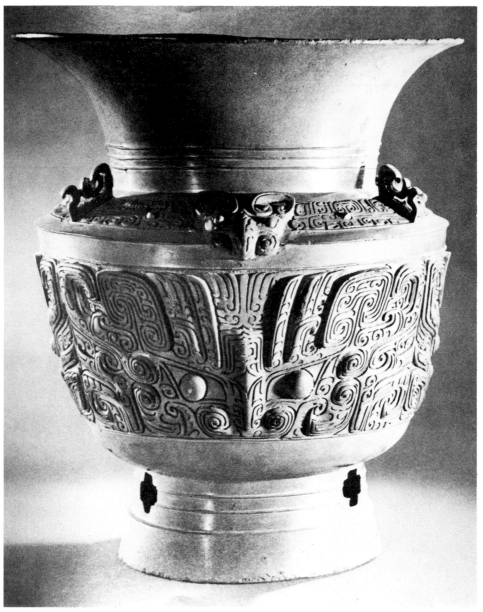

20 Wide-mouthed high-footed vase, *tsun*. Cast bronze. The cruciform holes in the foot are similar to those found on a *ku* (Pl. 14) and are related to casting techniques. Although composed of *t'ao-t'ieh*, the decoration is now executed on a rippling surface. From Funan, Anhui. 14th–11th century BC.

34

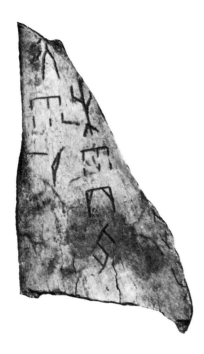

21 Fragment of oracle bone with incised inscription containing questions about rain. From Anyang. *c.* 1500 BC.

ruler mentioned. These bone inscriptions have been used by scholars for establishing the chronology of rulers and their relations with other states, and as a source of information on Shang agriculture and warfare. Although the exact date of the appearance of written characters is not established, by the mid-Shang period a considerable vocabulary of characters, usually of pictorial style, was in use. These characters are decipherable to the modern scholar and in many cases are recognizably the ancestors of the modern Chinese script. Furthermore, they show a growing awareness of the possibilities of the aesthetic quality of writing. The characters are designed, balanced and even composed over a wide area of bone with considerably greater freedom than is the case with the cast inscriptions, and a different style of calligraphy is used. This is the very beginning of an art form which was to be of great importance in China in later periods.

In tombs, Shang bronzes are found in association with jade, a stone which has retained its fascination for the Chinese since probably pre-Shang times. Endowed with all sorts of magical qualities, Shang jade seems to have been valued for its indestructibility; this was the reason why it was used in burial for sealing the orifices of the body. It was also appreciated for its resonant tone and early on was used as a chime. In such larger pieces the surface was decorated in a style similar to that found on cast bronzes. The techniques of carving and shaping the jade, which is harder than metal, by grinding it with

23, 24

22

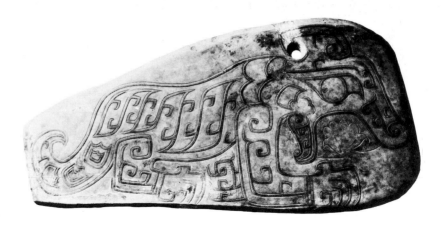

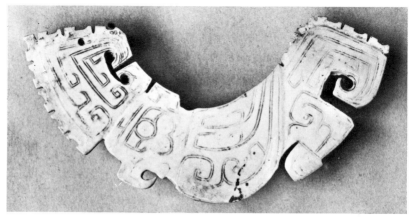

22 (*top*) Stone chime, pierced to be suspended in series and struck. The surface decoration of a crouching tiger in double line relief is closely related to contemporary bronze style. From Anyang. 14th–12th century BC.

23 (*above*) Carved jade plaque, pierced to be suspended. The design of a crested bird with serrated edge and surface motifs is also related to bronze style. 13th–11th century BC.

24 (*right*) White jade *tsung*. A ritual object of unknown use. The shape, a cylinder contained within a quadrangular form, has become traditional. 12th–11th century BC.

the aid of an abrasive powder, were inherited by the Shang craftsmen from their Neolithic ancestors. For the Shang peasant was still living in a Neolithic age; bronze and the arts associated with it were for the aristocrats and their rituals.

36

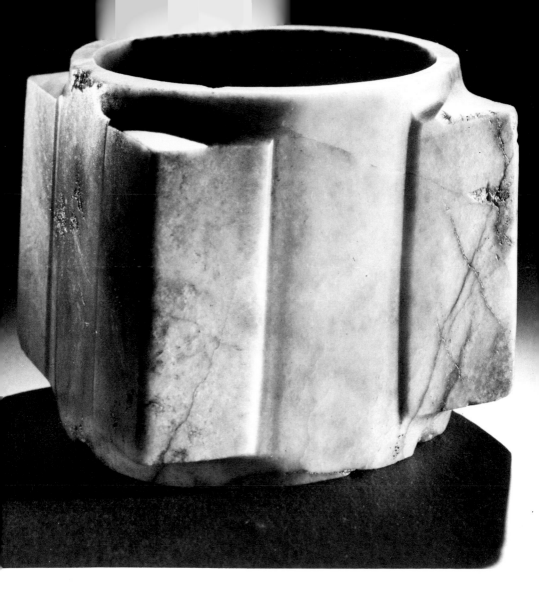

CHAPTER THREE
Status and Decoration
12th–3rd centuries BC

When the Shang fell it was to a warlike tribe who set up their capital on the Fen River close to present-day Sian. The Chou, as this people called themselves, had been mentioned on the Anyang oracle bones (fourteenth to twelfth centuries BC) as a troublesome tribe to the west. The new rulers allowed the defeated Shang ruler to remain in Anyang under the control of three Chou princes. However, when the first Chou king, Wu Wang, died, this arrangement collapsed with the insurrection of the captive and his guards. The regent restored the situation and established a system of enfeoffed states, each ruled by a prince of the blood. Under such a feudal system the Chou flourished and more and larger states grew up while the central royal state dwindled, although the latter retained ceremonial and Imperial power. As a result of these developments the theocratic art of the Shang lost its *raison d'être*: although the crafts of the former artisans continued, an important change had come over them. Relative status in society now became a matter of great importance. Bronzes and the products of other crafts became symbolic of honours and rank, and thus lost their hieratic character. Stylistically, the bronzes of the eleventh to ninth centuries BC show a continuation of the tendency, already noticeable in the late Shang period, to enlarge the vocabulary of decorative motifs, notably through the introduction of bird motifs. The shapes of vessels also changed: the *chüeh* and *ku* were replaced by the *yu, kuei* and *ting*. The wider forms of the *yu* and *kuei* lend themselves particularly well to the motif of the bird with the upswept pheasant tail. Finds from Anhui in the south are of especial beauty in their use of this interlocking motif. Bronzes were made in great quantity and are of bold shape, decorated with motifs derived rather closely from the Shang models, but in a broader style. The decoration became progressively secularized and the *t'ao-t'ieh*, where it remained, changed its character to that of a horned monster mask. Exaggeration, a characteristic feature of the new style, is evident in the extension of the flanges on the vessels, which often became vicious-looking, with hooked, upswept blades marking the profiles

25–27

26

25

25 Bucket with swinging handle, *yu*. Cast bronze. A piece showing some of the exaggeration characteristic of the early Chou period. The hooked and upswept flanges give a new profile to the vessel, although the decoration is still completely traditional. 12th–11th century BC.

38

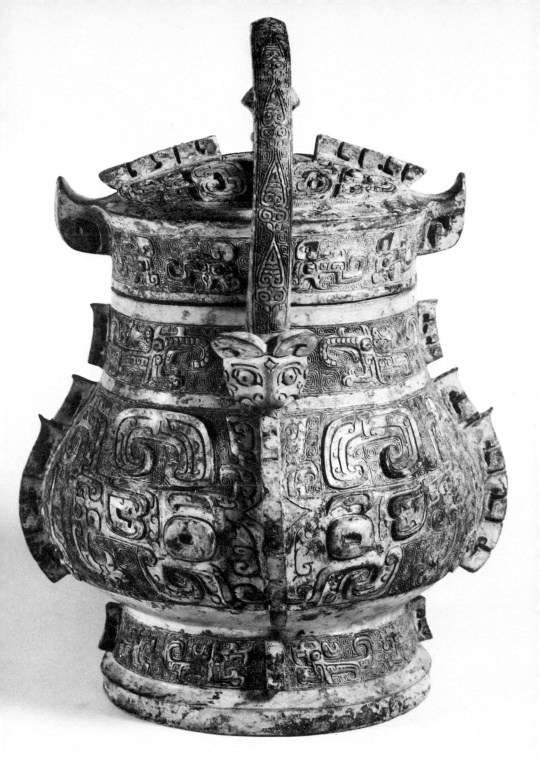

of the piece. The finds from Fu Feng, a site close to the capital, illustrate many of these features of the bronzes of the tenth to ninth centuries BC.

Not least of the characteristics of the bronzes of this period is the much greater length of the inscriptions cast into the pieces. These inscriptions consist of extended accounts of the occasion of the making and presentation of the vessel. They are carried out in a calligraphy more closely related to the modern script than the Shang inscriptions, in a style adapted to the medium and one, in further adaptation, used today in seal script. This longer, fuller prose implies a larger vocabulary. The information contained in these inscriptions makes these bronzes literary sources for historical study. Indeed, the period spanning the later Western Chou and the early Spring and

26 Bucket with swinging handle, *yu*. Cast bronze. The motif and design of the birds with long crests and swirling tails fit the squat shape of the vessel. Comparison with Pl. 18 shows the striking change in style between mid-Shang and mid-Chou. From Anhui. 10th–9th century BC.

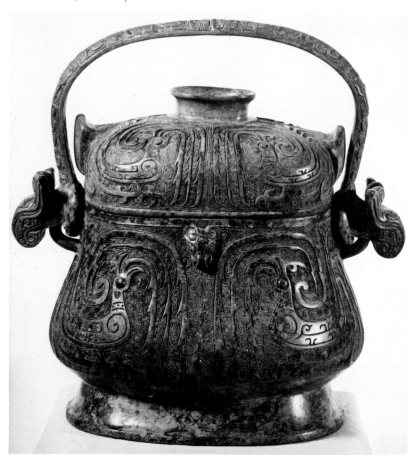

Autumn period (eighth to sixth centuries BC), covering the move of the capital from Ch'angan to Loyang, is regarded as one of decline in artistic quality but one in which bronzes acquire still greater documentary importance.

However, there was a considerable artistic renaissance during the last half (771–450 BC) of the Chou. During this time local styles established themselves in all crafts, which are some of the finest yet attempted. Despite the high quality of Chou craftsmanship and design, there seems to be a curious absence of expressive art during this period, whose broader cultural flavour it is hard to gauge. This may be due only to lack of surviving materials, and poor conditions of pit burial, the major source of our

27 Three-legged vessel with cover, *ting*. Cast bronze. The cover can be reversed to make a bowl. At this period elegance of form demanded subordination of the decoration, which is here abstract, with a quatrefoil motif in the centre of the cover. *c.* 6th century BC.

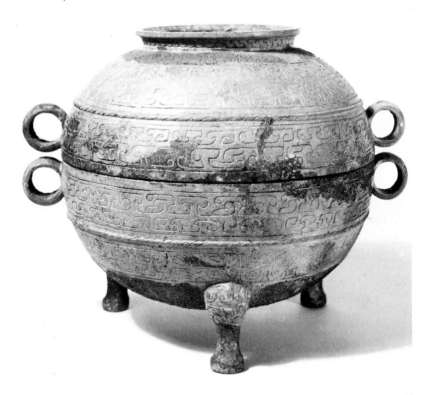

information, probably militate against the preservation of graphic art. Two squares of shamanistic cloth on which figures and signs have been painted do survive, however. These, although of great interest, cannot in themselves give a clear picture of an expressive art of the period.

Chou China covered a wide area, including states bordering on the Central Asian and Mongol deserts to the west and north, as well as a state to the south whose flourishing culture had developed independently from the old Yellow River culture. This state, Ch'u, was the source of much of the poetic element in subsequent Chinese art. The principal Ch'u craft consisted of woodcarvings painted in brilliant lacquer, depicting strange and exotic symbolic birds, snakes, and antlered deer with long hanging tongues. The Ch'u people excelled in architecture, especially palace architecture, which was much admired by the people of the north in this and later centuries. The two squares of shamanistic cloth mentioned above also come from Ch'u state sites. These are executed in sinuous line, in a scattered format with little concern for pictorial composition. There are no surviving bronze objects from the southern Ch'u state, but in eastern Ch'u (present-day Shou Hsien, Anhui) delicately cast bronze mirrors and fittings from the fifth and fourth centuries BC have been found. On these mirror backs a minutely fine all-over background design of angular geometric lines is overlaid with a broader concave line motif, which is sometimes enhanced with inlays of malachite.

This style is regarded as a variant of the so-called 'Huai style', which is more properly associated with the metropolitan Loyang area. Here the mirrors display a similar style, but the raised design is usually of lizard-like dragons twisting over the sharp surface decoration; sometimes the animal seems on the point of changing to a vegetable scroll. This element of ambiguity is present in much decorative work of the metropolitan style, carried through with such elegance as to to avoid grotesquerie. In general, the surfaces of late Chou bronze vessels display a complexity of intertwined dragon forms which sometimes dissolve into a hook and dot motif, enriching the surface texture. The use of undercut and pierced decoration necessitated the use of a wax matrix and the 'lost wax' process of casting. Gold and silver were also used in inlaid decoration and in gilding, techniques which became popular in the production of such adornments as belt hooks. Inlay, at first a thread laid and beaten into an incised line, is associated with Chin Ts'un, near Loyang; but it was practised in many places. The use of a bright metal inlay of completely abstract motifs of curls and volutes, particularly on small objects and fittings, is typical of the later Chou period. The general effect in the decorative arts of lacquered wood, inlaid or gilt metal fittings, and richly textured surfaces of bronze is one of clean-lined elegance and sober taste, qualities extending even to pottery.

28, 29

30

34

42

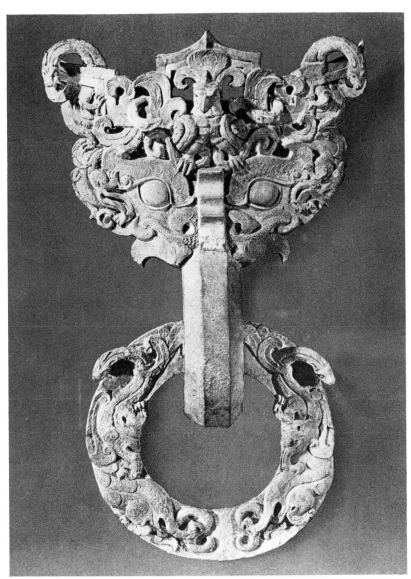

28 Cast bronze monster mask and ring handle. This piece may have formed the handle of a coffin or of a door. The mask is no longer the traditional *t'ao-t'ieh* and is surmounted by a bird and serpents. From Yi Hsien, Hopei. 5th century BC.

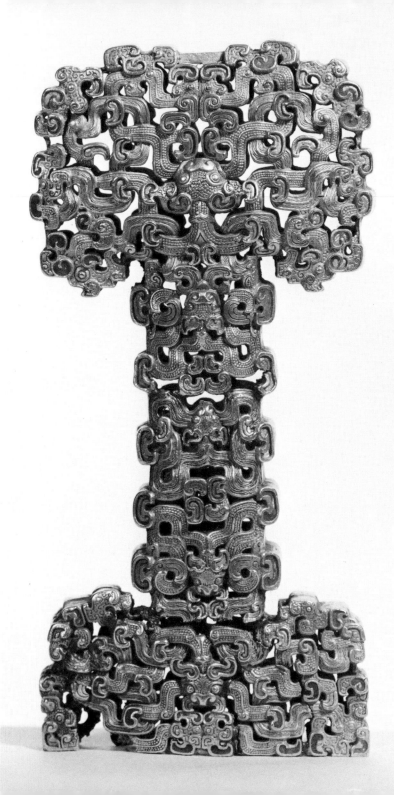

The personal adornment of Chou nobles seems to have been suitably decorative: belt hooks have already been mentioned, but decorated dagger handles and small swords with gold inlays were also in vogue. Scabbards were often intricately cast and sometimes contained tiny inlays of stone.

29 (*left*) Gold dagger handle. This piece, formed of interlocking dragons, has been cast by the 'lost wax' method, allowing for the openwork style. 4th century BC.

30 (*below*) Cast bronze table leg inlaid with gold and silver. The scroll and volute motif of the inlay has been adapted to the border and also to the body of the figure. This type of decoration is found in embroidery and lacquer of the period. 6th–3rd century BC.

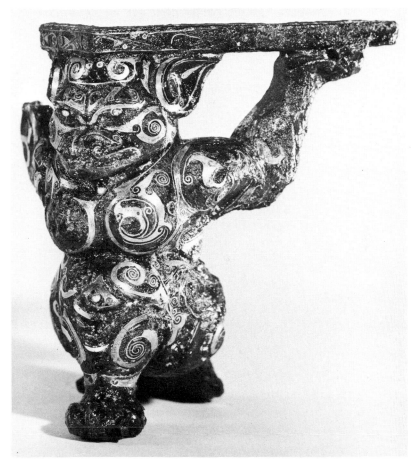

Jade and hard, semi-precious stone were also used in the decorative art of the later Chou states. As the hardest and rarest of the hardstones, jade acquired a mystique to which many attributes were to be added over the centuries. As jade is not found in China, its rarity value has always been high. During this period, its main source was in Central Asia. 'White' jade, which often has a brownish tinge, was the favourite colour in the fifth to fourth centuries BC. Thought to be indestructible, it was much valued especially for burial purposes. But as the taste for surface decoration became more subtle, the surface of jade was finely carved in the Huai style of curves and points, with a softened and polished treatment of concave and convex surfaces.

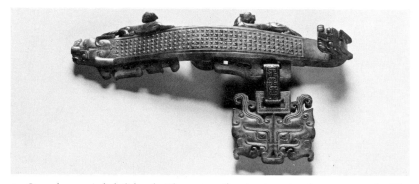

31 Carved green jade belt hook. The neat surface treatment and monster mask of the pendant can be compared with the bronzes of Pls 27 and 28. The small crouching felines on the upper edge of the belt hook are characteristic of the period. 3rd century BC.

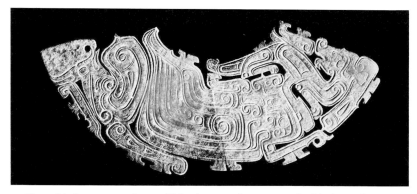

32 Carved jade crescent plaque. This piece can be compared with the 13th-century jade of similar shape and use (Pl. 23). Here the treatment is more elaborate and the composite bird and dragon motif makes a richer design. Early 10th century BC.

46

The Chou people were great city builders but little of their work survives except for city walls based on a core of *pisé* earth, and the stamped earth platform of major buildings. Chinese architecture had already established a tradition which was to persist, the main elements of which were wooden beams and pillars. Placed on a beaten earth floor, the weight-bearing pillars were 'tied' with cross-beams and topped by a further cross-beam structure which carried the roof. This roof support was at first simple, as it appears to have carried a light roof, perhaps of thatch. But as pottery tiles were adopted, the roof support gained in complexity to take the growing weight of the tiles. In the rare appearances of houses in early reliefs we can see this

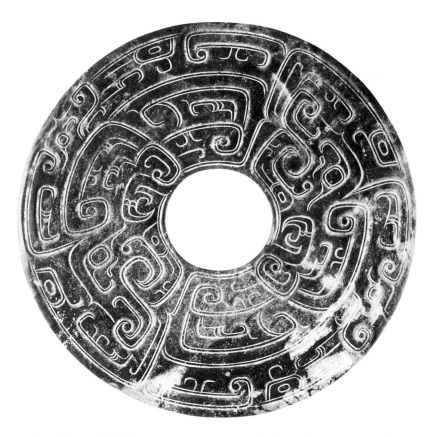

33 Carved green jade disc, *pi*. A very ancient ritual object of uncertain significance. The Shang examples are undecorated; this piece, perhaps datable to the 8th century BC, has an abstract meander decoration.

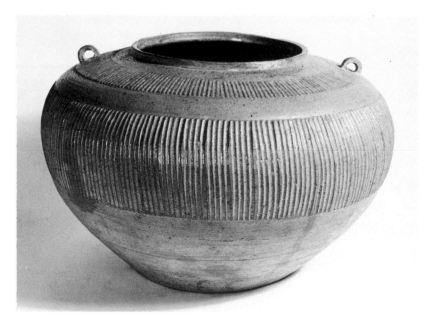

34 Grey stoneware jar with a slightly yellowish glaze, from the north Chekiang area. An example of the continuation by craftsmen in east China of the glazed stoneware techniques first seen at Shang sites (Pl. 11). 4th century BC.

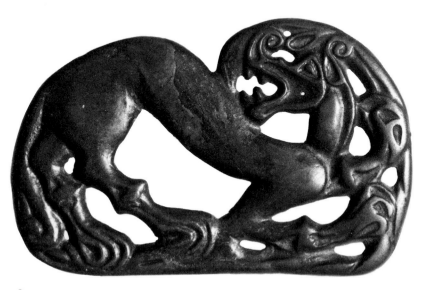

supporting structure growing to incorporate eventually the complex lever and bracketing which became such a distinctive feature of Chinese architecture.

The contact which Chou China enjoyed with its nomadic neighbours is reflected in the northern bronze decorative arts of the fifth to third centuries BC; this seems to be an example of the adaptation of a style, not wholesale borrowing. In the north, the Chinese were in contact with the nomads of the Ordos region, who in turn provided a link with the nomads of Central Asia. The Ordos nomads had evolved their own style of animal bronzes and from this halfway house the Chinese evolved the animal style found in northern China. The depiction of fighting animals in plaques or in relief motif, and the use of the animal-in-the-ring theme, appear late in the Chou period. This *35* representational decoration was outside the general mode or style of the metropolitan areas of north China and had an enlivening effect in later times.

The loose hegemony of the states of Chou inevitably lost cohesion and was brought to an end during the fragmented Warring States period (481–221 BC), a period remarkable for its magnificent craftsmanship. So much craft activity was encouraged perhaps by the very competition between the states and the proliferation of courts, which meant a greatly increased number of patrons. Even the oppressive move towards centralization initiated by the Ch'in Dynasty (221–206 BC) did not curb it. Chinese culture was on the brink of fresh developments.

35 (*left*) Cast bronze plaque showing tiger and tree. Ordos style. The motif of fighting animals stylized to fit into a rounded shape derives from the animal art of Central Asia. 4th–3rd century BC.

Nationalism and Expression
3rd century BC–*3rd century* AD

The arts of the brief Ch'in Dynasty and of the Han Dynasty demonstrate an entirely new aspect of Chinese artistic expression. Whereas in previous ages art had been associated with rituals and ceremonies, gradually evolving into a decorative expression of social status, the art first of the Ch'in and then of the Han is concerned with myths and everyday life. It was from the outset both a narrative and an expressive art.

The nation newly unified under the Ch'in embraced not only the metropolitan Chou states but also many foreign tribes with their own myths and beliefs, and, in some cases, with their own traditions of expression. This diversity made it imperative to seek a uniform cultural expression. The concept of 'Han' as quintessentially Chinese stems from this period, and the Han Dynasty is regarded as one of the golden ages of Chinese culture.

An explosion of activity in all fields of artistic expression accompanied the welding of a nation. Although there is some evidence for an earlier use of brush and ink, the use of brush, ink and paper is traditionally said to start in the early part of this period. It is certain that the free use of all three materials contributed to the increased volume of writing; histories were written and legends recorded. The extensive use of writing seems to have led naturally to pictorial narrative representation and to the development of painting as an expressive art. This is a logical evolution and it introduced the pattern of Chinese art which has held to this day. Painting and calligraphy remain the major expressive arts in China, all the other arts retaining something of the decorative character which they had acquired by the end of the Chou Dynasty.

In calligraphy, variant scripts had already been established for the cast inscriptions in bronze and for the incised and carved inscriptions in bone and stone. But the use of brush, ink and paper opened up many new possibilities and led to a proliferation of styles. The chief styles, designated by a system of aesthetic rules known to this day, were developed during this period: the seal script, based on the ancient cast bronze inscriptions; the *li* script, based on a script used for stone inscriptions, with a heavy stroke end (similar to the heavy serif of the Roman stone script); the flamboyant 'grass' or 'draft' scribes' script, designed for speed writing and adapted to become an art form in itself. Using a resilient brush made of animal hair, or sometimes the barbs

36

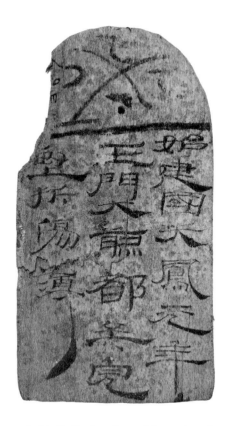

36 *Li* script with heavy serif, in ink on wood. This style, here adapted to brush and ink, was first used for incised calligraphy on stone. The overall balancing of thick and thin strokes and characters is evident even in this small sample. From Yumen, Kansu. AD 100.

of a bird's feather, bound into a bamboo stick, with ink made of compressed pine carbon and light glue rubbed down in water, the Chinese calligrapher exploited all the possibilities of his medium. Control of the brush, of the absorbency of the paper, and of the density of the ink, resulted in the full richness of thick and thin strokes, the subtle contrast of heavy and light strokes, and the studied expression of line – a strength of brush stroke that has nothing to do with weight, a liveliness of stroke that has nothing to do with speed of movement. Calligraphy also demanded a clear sense of composition, both for achieving balance within the single character and for establishing the relationship between the characters forming a surface composition on the page. From the first centuries of using brush, ink and paper, the Chinese *literati*, a select and self-selecting group, were conscious of their calligraphy and capable of a sophisticated connoisseurship towards it considerably in advance of their judgment of the charming narrative painting which had just started making its appearance.

37 (*below*) A group of burial jars from sites in the Kansu region. They are all slip decorated and show variants of the designs found in the villages of the area: Pan Shan, Ma Ch'ang and Hsin Tien. 3rd–2nd millennium BC. (See p. 13)

38 (*right*) Three-legged vessel for heating wine, *chüeh*. Cast bronze. This shape is unique to the Shang period although it is a development of a Neolithic Black Pottery shape. 13th–12th century BC. (See p. 28)

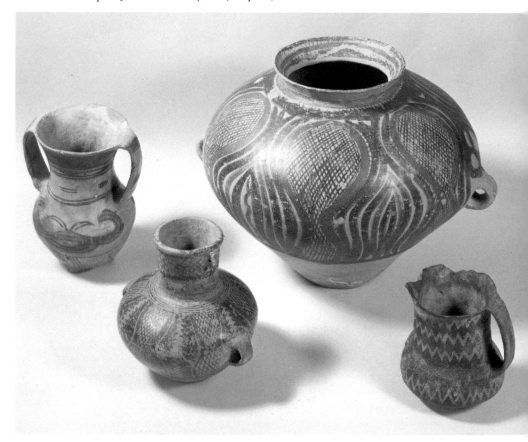

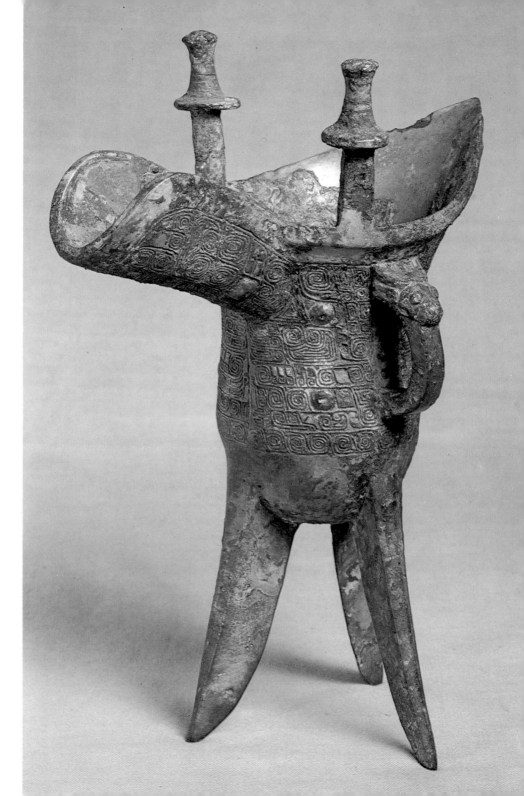

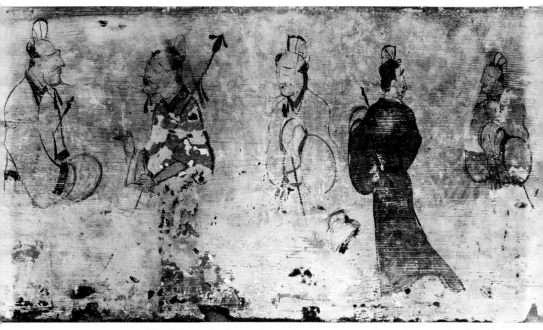

39 Painted brick from the frieze of a tomb near Loyang. This early example of brush painting shows sensitivity to brush line and interest in individual facial types. Although simply composed, the figures are related to each other by gesture. Han.

39

The concept of narrative painting perhaps came with the Buddhist sutras and temple art, brought to China by missionaries in the first century AD. However, when narrative painting first appears in China, it shows characteristics of a fully-fledged native style. Some of the earliest Han paintings on the walls of brick tombs show witty observations of people, almost caricatures, depicting individual facial types. Already they show an emphatic concern with the face as expressing the human being as a whole. Although little painting has survived, painting on brick tomb walls and lacquer-painted wood panels, again from tombs, show vivid narrative scenes in which a story is told in a series of 'stills', arranged in either vertical or horizontal episodes. A scroll-like composition is used even in wall painting.

40, 41

The painted hangings of the Ma Wang Tui tombs at Changsha, dated to the mid-second century BC, present a more complete painting style. Successive scenes, arranged in a vertical series, show the upper world of the heavens, the earth, and the underworld or sea. There is a marvellous unity between the representation of the mythical world and the representation of the mundane world, both worlds being equally real to the artist. These

54

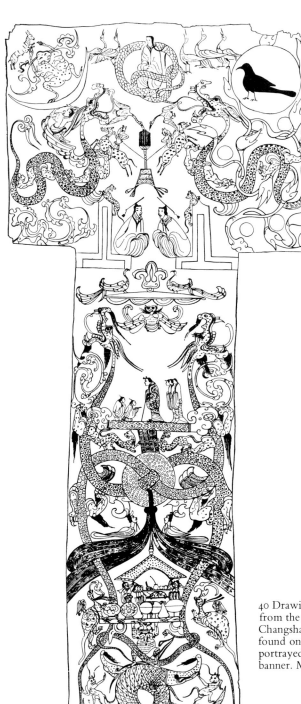

40 Drawing of funerary banner
from the Ma Wang Tui tombs,
Changsha. A symbolic painting
found on the coffin of the lady
portrayed in the centre of the
banner. Mid-2nd century B C.

55

41 Lower portion of the Ma Wang banner (see also Pl. 40). The style of painting in sinuous line and rich colour is probably close to the style of finer contemporary works on fabric, none of which have so far been found.

'T'-shaped hangings are painted in opaque colours, in a palette probably subdued with time, on a dark background. The upper section symbolizes the sky and the heavens and depicts several Han cosmological myths simultaneously; among other less easily recognizable creatures are the black birds, silhouetted against a sun, which the Hunter Li shot to relieve a scorching drought, and the three-legged toad in the moon.* The strange inhabitants of the sky fill the space above the small huddled scene of the deceased lady and the members of her household. That this is a portrait of the occupant of the tomb can here be proved by the freak preservation of the body in burial as a 'soft mummy' completely recognizable as the lady in the painting. The figures stand on a defined stage plane, not scattered in space, but in a group, with even a little overlapping. The relationship between them is simply established. Below them is another group of figures surrounded by burial objects, perhaps depicting the funeral ceremonies. The
41 murky underworld or sea is again represented by mythological scenes. The sinuous line of serpentine dragons, entwined in the jade ring (*pi*) and encircling the humans, seems to link this composition to Ch'u art of a century earlier. However, the treatment of the humans and of the mythological scenes is conceived in the 'new style', in which painting unites the real and the imaginary worlds. The juxtaposition of real and imaginary,
18, 42 first seen in the Shang bronzes, is characteristic of the Han period.
43 Related to the narrative paintings are the scenes cut in stone relief or impressed in brick. Because of the material used, these have survived better than the cloth hangings. They are all associated with burials or shrines, which determine their subject, and they are very varied in style. For, even in a period of intense nationalism, local art styles persisted. The reliefs on the
44 walls of the Wu Liang Tzu, a family shrine in Shantung, of the second century AD, are cut into a hard stone in a crisp, clear, silhouette-style composition. The stories depicted are from the official histories. The mode of composition is formalized and seems a little archaic. The figures are set on a platform, as in the Ma Wang Tui hanging, but here they rarely overlap, and depth is indicated by lifting a figure off the base plane, the foreground line being regarded as both the front and the main level. Minor characters in the composition are also represented on a smaller scale. The striking style of these reliefs depends partly on their lively use of silhouette, which gives a bold decorative strength to the compositions, and partly on their equally

* See M. Loewe, *Ways to Paradise*, London, 1979.

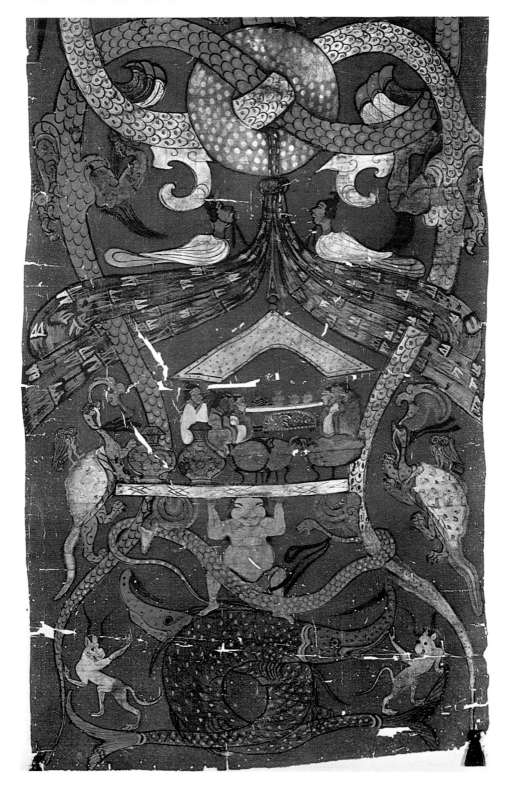

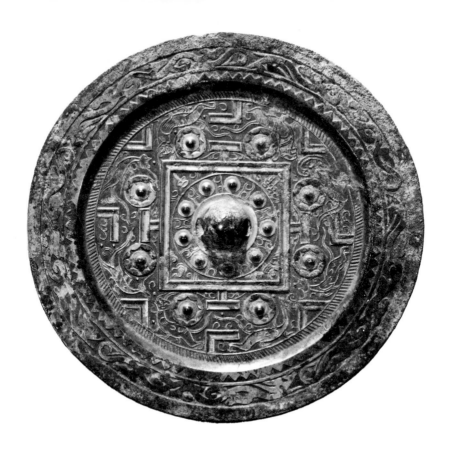

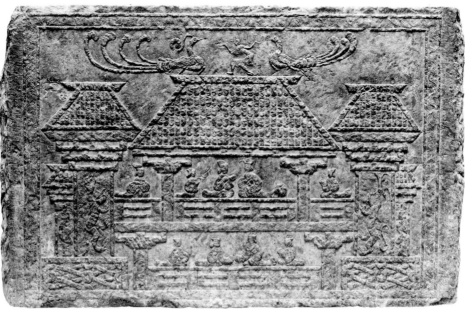

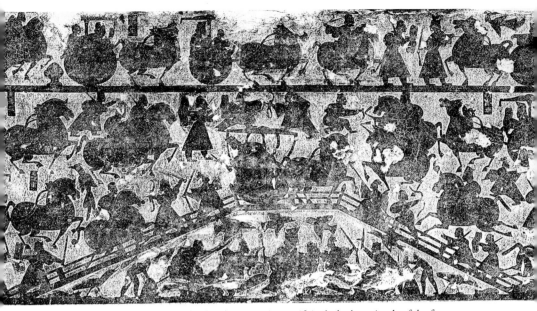

42 (*above left*) Bronze mirror back. The cosmic motifs include the animals of the four directions, and an angular arrangement used on a gaming board of the period. The reflecting surface of the mirror (not shown) is slightly convex and highly polished. Han.

43 (*below left*) Stone relief carving of a concert in a palace. The musicians sit on a balcony above the audience, and magic birds and spirits hover on the roof. From a funerary chapel at Ching Ping Hsien, Shantung. *c.* AD 114.

44 (*above*) Rubbing of a stone relief from the Wu Liang Tzu shrine, Shantung. This section shows a battle scene on a bridge over a river. The scattered surface composition reads from the base line upwards. AD 147–168.

lively and humorous narrative quality. The illustration shown here is of a rubbing, a method of reproducing reliefs which became popular in China at this time.★ In the present case, the result looks almost like a woodcut, again a technique developed in China shortly after this period for the reproduction of pictorial work, particularly in connection with printed books which first appeared in the third or fourth century AD.

Distant from Shantung, but contemporary with the Wu Liang Tzu reliefs, are the reliefs from Szechwan in western China. There the local stone was

★ Instead of the wax ball used by Europeans the Chinese use a silk pad which absorbs damp ink. A supple yet strong paper is dampened and then beaten into the surfaces of the relief to be rubbed. The inked pad is then dabbed firmly over the surface of the paper. In this process there is considerable control over the tone and the depth of the relief reproduced, for the weight and sharpness of the rubbing can be regulated. This art, as it is recognized in China, is used to reproduce any relief from a coin to monumental sculpture.

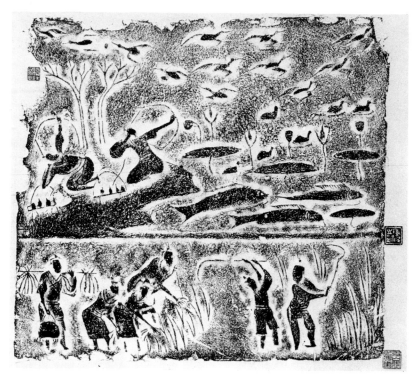

45 Rubbing of a stamped brick from Chengtu, Szechwan, showing hunting and reaping scenes. The Szechwan artists had a more adventurous pictorial approach than the contemporary Shantung artists (Pls 43, 44). Late Han.

unsuitable for carving, and stamped bricks were substituted as the cladding for the walls of underground tombs. The narrative decorations on these bricks seem to derive from free brush drawings and consist of a joyous mixture of real and mythological subjects. Scenes of harvesting, hunting and teaching record, if somewhat sketchily, the various activities of the time. Scenes as a whole are loosely composed on the surface with indications of depth, but with no strong ties in the third dimension. Indeed, the scenes owe much of their charm to their understatement and informality which allow each episode in a picture to be read separately. When mythological beings appear in these brick pictures they are often difficult to identify; such beings reflect, perhaps, a strong local tradition, unrecorded in the corpus of national myth but surviving in the visual arts. Stamped brick of a different type was used in the tombs of the Loyang area. Here the repetitive quality of a stamp is exploited. The motif of the figure flanked by trees, used in many early

45
46

60

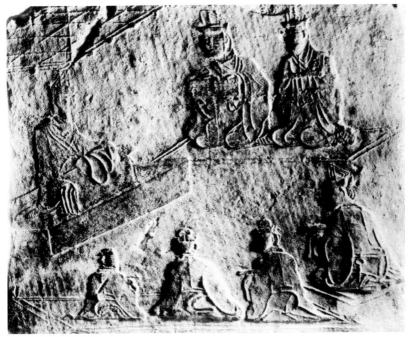

46 Stamped brick from Chengtu, Szechwan, showing a teacher with students. The grouping of figures on a flat surface develops the use of an isometric projection much used in later Chinese and Japanese painting. Late Han.

painting compositions, is a favourite one, becoming almost a cliché. At this date it survives only on the bricks, probably copied from contemporary paintings.

Magnificent tomb furnishings provide further information about the applied arts in this period. The life-size human and horse figures found in one of the gateway chambers of the tomb at Lin T'ung, Shensi, of the Ch'in Emperor (Ch'in Shih Huang-ti, c. 221–209 BC) are rare examples of sculptures in clay. Partly modelled and partly cast, they are made of terracotta approximately 3 inches (7·5 cm) thick. The heads and hands of the men are removable and appear to have been modelled with much attention to details of hair style and individual facial types. They are not glazed but were probably originally coloured with slip or paint, as traces of a red pigment remain. These figures must have represented the entourage of the Emperor (perhaps only a small proportion of the guardians of his tomb, for

50–52

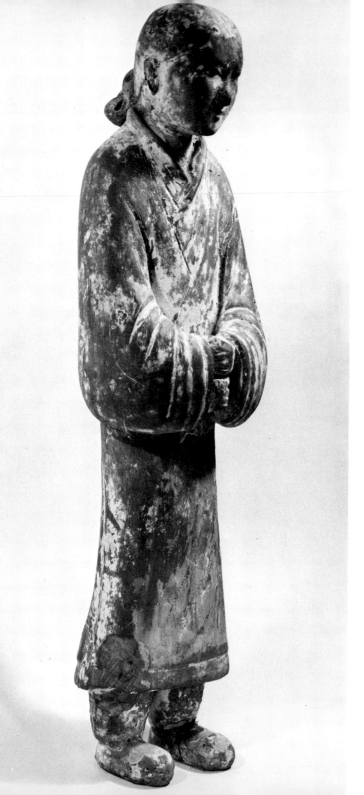

excavations are still incomplete) and include types which may be portrayals of actual members of his bodyguard. They accord with Chinese concepts of characterization in that they display much more interest in personality than in the form of the human body. Although these figures can in no sense be compared with Indian or Greek sculpture, they possess a quality which is memorable and they stand at the beginning of a tradition of human and animal tomb art which continued over many centuries, gradually becoming miniaturized. The tomb models of the T'ang period (AD 618–906), sometimes regarded as an art form in their own right, should be seen in this context. They reflect one aspect of a. tradition of comment on the human situation, typical of Chinese genre art, both pictorial and sculptural. Related to the tomb figures are the very rare bronze figurines of wrestlers or acrobats. Only some 4 inches (10·2 cm) tall, these little figures are full of life and must have been intended as ornaments for the house.

47
86
48
49

47 (*left*) Standing figure of a servant. Grey earthenware with traces of pale slip. This is a solidly modelled tomb figure which apparently once held a staff. Probably of Han date and close to the style of the figure of Pl. 52.

48 (*below*) Unglazed pottery tomb model of a farmhouse. The two-storey dwelling houses the family upstairs, and the animals below and in the yard. From Canton. Han.

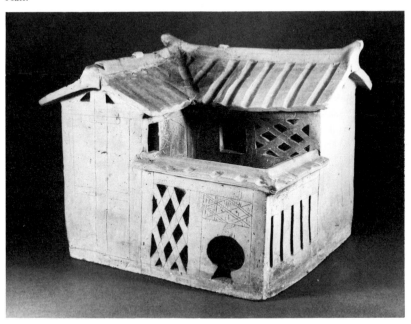

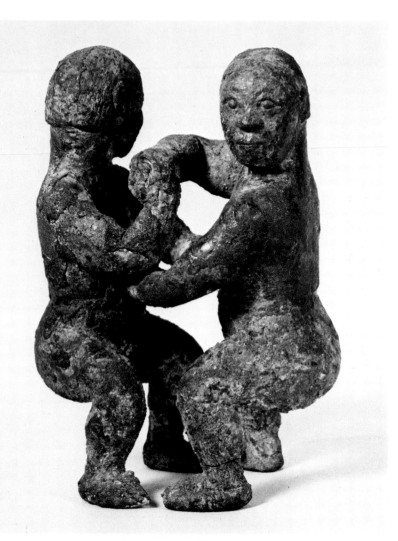

49 Pair of cast bronze wrestlers or acrobats. These unusual figures were apparently not primarily intended for burial use. Late Chou or early Han.

50 Covered box for the storage of mirrors, *lien*. A gilt bronze vessel with a meander design etched on the outside and a painted phoenix among cloud scrolls within the cover. The animal legs and swinging ring mask cartouches are characteristic of the period. Han.

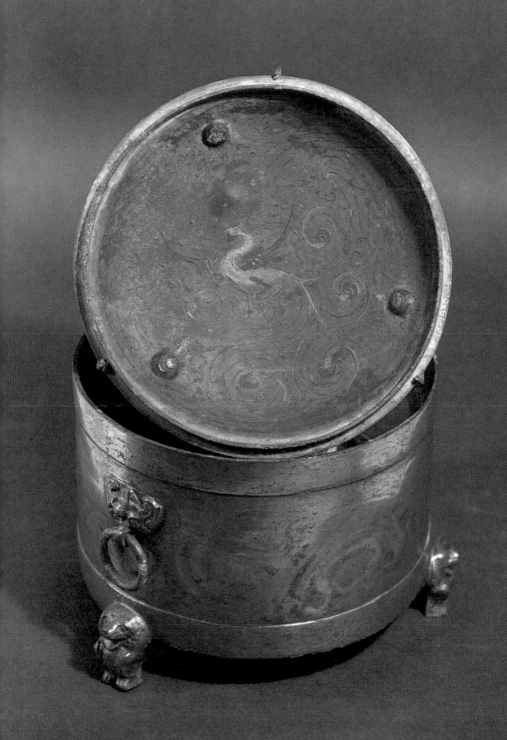

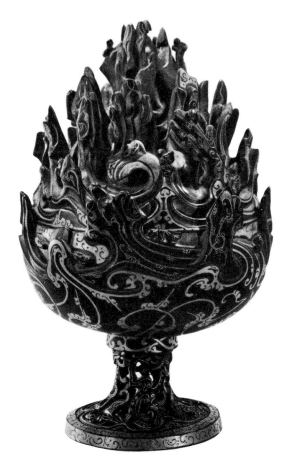

51 (*right*) Incense burner in the form of a mountain. Cast bronze with gold and silver inlays. The cover is pierced so that the incense smoke wreathes out. Small animals and humans wander amongst the peaks. From the tomb of Prince Liu Sheng, Man Ch'eng, Hopei. Late 2nd century BC.

52 (*far right*) Gilt bronze oil lamp in the form of a kneeling servant girl. Her right arm and sleeve form the chimney of the lamp, and the cylinder around the wick revolves to allow the light to be directed. From the tomb of Princess Tou Wan, Man Ch'eng, Hopei. *c.* 2nd century BC.

An increase in prosperity and the spread of Han authority took officials to distant regions, and grand Chinese tombs can be found in remote places, furnished with metropolitan riches. A pair of such tombs, found at Man Ch'eng, 95 miles (150 km) south-west of Peking, date from the late second century BC. These are rock tombs cut 165 feet (50 m) into the hill and were built for Prince Liu Sheng and his wife, Princess Tou Wan. The couple were closely related to the Imperial family and the tombs, though idiosyncratic in construction, represent in every other way a rich Western Han burial. Both husband and wife were buried in jade 'suits' and surrounded by treasures. These were arranged in antechambers and side chambers cut at right angles to the central passage leading to the burial chamber. The contents of the

66

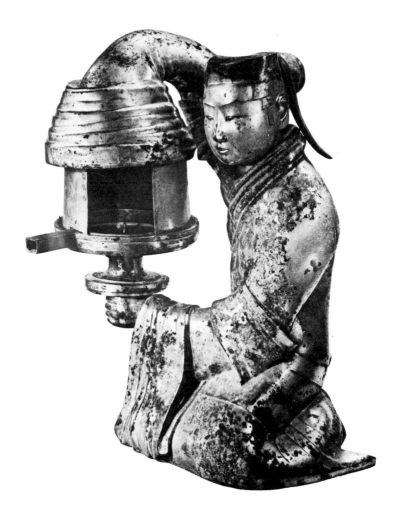

tombs include pottery, jade and gilt bronze. In keeping with the richness of
the owners – for the Prince was the local ruler – the objects are for the most
part, perhaps excluding the pottery only, not burial replica wares but actual
treasure. The Prince's tomb contained gilt bronze vessels which, although 51
classical in shape, have bold decoration in gold of evident splendour but no
apparent symbolism. The style seems to derive from the Huai style of
previous centuries, but it here becomes much more flamboyant with the
addition of gold and inset jewels. The pottery found in this tomb is grey and
slip-painted in close imitation of bronze decoration; it was perhaps intended
for use in the burial ceremonies carried out within the tomb. It is in the
Princess's tomb that the leopard pall-weights shown in the 1973 Chinese

Exhibition were found. These small animals are of bronze with gilded spots, and each animal has ruby eyes. The stylization of the animals is perfect for their scale. The small servant girl in gilt bronze, who acts as an articulated lamp, is another of the chief treasures of the Princess's tomb. Inscribed to show that it once belonged to her grandmother at court, this is probably an heirloom piece dating from the very early Han period. A small genre sculpture, it bears a strong resemblance in style and subject to the kneeling female figures found in the Lin T'ung tomb.

Far to the north-west, in Kansu, Han tombs of a later date (second century AD) have been found to contain many lively horse sculptures cast in bronze.

53 Large heavy stoneware jar with incised decoration on the shoulder and green high-fired glaze. Probably from the north Chekiang area, this storage jar in bronze shape is part of a long tradition of high-fired potting in east China. Han.

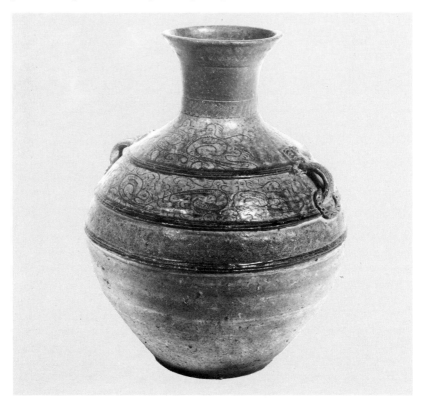

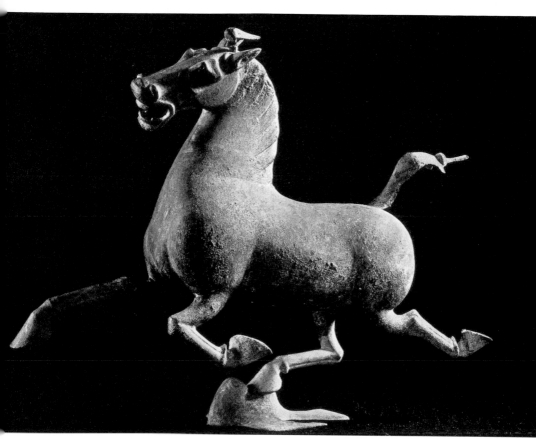

54 Cast bronze figure of a horse with one foot poised on a flying swallow. This famous piece comes from Kansu and represents a lively tradition of horse models in the area. 2nd century A D.

The famous 'flying' horse comes from this region and is one of many vivid 54 representations of an animal which was to continue to fascinate both artists and owners for many centuries.

The Han period brought improved technology and great vitality to the 53 arts: calligraphy was established as an art form allied to the growing literary arts; painting began to be explored for its narrative quality, and also as a complement to the written word; portrayal of genre subjects seems to have become the main concern of the painters, who were also experimenting with compositional techniques. From the Han period painting began to emerge as the major expressive art in China: despite variations in style and content, it has retained this position up to the present day.

The Imprint of Buddhism
1st–10th centuries AD

Although the first Buddhist missionaries had come to China in the Han Dynasty, and Buddhism was established at court during this period, the effect of the new religion on the arts in China was only gradually felt. The introduction of a mature, much travelled artistic tradition into a lively and developing society brought many and varied results. Just as Buddhist narrative traditions enriched the literary culture of China, so Buddhist traditions of iconography, temple and tomb building, and painting on scrolls and walls, opened up new possibilities for the artistic culture of China. In sculpture and painting, Buddhist iconography was adopted and adapted to fit native systems of belief, while the Buddhist temple became the model for all Chinese temples, Taoist and Confucian. Scrolls of silk and paper became the format for written and pictorial records, replacing the bamboo slip 'book' records of the Han. The handscroll was quickly joined by the hanging scroll as the favourite format for painting. In all these ways, and in many others, Buddhism left a large imprint on Chinese art.

As a compound of buildings, each with its own well-defined ecclesiastical function, the Chinese Buddhist temple came to be formalized in the metropolitan area of China, and it is today reflected in the classic temple compounds preserved in Japan. The ground-plan and the separate buildings 55 of the Horyuji, Nara, faithfully reflect those of a seventh-century temple of Ch'angan. At the Horyuji the walled compound encloses a series of buildings, diverse in plan and function, but related to a central axis. Both the building technique, executed in wood and based on a pillar and beam structure, and the concept of the plan were derived from native Chinese traditions of palace building.

The one building in the Horyuji compound which does not derive from the Chinese palace, but which is unique to Buddhist architecture, is the pagoda. Starting as a simple one-storey building, it seems to correspond to the Indian stupa. However, very soon the Chinese added extra storeys until they reached the very considerable height of twelve storeys. The earliest remaining pagodas were built in stone and brick, but the Horyuji pagoda is the best early example of a wooden pagoda and preserves Chinese seventh-century styles. It is of seven storeys and built around a central pillar. The Kondo building in the Horyuji is a hall very close to the mainland style of the

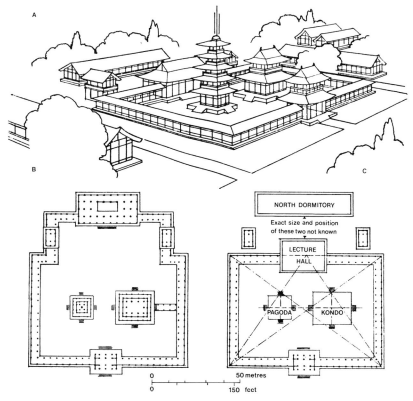

A

B

C

NORTH DORMITORY

Exact size and position
of these two not known

LECTURE
HALL

PAGODA KONDO

0 50 metres
0 150 feet

55 Projection and plans of the Horyuji, Nara, Japan. 7th century. **A** and **C** show the
original layout of the temple; **B** shows the present plan.

seventh century, and by considering it together with the Fo Kuang Ssu hall
on Mount Wu T'ai, which is a mid–ninth-century (T'ang) construction, we
can draw some general conclusions as to the technique and style of building
in what is considered the classical period of Chinese architecture. The
platform plan of the Kondo building is laid out on stone, and a double row of
pillars (an inner and an outer series) supports the roof on branching
bracketing, which enables the eaves to be extended far beyond the outer row
of pillars. At this period an *ang* was used in the roof structure. This is a
slanting curved arm, reaching right out under the eaves, which was used as a
lever bridging the two sets of bracketing. This clever means of construction

71

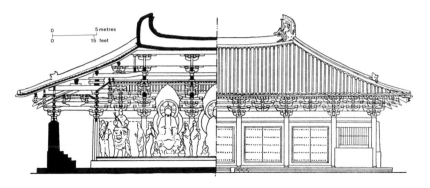

56 Section and elevation of the Fo Kuang Ssu hall on Mount Wu T'ai. Mid-9th century. Comparison with Pls 120 and 121 shows the changes in proportion and the more pronounced roof curve used in later buildings. The section shows the *ang* lever, here used double.

57 Detail of the bracketing and eaves of the Fo Kuang Ssu, showing the projecting bracketing on three arms and the intermediate bracket between the pillars, which all act with the *ang*.

was dropped in the Ming period when the interior structure of the roof was simplified and the proportion of the building changed with the adoption of taller columns and narrower roofs. The Fo Kuang Ssu, an image hall, is a handsome building of squatter proportions than later Chinese buildings; it is often described as 'masculine' in style, as the proportion of the pillar to bracket and roof, and the weight of woodwork in the eaves, all add up to an impression of strength.

56, 57

Such wooden buildings were easily destroyed in the repeated attacks by the State upon established Buddhism which reached a crescendo in the ninth century, leaving few early temples in China. What have survived, however, are the temples cut into rock. These reflect a tradition of building brought to China from the north Indian subcontinent; the route can be traced through Bamiyan (Hindu Kush), Kizil and Turfan (Central Asian Basin) and Tun Huang (north-west China). When it reached north-west China, the tradition

was already fully developed. The rectangular caves were cut into a cliff face, and wooden or stone stairways led to the higher caves which were sometimes connected by verandahs and passageways along the cliff face. These caves were usually quite small and consisted of simple cells, but they could be expanded and they contained many niches. Depending on the suitability of the stone, the caves were decorated with relief carvings or with stucco and painting on a prepared gesso wall. Each cave temple contained a stone or stucco stupa, or images of the Buddha with attendant Bodhisattvas. It had already become a tradition to make at least one colossal Buddha figure, standing or seated, which dominated the whole site. Foreign though this idea was to China, it was adopted with enthusiasm, and many large cave temple sites were excavated from the fifth to the eleventh centuries, when the impetus seems finally to have petered out. These cave temples are of especial importance both for their own beauty and because they are the repository of the major sculpture of China. Because of the destruction of the T'ang Dynasty urban temples, much of the free-standing work in them has also disappeared, and it is in the cave temples that the main body of this art has been preserved.

The earliest cave temple sites now known (fourth century AD) are at Ping Ling Ssu and Tun Huang, in Kansu. Tun Huang is a border town and the gateway to the trade routes which crossed Central Asia. It was a garrison post for the Chinese border guards, an important trading post and the entry point of Buddhist missionaries. Near the town, monks established temples, monasteries and extensive libraries where scholars and translators gathered to undertake the production of Chinese sutras and to prepare translations of Buddhist literature. The Buddhist settlement at Tun Huang included three groups of cave temples made initially directly on the model of those of Central Asia, presumably by itinerant artist monks. Now known under the general title of Ch'ien Fo Tung ('Thousand Buddha Caves'), the three sites are at Mo Kao K'u, Hsi Ch'ien Fo Tung and Yu Lin. Mo Kao K'u is the largest and most important site, situated in the valley of the Ta Ch'uan River. The caves are cut into a cliff, approximately 1 mile (1,698 m) long and 130 feet (40 m) high, on the west bank of the north-south flowing river. Some four hundred and eighty caves, in two or three tiers, were made over a period of four centuries and they provide a survey of the changing styles of Buddhist art in this area.

The earliest date recorded (on a stele of 698) is the opening of a cave in 366. However, the earliest surviving caves are of a fifth-century date. The Northern Wei captured Tun Huang in 440 and from then until the latter half of the eighth century, when the city was occupied by the Tibetans, Tun Huang was in close touch with metropolitan China. The caves at the

58

northern end of the cliff include the earliest Northern Wei and Western Wei caves. As the local conglomerate rock is quite unsuitable for carving, these caves are decorated with stucco figures in the round set against rough gesso walls, the whole painted in sombre body colours. The Northern Wei decorators created flickering, sweeping compositions of Jataka stories of the life of the Buddha, told in horizontal narrative strips, in which the real and the mythical intermingle in a way reminiscent of the Han artists' work. A feeling of airy lightness is everywhere as apsaras float with trailing ribbons and scarves in a sky scattered with clouds and flowers. The solemn-faced Buddha and Bodhisattvas have a grave quietness which is emphasized by the colour scheme of these early works. The painting is executed in earth-greens, blues, ochres, and a red which has oxidized to black, resulting in a severity which was not originally intended. This style is regarded as Chinese, in contrast to the stolid Asian styles of Kizil, and it is also very characteristic of painting in other more central areas. Metropolitan paintings and reliefs, of non-Buddhist subjects, show some of the same stylistic effects. Episodic narration, floating drapery and elongated figures are found, for example, in the late fourth-century *Admonitions* scroll of Ku K'ai-chi (see chapter 6, below). This points to Chinese artists being used in Tun Huang from the beginning. It also underlines the complete adoption of Buddhist iconography into Chinese style.

74

Later on, at Tun Huang, the Sui period (sixth to seventh centuries) is characterized by a stillness in both painted and sculpted figures. The Buddha and his attendant Bodhisattvas become more important and the Jataka stories recede. Mahayana was the form of Buddhism which took root in China and this led naturally to the cult of Bodhisattvas. The Bodhisattvas, beings who have achieved Nirvana but who elect to stay in touch with the world to lead lesser mortals, are portrayed as bejewelled, foreign princelings of Indian origin. In the sixth century, the figure representation became stiffer and the jewellery richer, probably reflecting a wave of influence from the Middle East. The floating ribbons noted in the work of the Northern Wei decorators have gone, but the palette has become much brighter and more varied. The Tun Huang cave area was extended still further during the first part of the T'ang Dynasty (618–906) until the Tibetan invasion (late eighth century) temporarily stopped Buddhist activity.

Buddhist art had already moved into metropolitan China. Even though Tun Huang is the most extensive and the longest surviving cave temple site, it has many rivals in richness. When the Wei moved their capital from Lanchow, in Kansu, to P'ing Ch'eng, in Shansi, a new cave temple site was opened at Yun Kang in 460. Here the stone is suitable for carving and the entire decoration is carried out in relief and in free-standing sculpture. This

59

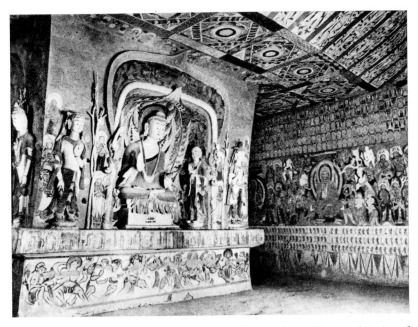

58 Cave no. 428, Tun Huang. The richness of effect is achieved by a combination of painted stucco figures in the round set against a painted background which extends over walls and ceiling. 5th century.

59 General view of part of the caves at Yun Kang; all the frontal structure is missing, but the colossal Buddha (Pl. 60) is clearly visible. The size of the cave temples ranges from small shrines to quite large chambers.

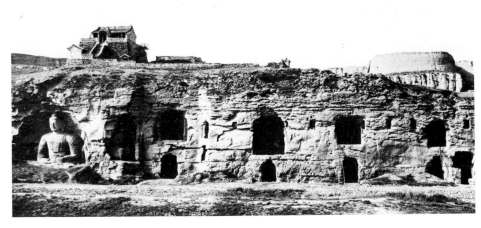

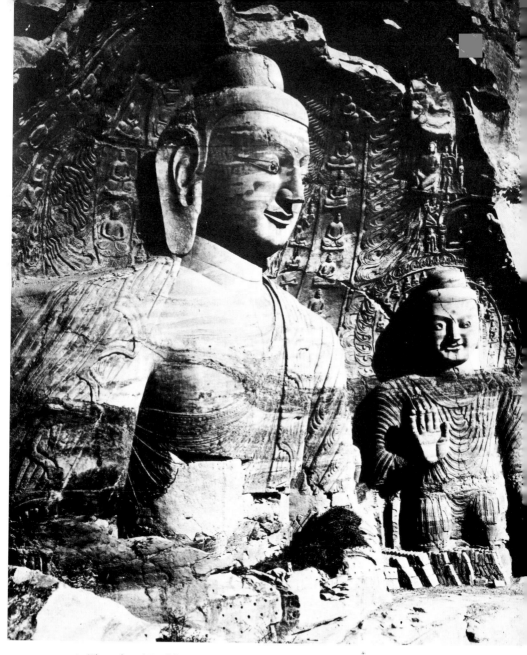

60 The colossal Buddha with attendant Buddha, Yun Kang. The seated Buddha is a
fine example of Northern Wei monumental Buddhist sculpture, and the standing
attendant shows the early style of rendering folds of drapery. *c*. 460–470.

76

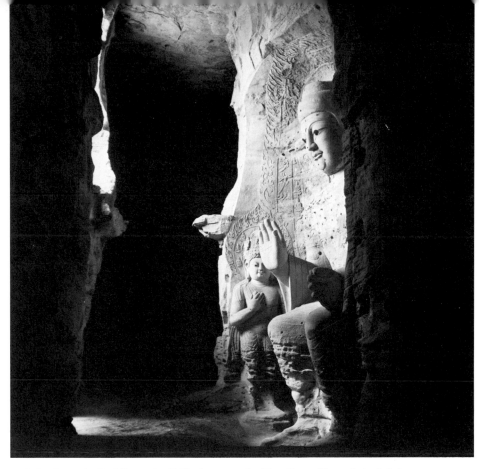

61 Side view of a Buddha at the Si Ku Ssu temple, Yun Kang. The style is slightly later than that of the colossal Buddha (Pl. 60), as is shown in the rounder face of the Buddha and the more static Bodhisattva to the left. 460–494.

series of caves is in the mainstream of the late fifth-century stone sculpture style, one which shows some remains of Asiatic influence in the poses of the Buddha and in details of the head-dresses and costumes of the Bodhisattvas, yet is moving towards the metropolitan style of Lung Men and Kung Hsien in Shensi. The style and content of the decoration are close to that of the 62 contemporary painting at Tun Huang, with the same floating figures and strip narratives, and the same solemn Buddhas with their elongated limbs, long faces and quiet smiles. The colossal figure triad at Yun Kang, one of the 60 earliest stone sculpture groups in China, is a massive work which dominates the whole site.

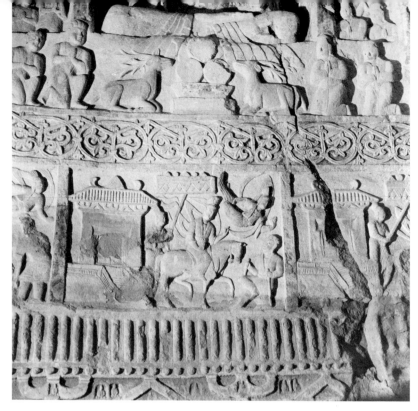

62 Detail of a relief from Yun Kang. The relief shows an episode in the life of the historic Buddha, who is here seen riding on his horse and meeting a beggar. Such narrative reliefs replaced the paintings of Tun Huang (Pl. 58). Second half of 5th century.

At Yun Kang the caves are in a high cliff, quite difficult to reach and very big, especially caves 16–20. The caves are rich in sculpture, and it is possible to trace development of style within the cave complex. Here the typical fifth-century Buddha figure is broad-shouldered, with a sturdy face and a serene expression. This is the style immediately preceding the more fleshy, round-faced, early sixth-century model, found in caves 7 to 8. The later sixth-century style carries this elaboration still further with a more richly clothed and elegant type of figure. This later Yun Kang style is picked up at Lung Men, near Loyang.

The Wei moved their capital yet again in 494, to Loyang. This city was destined to be a capital for successive dynasties until the Sung finally moved away east, to Kaifeng, in the eleventh century. The Lung Men caves, close to Loyang, were cut in the cliffs on both sides of the Feng River which flows south to north. The eastern side, containing mainly T'ang period caves, has

60

61

78

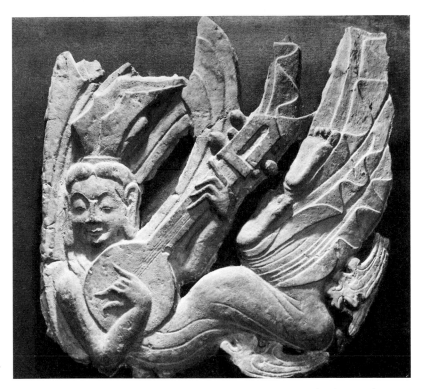

63 Shallow relief carving of a celestial musician (*gandharva*). The floating draperies and beautiful treatment of the folds give such figures grace and lightness. Probably from Lung Men. Early 6th century.

been badly damaged by the earthquakes which occur in this area. The western bank is honeycombed with over a thousand caves, ranging from impressive named temples to small shrines. The river is wide, shallow and slow-flowing, and is fed by many small streams tumbling down the hillsides. Although the rock is suitable for carving, it is susceptible to water damage, landslips and earthquakes. At the Feng Hsien Ssu (672 and 675), the colossal triad flanked by two pairs of guardians is now exposed although it was originally sheltered by an enormous superstructure. This round-faced, benevolent Buddha, some 56 feet (17 m) high, provides a striking contrast to its Yun Kang predecessor, and the guardians display a dramatic movement and ferocity which is new to Chinese sculpture but which heralds the T'ang style. Earlier caves on this west side include twenty-eight larger temples of Northern Wei to Sui date (420–618). The most noted Northern Wei carving is to be found in four of these caves: Ku Yang Tung, Ping Yang Tung, Lien

66

63
69

79

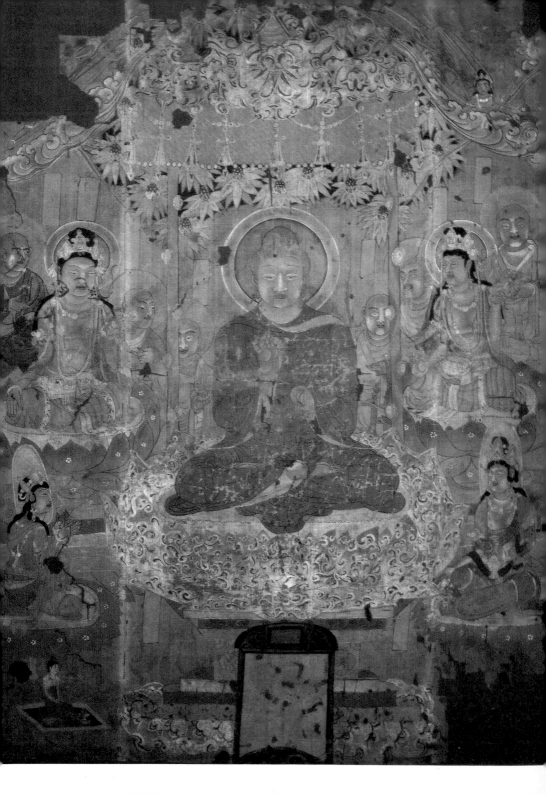

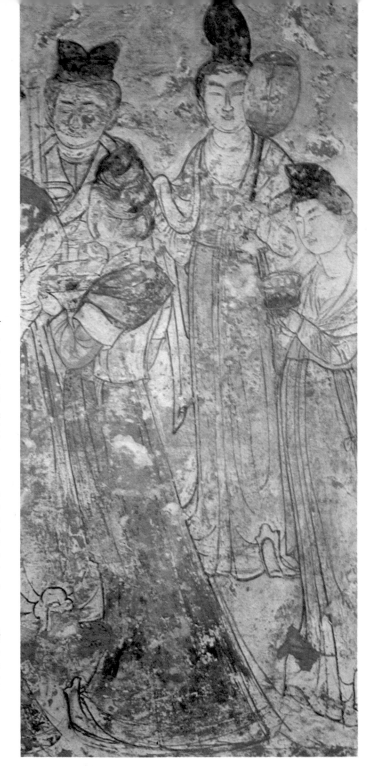

64 *The Paradise of Amitabha*. The Buddha, holding a crystal globe and seated on a lotus throne, is surrounded by Bodhisattvas and monks. The donor is shown in a very humble position to the lower left. Silk painting from Tun Huang. 8th century. (See p. 87)

65 Detail from the murals in the tomb chamber of Princess Yung T'ai, near Ch'angan. A serene expression of gentle movement now complements the traditional linking of figures by facial expression and gesture. There is here a real representation of space and volume on the ground plane and around each figure. Dated 706. (See p. 95)

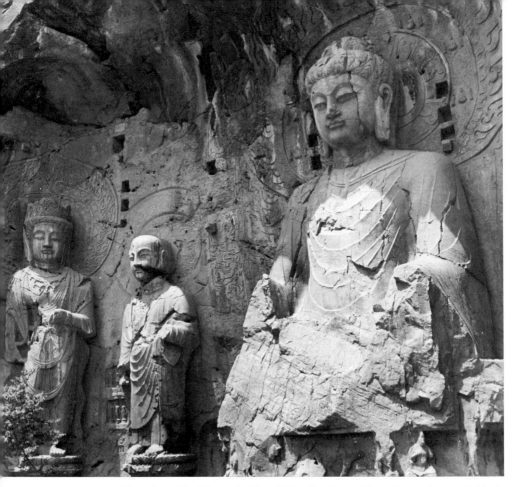

66 The colossal Buddha at the Feng Hsien Ssu, Lung Men. Comparison with Pl. 60 demonstrates the changes in stone sculpture style. The monk and Bodhisattva also show the softening of representation and gradual change in proportion. 672 and 675.

67 Hua Tung and Shih K'u Shih. The Ku Yang Tung cave is entirely lined with relief carvings. Dedicated shrines in three tiers fill the walls; in each a seated Buddha is enshrined in a draped niche flanked by two attendants. The ceiling is also covered with carvings, apparently in no ordered plan, but each unit added until the entire surface is covered. Originally, there was a stone Buddha in the centre of the cave; this was replaced in the Ch'ing Dynasty with a Bodhisattva. The dates of the dedication of this cave are between 495 and 502. The Wan Fo Tung cave was dedicated by a nun who donated the delightful Kuan-yin relief at the left of the doorway. It is of plainer decor; the walls are covered with tiny Buddha figures in relief, almost like a textured

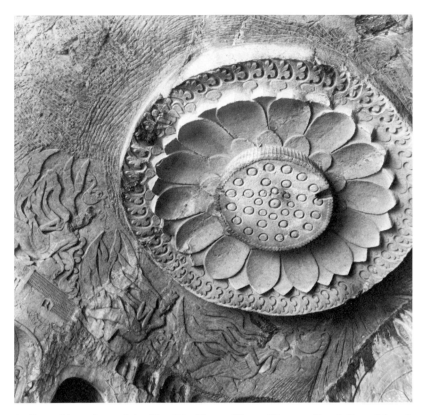

67 Central lotus boss of the Lien Hua Tung ('Lotus Blossom Cave'), Lung Men. A ring of *apsaras* carved in relief encircles the lotus, which is the canopy for the Buddha. 6th century.

68 (*overleaf*) *The Emperor Ming Huang Travelling in Shu.* Colour on silk. The picture reads from left to right and falls into three episodes. It is executed in the style of idyllic landscape painting of the T'ang Dynasty. Later copy of 8th-century original. (See p. 97)

wall-paper. The stone carved triad is of imposing Sui (late sixth-century) style, weight and solemnity. This is the equivalent, in sculpture, of the painting of the same period in Tun Huang. The change of style in stone from Wei to Sui is reflected in the change of the proportion of the figures. The head has become enormous and the limbs shortened to produce that grotesque proportion sometimes used in large sculpture which is to be viewed from below. The Chinese adopted this mannerism which accentuates the massive stillness of the figures. The style is far-reaching, for Chinese ceremonial sculpture, from this time onwards, tended towards the heavy and imposing, relying very much on sheer size for effect.

83

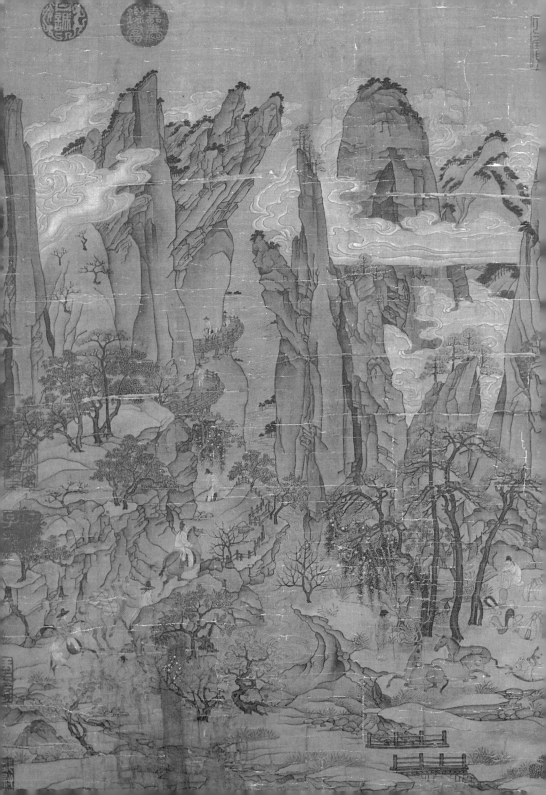

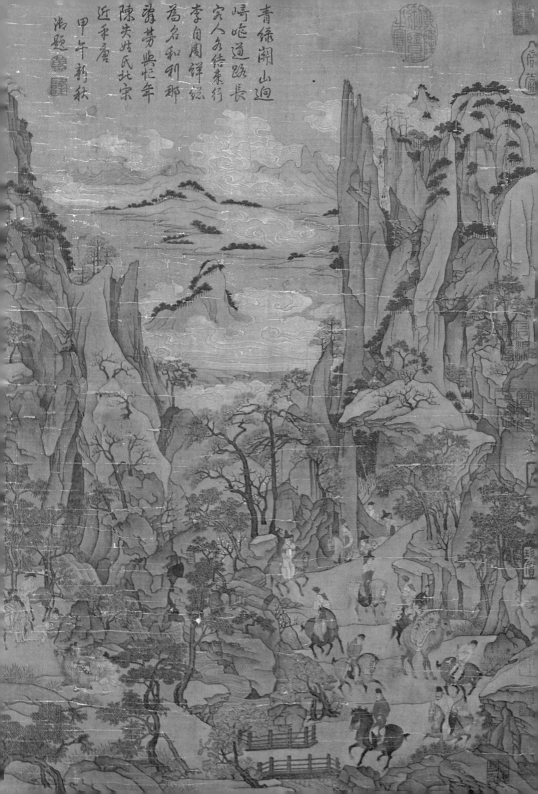

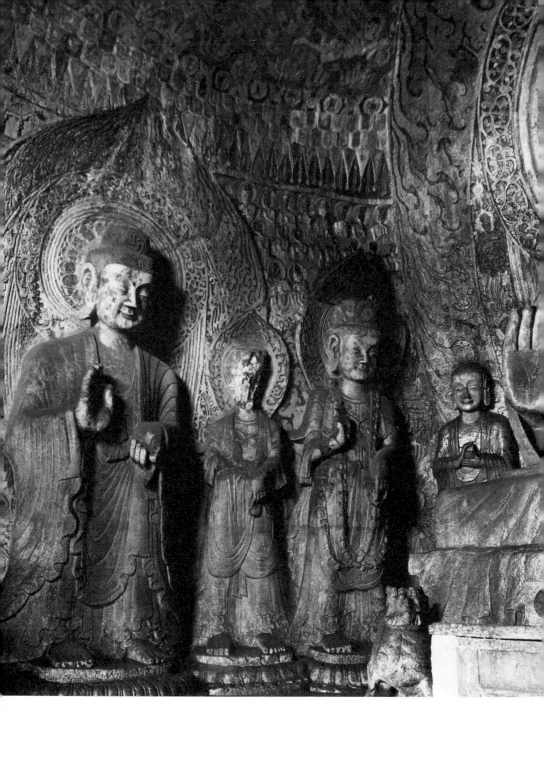

Not more than 25 miles (40 km) to the east of Lung Men, is the Kung Hsien site of cave temples, started and largely completed in the sixth century. This site includes one colossal Buddha, five caves, and two hundred and thirty-eight niches; there is also some T'ang carving. But it was inevitable that temple building should decline during the persecutions of the later T'ang period.

Indeed, T'ang style is not well represented in cave temples, but it can be seen in the lovely, free-standing figures preserved in museums. After the stillness of the Sui stone figures, the 'International' T'ang styles produce a *70* strong and almost turbulent movement in sculpture. The twist of the body *71* into a mild dancing pose is far removed from its Indian equivalent. But, at its best, it is distinctive to China and it inspired a Japanese tradition; indeed, the two traditions of China and Japan should be considered together in the ninth century.

Where ninth-century sculpture takes a strong turn in style, so too does painting, perhaps with more far-reaching effects on the whole course of Chinese art. After the still richness of the Sui compositions, the T'ang paintings erupt into activity. The huge Paradise scenes beloved of the Amitabha sect, which was now dominant, are complex compositions *64* showing palace and temple compounds in which crowds of mortals and immortals are disporting in a pleasure garden, with singing, dancing, discussion and preaching, and magical happenings. These compositions consist of an isometric projection of the buildings seen from above, in which the figures are shown at eye level and usually out of scale. The colour is brilliant and decorative rather than atmospheric. The total effect is, once again, an amalgam of the real and the supernatural which sparks the scene into life. These large compositions, whether pure landscapes or religious subjects, are the start of a long tradition in Chinese painting.

Large, single-figure painting was also popular at this time. In terms of surviving evidence, the nearest we can come to such works are the now damaged panels in the Horyuji, Nara, in Japan. These show sensuous, freely moving figures, bejewelled and richly coloured. They are the counterpart of contemporary sculptures and led to a tradition of figure painting on a more monumental scale, both religious and secular.

Buddhist painting traditions contributed much to Chinese compositional techniques, particularly the strip narrative, for both mural and scroll *72*

69 Standing Buddha with attendants at the Ping Yang Tung, Lung Men. The all-over treatment of the wall surface by relief carving is equivalent to the painted decoration at Tun Huang (Pl. 58). *c.* 523.

87

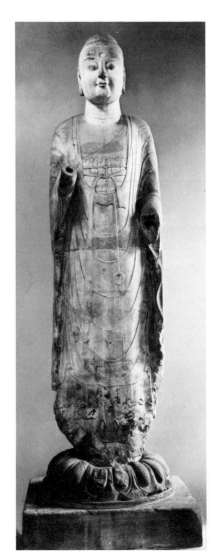

70 Colossal standing Amitabha Buddha. Marble sculpture in the calm style of Sui. The Buddha is now much more fully clothed, and the treatment of the folds and threads of the drapery has become an important part of the sculptor's expression of form. From Hopei. Dated 585.

71 Headless torso of a Bodhisattva. Marble. The walking movement of the figure brings an entirely new character while the sensitive treatment of clothing emphasizes the sculptor's awareness of the form of the figure underneath. c. 670.

72 Detail of incised carving on a stone sarcophagus. The narrative is acted out in a mountain and forest setting. Such carvings give some indication of the sophistication of pictorial composition in the Wei period. *c.* 525.

painting, and the huge composition, both of crowded scenes and of single figures. The use of colour is more difficult to be sure about, but there seems reason to associate pre-Buddhist painting in China with a very restricted palette, perhaps confined to colours derived from lacquer painting with its stress on red, black and yellow. Thus Buddhist painting, introduced for religious purposes, can be said to have enriched Chinese painting in ways far beyond the religious sphere. In sculpture, the impetus of Buddhism brought life to a tradition which has had periods of great beauty but which has never been as near to the centre of expressive art in China as in many other cultures. The bronze figurines cast for Buddhist use, from the fourth century AD, are a *frontis.* part of a longer Chinese tradition which was adopted in the service of Buddhism. The earliest cast bronze figurines known are of Chou date. The small wrestlers and animal figures of the Han show a lively tradition already *49* established. The craftsmen of the affluent T'ang period made beautiful groups and single figures as portable altarpieces for use in the temple and home. These miniature sculptures follow the general trend of style of the larger sculptures, but often achieve a special charm.

89

Internationalism and Showmanship
4th–10th centuries

Once the rich possibilities of painting as more than a decorative adjunct have been discovered and adopted in a culture, the artist's fascination in the art carries him to perennial elaboration. Although little remains of their work, it is evident from written records that Chinese painters became involved in experimenting with the medium from the first century AD, when narrative painting was first introduced. At this very early period, painters were employed to paint portraits and to decorate temples, palaces and tombs. The proliferation of states and their courts during the Northern and Southern Dynasties period (219–580) contributed to the development of painting by leading to increased and more varied patronage of the arts.

74 With very little painting surviving from the Northern and Southern Dynasties period, we must look to such works as Ku K'ai-chih's *Admonitions*
73 and *Nymph of the Lo River*, both preserved in the British Museum in the form of later copies of the fourth-century originals. These are narrative handscrolls, one an illustrated text, the other a continuous narrative scroll telling in pictures the story of a king who was tempted by a nymph of the Lo River. The *Admonitions* scroll is intended as a work of homily or advice to a girl entering the palace; it consists of a series of illustrated figure scenes, each with an accompanying text, which provide comments on right conduct or allude to stories of honoured concubines. The illustrations tell the tale economically and with great elegance of line. Groups of figures relate to each other both spatially and psychologically; there is absolutely no doubt about relationships within each scene. Just as there is almost no setting surrounding the figures, so there is no clear boundary to individual scenes, which fade off to give way to the text to be illustrated next. The style of composition is still that of a Han narrative work, as the artist relies on establishing the space around his figures and uses the tension between the figures to hold the picture together.

Ku K'ai-chih painted in the fourth century at the capital of the Chin Dynasty, close to present-day Nanking. His beautiful line was much admired as was the likeness of his portraits. Sinuous line and floating draperies were the style at this time, and it is interesting to compare his paintings with those of the journeymen painters of the Buddhist caves at Tun Huang and other contemporary sites.

73 Ku K'ai-chih (*c.* 344–*c.* 406), *The Nymph of the Lo River* (detail). Handscroll, ink and colour on silk. Later copy. The group of figures around the Emperor as he talks to the nymph reflects early painting techniques (compare Pls 58, 72).

74 Ku K'ai-chih, *Admonitions of the Instructress to the Court Ladies* (detail). Red and black ink on silk. Probably a very near copy. Contemporary with the Tun Huang Northern Wei paintings (Pl. 58), but done for the court of the Chin state at Nanking.

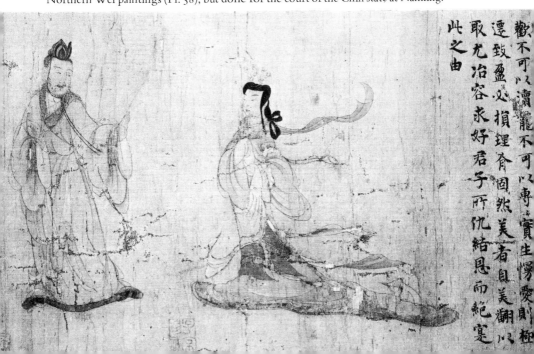

75 Three-colour lead glazed earthenware dish. The type of ware made for grand burial in China. There is a close relationship between this ware and contemporary Middle Eastern wares, both in technique and in the floral motifs. 8th century. (See p. 106)

76 Ju ware vase. The aristocratic ware of the 12th-century court at Kaifeng. One of the masterpieces in the great stoneware tradition of grey-bodied wares with blue-green monochrome glazes. (See p. 117)

Ku's own contemporaries, however, judged him not to be amongst the most dynamic artists of the day. Owing to a shortage of evidence this judgment is impossible to check. What nevertheless is important is the judgment itself. Growing out of the early tradition of connoisseurship in calligraphy, a whole critique of painting existed at this time. The earlier texts are preserved in the commentaries of later (ninth-century) critics. A survey of ancient painting, *Ku Hua P'in Lu* (*Old Record of the Classifications of Painters*), by Hsieh Ho, of the sixth century, is perhaps preserved unchanged.★ In his introductory comments Hsieh Ho lists six points to consider in judging a painting:

1. Spirit Resonance, which means vitality ('Spirit' here seems to denote nervous energy which is to be transmitted from the artist through the brush into his work).
2. Bone Method, which means using the brush (this seems to be an allusion to an ancient term dealing with anthroposcopy, the reading of character from the bone structure in the head and body).
3. Correspondence to the object, which means depicting the forms.
4. Suitability to type, which has to do with laying on of colour.
5. Division and planning, that is, placing and arranging.
6. Transmission by copying, that is, the copying of models.

Hsieh Ho says that the most important of these critical principles is the first, and that if this element is absent one need look no further. The very simplicity of this categorization has given rise to several interpretations among scholars. But it is generally agreed that Hsieh Ho thought that, having first confirmed the 'life' of the painting, one could then proceed to assess the quality of brushwork, composition, structure and likeness. The mention in Hsieh Ho's sixth principle of the importance of antiquity and of the need to imitate the ancients has led some students to consider these points as exhortations to painters, rather than as critical principles. However, the first five points seem designed as principles of art criticism or of connoisseurship for the collector.

This seems to have been what was intended in a later, larger work, completed in 847, by Chang Yen-yüan, *Li Tai Ming Hua Chih* or *Record of Famous Painters of All the Dynasties*. The first three chapters of this work cover briefly the origins and history of Chinese painting; they provide lists of painters, repeat the six principles of Hsieh Ho, offer a classification of painters relating them to their teachers, discuss signatures and other considerations of connoisseurship, technique and materials, and finally give a survey of

★ See W.B.R. Acker, *Some T'ang and Pre-T'ang Texts on Chinese Paintings*, Leiden, 1954.

Buddhist and Taoist temple painting and of private collections of the day. In the rest of the book the author goes back over his list of painters and grades them into classes, giving brief biographical details. It is interesting to see that by this time Ku K'ai-chih's work is considered to be very rare and is extremely highly valued, and Chang advises the collector to pay anything to acquire even a tiny fragment of Ku's work.

Chang Yen-yüan repeats Hsieh Ho's six principles without altering their meaning, but it is clear that he is writing as a critic with the style preferences of his own time in mind. Chang admired his contemporary Wu Tao-tzu, apparently an opinion widely shared in Ch'angan where the artist worked prodigiously. To us, Wu Tao-tzu is only a legend, as none of his paintings survive, but his linear brush style engendered much later work. Regarded as a magical painter, able to transmit actual life into his pictures, Wu produced wall paintings for temples and palaces, as well as hanging scrolls and handscrolls. He was believed to have executed paintings of horses which galloped away and of dragons which flew out of the picture over night, such was the feeling of life in his work. In this respect, he must have been the embodiment of a certain aspect of Hsieh Ho's first principle. His line was apparently calligraphic, thick and thin, nervous and energetic, expressing life within the line as does the hand of many a great draughtsman.

It was the bravura of Wu's line which was so much admired in his own day. This bravura may perhaps be reflected in the work of the later Ch'an artists. To some degree it is demonstrated in the tomb paintings of the Ch'angan district. Ch'angan was one of the capitals of the T'ang Dynasty and in the eighth century it was the site of many grand tombs. Recently excavated are the three royal tombs of the Princess Yung T'ai, of her brother and of her uncle. The Princess's tomb is particularly rich in wall paintings. A painted procession of civil and military guardians lines the passageway underground to the tomb chamber where the walls are painted with a group of the Princess's household women. Almost life-size, the figures are arranged 65 in an informal group in a sketchy setting. The drawing is in free line, executed with great fluency, at first in a light ochre but finally drawn in black. The painting is only partly coloured and there is a half-finished air about the whole. The composition within the procession is arranged in recurrent groups in which not only is the ground plane established but also the volume of each figure is surrounded by space. The female attendants in the chamber are beautifully expressed in loose groupings moving towards the site of the coffin. Each girl is so individual that one is tempted to believe that the attendants were painted from life. This is a royal tomb for which the decoration would have been supplied by the relevant palace office. At one time this office was headed by the noted artist Yen Li-pen and his family.

There is no indication of the identity of the painter of these murals, which indeed seem to be the work of an atelier. Incomplete as these murals are, they give a clue to the possible style of palace decoration of the period – racy, full of life and colourful. Drawing, in a bold, thick-and-thin line, is the basis of the painting, and colour the embellishment to a rich composition.

Figure painting probably reached its greatest vitality at this time; it seems *78, 79* to have been the dominant style of painting. However, there was a kind of landscape painting closely related to the background and side scenes in the larger Buddhist murals. Very few scroll paintings have survived which may be as early as the ninth century. One of the most famous is the landscape with horses, *The Emperor Ming Huang Travelling in Shu*, now in the Palace *68* Museum, Taipei. This is executed in colour on silk, in three related narrative scenes, and rather like an abbreviated handscroll, it reads from right to left. The cavalcade of horsemen come through the defile to rest on the plateau in the centre, they remount and move off up the mountain to the left. There is decorative solidity in this style of painting in which the hills are built up as piles of rocks and coloured with cobalt–blue and copper–green, with touches of gold. In the decorative trees there is still a hint of the Han style. This is an example of the T'ang decorative landscape style later summed up in the term 'blue and green'.

The late T'ang period (ninth century) saw the introduction of a school of painting which was to become absorbing to many painters. This is the poetic monochrome landscape style. Wang Wei is credited with the invention of quiet, contemplative, allusive painting in ink on silk. None of his work survives, but the definition of his style as 'a poem without words' stands at the beginning of a school of landscape painting. That the vogue for painting in ink and for avoiding the use of colour arose in the midst of this most colourful and flamboyant period, should perhaps be seen as a reaction, as also perhaps the choice of subject, away from the recording of splendours and paradises, so popular in both religious and secular art in this dynasty.

Although developments in painting dominated the artistic culture, and painters gradually asserted themselves as the artists most worthy of serious attention, the T'ang period as a whole was rich in the major decorative arts. Never accorded the same literary attention as calligraphy or painting, but valued as complementary adjuncts to visual culture, selected crafts were held in high esteem. In the period from the third to the ninth centuries the

77 Chao Meng-fu (1254–1322), *Autumn Colours on the Ch'iao and Hua Mountains* (detail). Handscroll, ink and light colour on paper, dated 1295. The brush style reaches back from the 14th to the 10th century. Compare the trees with Pl. 88 and the long modelling lines with Pl. 89. (See p. 138)

cultivation of these complementary arts began, and, at first, it seems that ceramics held pride of place. This craft maintained its position as both a useful and a decorative part of the domestic culture. During the period from the fourth to the sixth centuries, technical developments resulted in two traditions of stoneware potting. Centres in Chekiang (Chin), in the south, and in Shensi and Hopei (Northern Wei) developed two contrasting styles:

78 (*left*) Rubbing of incised decoration from the sarcophagus of the Princess Yung T'ai tomb, Ch'angan. This carving indicates the style of figure painting in the 8th century: a flowing line and simple composition expressing both space and volume (see also Pls 65, 73). Dated 706.

79 (*above*) Bodhisattva flying on a cloud. Ink painting on hemp preserved in the Shosoin, Nara, Japan. This is perhaps the closest we can get to the vital thick-and-thin line so much admired in the work of Wu Tao-tzu. 8th century.

grey-bodied with a green glaze, in the south, or white with a straw-coloured glaze, in the north. Obviously of great practical importance, this stoneware was used by potters for their most prestigious wares. The discovery of stoneware clay and of its qualities of plasticity and fusibility to the point of imperviousness, together with the development of a kiln capable of long, high firing to mature the clay and its related glaze, were the great

80 Water pot from Shang Lin Hu, Chekiang. This is Yüeh quality ware, one of the most highly regarded wares of its time. The green glaze is applied thinly and smoothly so that it enhances the elegance of the potting. 10th century.

81 White ware indented jar from the north, possibly from the Ting Chou region. The body is quite white and unoxidized, while the glaze has a faint ivory shade much accentuated in the 'tear drop' on the side and in the finger marks at the base. 10th century.

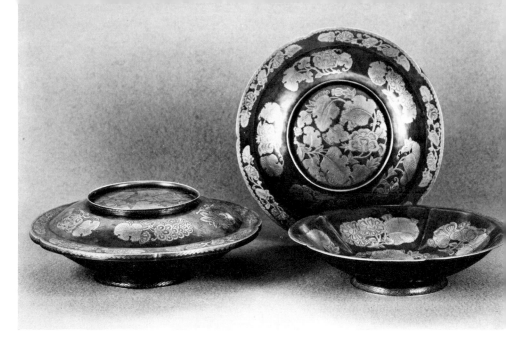

82 Pair of silver bowls and covers with chased and gilt decoration. The foliated shape with a rim perhaps came to China in metal forms from the Middle East and quickly transferred to ceramics. The decoration of rich flower motifs seems established at this time. c. 750–850.

innovations of the Chinese potters; from these materials and techniques they produced what are considered the classic Chinese wares. The high-fired wares are of strong simple shapes, often reminiscent of bronzes and clothed in a smooth glaze of restrained colour. These colours range from dark green-brown, through green-blues, to a pale straw, all are derived from iron in the glaze, which has been fired in a reducing atmosphere. In reduction conditions oxygen is removed from the metallic compounds in the glaze, and reduction firing became traditional in the production of Chinese high-fired wares. Iron is the most persistent metallic oxide and varying quantities of iron supplied glaze colour. How far the resulting green-blue colour was achieved by choice at first is not clear, but the sombre range soon became an established taste, probably closely related to the taste for jades and bronzes.

The appeal of sombre colour in pottery did not exclude, however, the equally evident delight in exoticism and richness, which reached great heights in the Buddhist sculpture, gold ware, textiles, glass and other crafts of the T'ang period. The artists and craftsmen of China were never closed to new ideas. At this period of ebullient experimentation in the fine arts, craftsmen evolved a whole canon of style which has been called

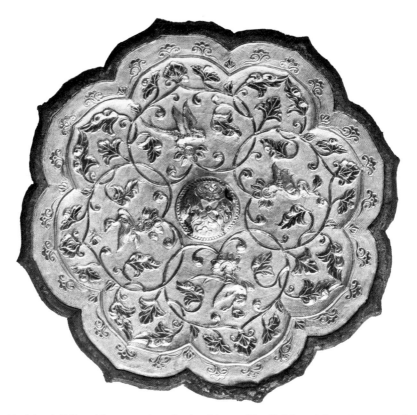

83 (*above*) Foliated bronze mirror back with a gold relief sheet inlay. Far removed from the Han mirror of magic powers (Pl. 42), such T'ang mirrors were treasured as decorative objects. The bird and flower scroll motif is developed in the 'International' style of the mid–8th century.

84 (*right*) Pilgrim flask. Stoneware with brown glaze over white slip. The flattened shape is based on the leathern flask carried by Central Asian travellers, and the moulded decoration showing a vintage scene is also derived from the tooled original. Mid-8th century.

'International' to denote that it is part of a wider tradition than that of the subcontinent alone. This wider tradition has roots as far away as Asia Minor and the Caucasus. It remained a strand in the many styles recurrent in China and is most clearly seen in the gold and silver wares of the T'ang period, made by Chinese techniques, which favoured casting, in contrast to the Sassanian models, which are turned and beaten. Decoration is also subtly adapted at this time, themes originating in Central Asian and Near Eastern motifs being absorbed but their scale changed to suit Chinese ideas. A taste

82, 83

84, 85

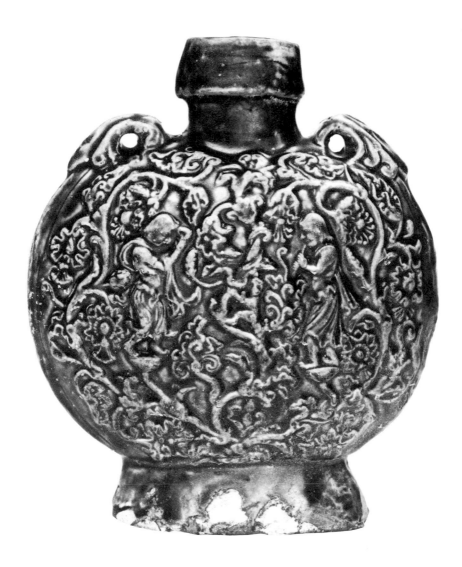

for the exotic recurs throughout much of the metropolitan craftwork of the seventh and eighth centuries.

Glass was also made in China in bright blues, or in brownish yellows when in 'International' style, or as a substitute for jade, moulded in the shapes of archaic pieces and imitating their colours. Hardstones of every variety, carved as vessels or ornaments, inlaid wood, amber and inlaid bronze mirrors all crowd the tombs of this period, and they presumably also filled the houses of metropolitan China at one of the most flamboyant moments of its history.

85 Fragment of woven silk with a design of wine drinkers. From Astana, near Turfan, Sinkiang. Both the technique of woven tapestry, which probably originated amongst the nomadic tribes of Central Asia, and the motif of confronted figures in a roundel became traditional in China (see also Pl. 110). 8th century.

86 Tomb model of a saddled camel. Cream, green and yellow glazes over a white earthenware body. Such models of animals, servants, entertainers and household goods were produced in quantity in the 8th century. Cast from moulds and assembled in sections, they achieve many lively poses.

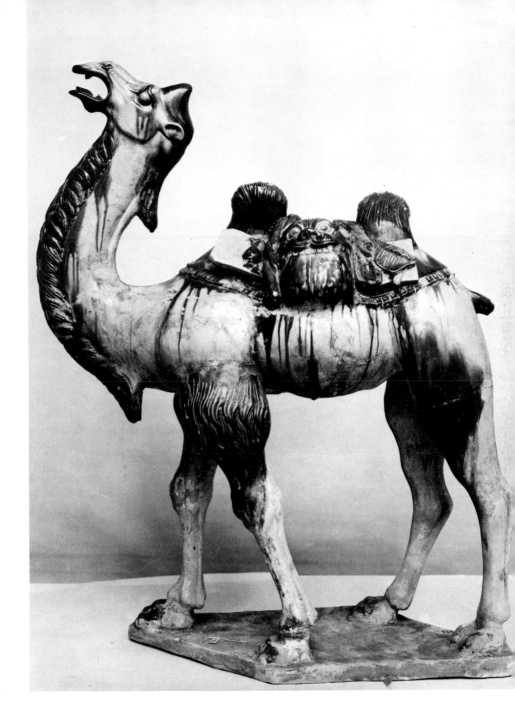

T'ang silks – dyed, printed and embroidered – are beautifully preserved today in the Shosoin collection in Japan. Also in this collection are two painted and inlaid wooden musical instruments with decoration of exceptional quality. Particularly noteworthy are the fanciful landscape paintings in full colour on the face of the *p'i-pa*, a lute-like instrument.

Amongst the most colourful works of this period are the tomb models made in low-fired pottery and glazed with brightly coloured, lead-fluxed glaze, a technique used by the Han. The vogue for such models became so insistent in the eighth century that great quantities were made in the metropolitan area. At their best, the quality of modelling of these tomb figures justifies their being considered as sculpture. In true Chinese fashion, their interest lies primarily in genre representation and human characterization. By the tenth century the varied and cosmopolitan society which they reflect was no more; the richness had passed and a more contemplative mood was to be expressed in landscape painting in the style of Wang Wei.

87 Detail of a lacquer landscape painting on the face of a *p'i-pa*, a type of lute. This is the upper part of a Buddhist figure scene and is one of the earliest painted river and mountain compositions known. 8th century.

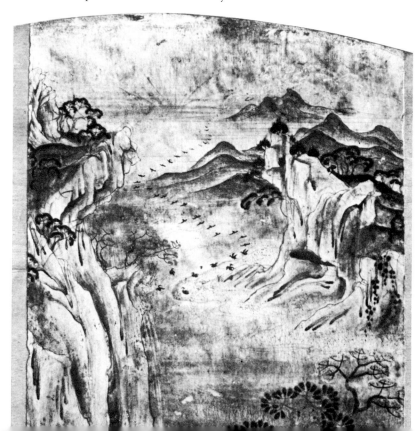

Space and Monumentality

10th–early 12th centuries

The possibilities opened up by ink painting on silk and the richness of landscape themes were soon to provide painters with compositional alternatives in the scroll format. In particular, the large hanging scroll was to become the chosen format in which classical masterpieces were painted. Space, recession and volume became the central preoccupations of artists. Once a rectangular framework had been established, these qualities could be expressed in various ways, and in the early period painters explored the possibilities offered by the manipulation of eye level. Perhaps as a development from the vertically arranged narrative 'stills' of previous centuries, a technique evolved of raising the eye level in a continuous, upright composition so that successive eye levels are established. This allows the expression of great distance and height within a restricted format, avoiding vertiginous effects. Not only does a huge mountain not menace or overhang as one looks square at its face from a respectful distance, but chasms and many receding valleys can also be expressed comfortably within the same frame. Using a completely different formula for pictorial perspective from that evolved in Europe, the Chinese artists of this period proceeded to compose elaborate and evocative paintings of mountain landscapes. The moving eye level was allied to a control of the surface composition by judgments of balance of line and tone close to that developed in the composition of calligraphy and entailing a fine understanding of the surface tension which holds a painting to its frame. The receding composition is tied to the picture edges, but the balance of the painting is preserved through the manipulation of line and tone. Curious anomalies of tone and recession are conceded to gain this balance. The result is that the composition can be read from many points because there is not one focal point in the composition, just as there is not one viewpoint or one eye level. These massive compositions, often six feet high and three feet wide (1·8 m × 0·9 m), are complex constructions. The conventions of scale worked out at this time became traditional to a school of landscape painting in which, for instance, the figures, although insignificant, are usually too big and considerations of visual scale are secondary to those of pictorial scale.

Mountains as a subject appealed in China for many, almost inherent, reasons. Taoist beliefs can be expressed in landscape, and particularly in what

mountains evoke: the remote, the eternal, an overpowering sense of scale when they are related to human beings. All these aspects became part of the Chinese painter's concern, part of that elusive quality of 'life' or 'breath' – the same first principle as in Hsieh Ho's list of six. Painters also sought to express the 'life' which they found in the world, in both animate and inanimate things, and themselves in relation to the world. In choosing landscape as their major theme, painters were doing no more than seeking to express, as directly as possible, the very ancient Chinese belief in the unity of man and nature.

88, 89
Although we know the names of painters who became famous in the tenth century, like Tung Yüan and Chu Jan, few paintings from this period have survived, but two fine examples from the Palace Museum in Taiwan
90
embody much of the style. *Travelling in Streams and Mountains*, by the court painter Fan K'uan (*c*. 950–1050), is the earlier of the two. This is a large scroll, painted in ink, with very slight, sombre colour, on a silk now darkened to the tone of pale tea. The massive rock dominates the scene and controls the picture which is divided into background and foreground by a cloud-filled chasm. The tiny figures on the right struggle along a stony road in a rocky landscape, in which groups of trees and rocks create pyramidical inner units echoing the greater mass. This is a still and impressive picture painted with beautiful, nervous ink strokes which build up the tone and texture. The composition is of the style known as 'Master Mountain' on which many variations have been played and in which the landscape is dominated by one peak, often expressed as a cluster of rocks. This picture is probably a later interpretation of the original theme; it is simple in conception and has a great, quiet dignity.

91
About fifty years later, Kuo Hsi (*c*. 1020–1090) painted *Early Spring*. This artist also painted at court, by now that of the Northern Sung at Kaifeng. He was not only a court painter – which implied portraiture, decoration and religious painting – but also the head of the Imperial Academy. He must, therefore, have been an artist of considerable standing amongst his contemporaries. There are, indeed, records which confirm that he was a good painter in many fields, who painted landscapes for his own satisfaction. Few of his works have survived, and of these *Early Spring* is probably the best known. It is, again, an ink painting, with very slight colour, on darkened silk. The signature and date of 1040 may well be subsequent additions, as the

88 (*right*) Tung Yüan (*fl*. 947–970), *Festival for Evoking Rain*. Ink and slight colour on silk. Comparison with Pl. 87 shows a more conscious knitting of the composition, but a similar evocation of space. Tung Yüan, from Nanking, painted the gentle mountains of that part of China.

89 (*overleaf, left*) Chu Jan (*fl. c.* 960–980), *Seeking the Tao in the Autumn Mountains*. Ink on silk. A classic of the 'master mountain' type of landscape, in which the viewer is taken from the foreground up into the mountain. Chu Jan was famed for his use of long modelling strokes and accenting dots.

90 (*overleaf, right*) Fan K'uan (*c.* 950–1050), *Travelling in Streams and Mountains*. Ink and slight colour on silk. Another masterpiece of the Northern Sung School. The artist builds on clearly discernible eye levels, using a mist to create depth between the nearer ground and the huge mountain mass.

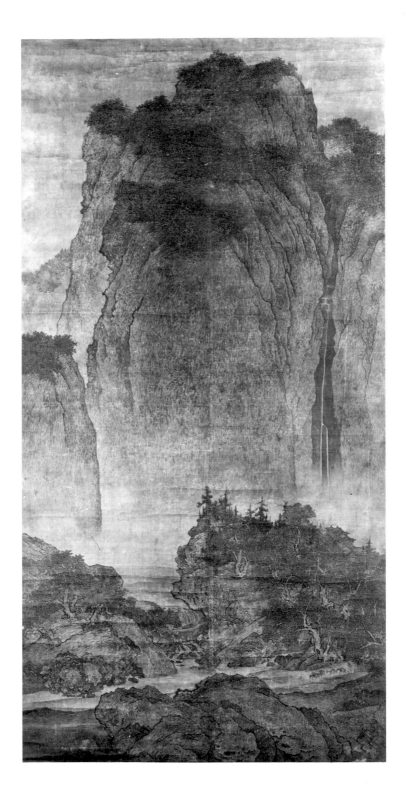

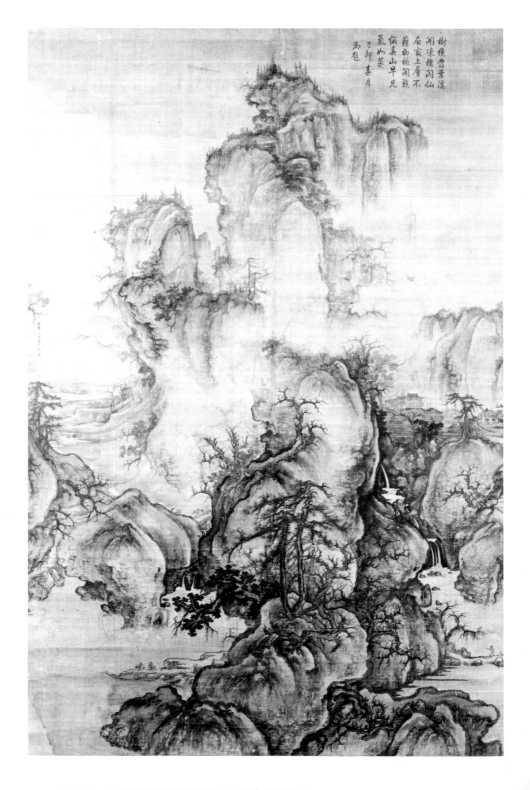

樹繞蒼葉溪
澗凍擒閩仙
居窟上屠不
藉杨挽澗誕
假玉山早兄
氣如蒸
己卯春月
尚題

practice of signing work became customary only later. If Fan K'uan's picture was a representation of a classic theme, Kuo Hsi's is a Baroque variation. The mountain stands in the centre of the composition like a great column of smoke. On both sides of this central pillar are many smaller scenes, each with its own eye level and each painted to catch and hold the eye before it makes its way on a journey through the landscape and around the surface of the painting, up the steep path to the temples, to the right, or away into the wide valley, to the left. Such is the spatial complexity of the work that the artist is able to project the viewer into varying heights and depths within the composition, and to take him for a journey within the landscape, as indeed is his intention. *Early Spring* is painted more richly than *Travelling in Streams and Mountains*. Kuo Hsi used wash and ink strokes, wet and dry ink. The faint colour is of earth-browns and green, used to emphasize lightly but not to 'colour' the picture. Kuo Hsi's handling of trees was much admired, but it became a cliché in the hands of lesser artists. This is one of the last pictures of a classic tradition. Like the Baroque in Europe, it was succeeded by a move towards a smaller compositional format as well as by an apparent change in compositional devices.

The handscroll painting by Hsu Tao-ning is almost contemporary with 92
Kuo Hsi's *Early Spring* and is also painted in ink, on silk. The case of this artist was unusual in that he did not belong to the official class from which most painters came; at least in his early life he had earned his living as an apothecary. The landscape which is represented in his handscroll is more stylized and avowedly 'romantic' than the Baroque landscape of Kuo Hsi, and it shows a fresh move towards elegance of brushwork. The more intimate handscroll format, designed to be viewed at openings which can be comfortably selected by the viewer, is also unique to the Far East. The long strip presents novel problems of composition: it is, in fact, planned by the artist in a series of overlapping compositions which reveal themselves as the scroll is slowly unrolled on a table by the viewer, who holds both rollers in his hands and rolls and unrolls the two as he views small sections from right to left. A handscroll is not meant to be unrolled completely to be viewed as one long strip. The Hsu Tao-ning river landscape is very simply constructed, with a river foreground and receding valleys divided by dramatic rocky cliffs. Each end of the scroll is bounded by trees and rocks coming close to the foreground, which, as with other landscape painting of this time, is established at quite a distance from the viewer.

91 Kuo Hsi (*c.* 1020–1090), *Early Spring*. Ink and slight colour on silk. Comparison with Pls 89 and 90 shows the movement towards a richer composition and a more Baroque style.

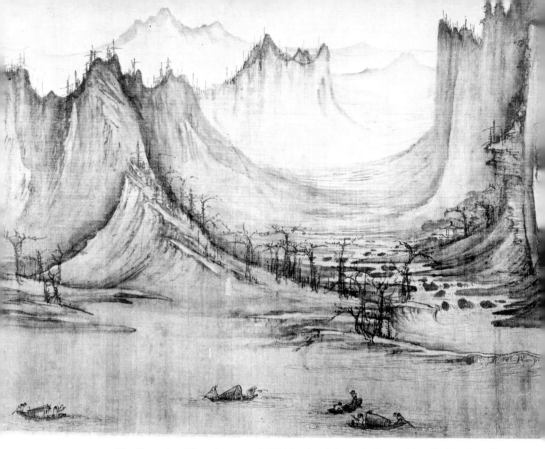

92 Hsu Tao-ning (*fl.* 11th century), *Fishing in a Mountain Stream* (detail). Handscroll, ink on silk. A highly individual handling of this bleak landscape, as can be seen from a comparison of the distant valley with that of Pl. 91.

Landscape was the major theme for serious painting, but not preferred to the exclusion of all other subjects. The love of classification quickly led the Chinese to attribute roles to selected subjects. Thus 'bird and flower' painting at this time is regarded as decorative, while 'bamboo and orchid' painting may well be very scholarly with calligraphic connotations. Clear divisions were also established between paintings in ink alone and those in which colour played a major part. The use of colour came to be the dividing point between decorative and non-decorative painting.

Decorative art does not imply artistic inferiority; it formed a highly valued part of Chinese domestic culture and it applied to all the crafts of the period. One cannot emphasize enough the richness and quality of craftsmanship and imaginative inventiveness which characterized the

93

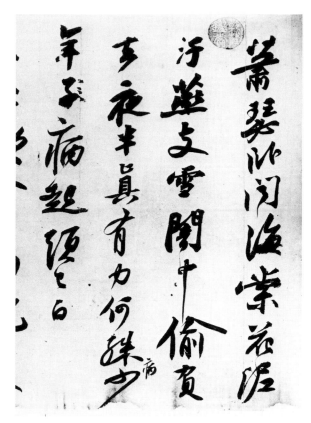

蕭瑟臥聞海棠花泥

汙燕支雪闇中偷負

去夜半真有力何殊少

年子病起頭已白

93 Fragment of calligraphy by Su Shih (1036–1101) of his poem 'Cold Provisions Day'. Su Shih was a fine scholar, poet and calligrapher, and a noted painter of bamboo.

decorative arts at this time, alongside the apparently growing asceticism of landscape painting as it was evolved by the major school of court painters. The increasing sophistication of life, and probably the increasing complexity of urban living, demanded much from the craftsman. In the tenth century, whilst the country was divided and several courts flourished, local crafts received a great boost. In ceramics, the potters of Chekiang, notably at the Shang Lin Hu kilns, produced Yüeh ware for the Wu court, at present-day *80* Nanking. This grey-green stoneware was of such beauty that it was treasured by contemporary collectors and even inspired poetry. The Yüeh stoneware is restrained and largely undecorated, relying for its distinction on subtle and elegant surface texture and colour.

In the meantime, in the north, the Honan potters produced black glazed *96* stoneware and a wide variety of white wares. Ting ware, reputed to have *81, 94* been made at Ting Chou, in Hopei, was the most distinctive among the many white wares made in the province. This, at its best, is a white-bodied

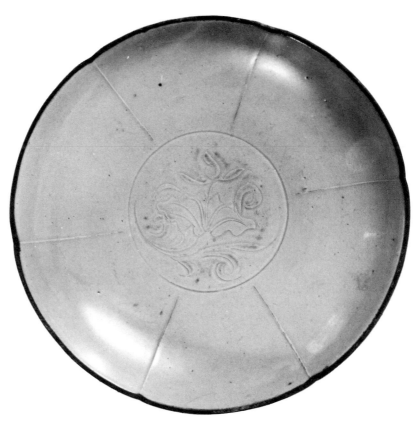

94 Shallow foliated Ting ware bowl. The incised floral decoration is made with a sloping blade which gives a shaded line as the glaze gathers in the cut; one side of the line is sharp while the other shades off in the slope of the cut. 11th–12th century.

but not translucent ware which has a transparent, ivory-coloured glaze. The potting is exquisitely refined and often, apparently, based on silver vessels. The distinctive metal binding of the lip of Ting bowls and saucers is the result of firing face down in a special saggar; this resulted in an unglazed lip which was then bound with silver or bronze. The decorators at Ting Chou used a shallow, incised line for free floral motifs, in a style imitated later by other potters. Also imitated was a technique of impressing the decoration: the thrown bowl was laid on a clay mould and turned on the wheel to result in a thin-walled bowl with a relief decoration inside. Ting ware was the most

95 Chun ware dish of pale-blue glazed buff stoneware. The purple zigzag splash is copper painted into the glaze. One of the brightest coloured wares produced at this time. 12th century.

highly esteemed ware in the early eleventh century but it lost favour owing to glaze flaws called 'tear-drops'. The taste of the court then turned to the other great tradition of Chinese ceramics, the grey-bodied stoneware with an iron-bearing glaze. At this period the finest northern stoneware of this type was the Ju ware made at Lin Ju, near Loyang. This is characterized by a fine-grained body, simple but elegant shapes – mostly bowls and vases – and an exceptional bluish glaze which could result in a soft hazy colour. The glaze is thick and semi-opaque with bubbles. Ju ware was highly prized in its day and is very rare today. The more readily available, related, ware is Chun

76

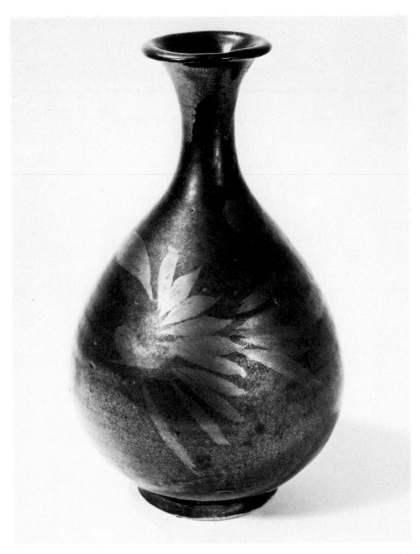

96 Pear-shaped vase. This is a northern pale-bodied stoneware with an almost black glaze into which the design of a flower spray has been painted, resulting in a metallic lustre effect. Probably from Honan. 12th–13th century.

95 ware, also made near Kaifeng. This was a more ordinary kind of pottery for everyday use. It is a very heavy, high-fired stoneware, thrown with a pronounced heavy foot; the glaze is thick and misted with bubbles and impurities. Chun ware glaze is a pronounced blue with a lavender shading to

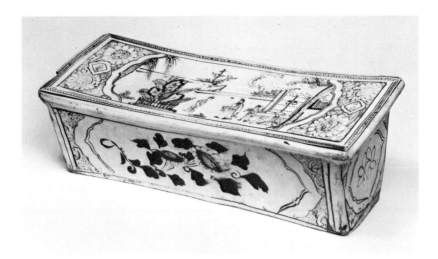

97 Tzu Chou ware pillow with slip decoration under a colourless glaze. Comparison both of the motifs and of the layout of the design with later blue and white porcelain (Pl. 140) suggests possible but unexplained links. 12th century.

which a bright purple splash is often added. Both Ju and Chun wares established a type of stoneware which was imitated at other kilns in both north and south China. Northern celadons, from kilns north of Sian, Shensi, are of a different style: in these pieces a severe olive-green, clear, shining glaze was used over a richly worked surface, either incised or impressed. The love of such decoration is nowhere better expressed than in the Tzu Chou pottery. This was another utility ware, made in Hopei. It is distinguished by its heavy, grey body which was slipped white and then decorated by incised lines of slip painting. The painting in particular can be lively and, especially when figure scenes are involved, very painterly. One group of ceramic pillows, decorated with what appear to be copies of woodcut book *97* illustrations, are exceptional and introduce a type of decoration which was developed to great heights in the fourteenth century in the south.

This diversity of high quality potting in Northern Sung is evidence of a degree of connoisseurship which was not reserved for pottery alone; it extended also to woven and embroidered silks, tapestry, lacquer, carved jades, hardstones and ivory – although many of these objects have not survived very well. At this time, alongside the appeal of contemporary styles, there was also a taste for archaistic style. The persistence of this taste in the applied arts at all times is something that has to be taken into consideration; it is a positively creative force in Chinese design and it emerges again and again as a major factor.

Court and Ch'an Buddhist Arts
early 12th–early 14th centuries

Like the decorative arts, painting in the Kaifeng court of the Northern Sung, in the early part of the twelfth century, enjoyed Imperial patronage and it reached one of its zeniths. The Emperor Hui Tsung, the last of the Northern Sung rulers in Kaifeng, was a man of definite tastes and autocratic temperament. He surrounded himself with artists and formed an Academy, which he controlled personally. He met his painters every day and it is recorded that he organized competitive painting exercises. Such was the vitality of the arts at this time that even this apparent interference by the Emperor did no damage, but rather gave impetus to a new movement already underway.

Avowedly decorative, the Northern Sung Academy School exerted an influence which survives to the present day. Using the format of a small album leaf, the Academy painters discarded the compositional devices used by contemporary landscape painters. By severely restricting their subject, they were able to develop a surface, almost two-dimensional, composition in which the judgment of line, mass and space and the awareness of balance within the frame could be brought to perfection. This twelfth–century court
98 art of the Northern Sung is typified by jewel-like representations of birds and flowers, exquisitely observed, painted feather by feather, stamen by stamen, in enamel-bright colours. It is a style far removed from that of the grand landscapes of the eleventh century.

When northern China suffered a Turkic invasion, resulting in the setting up of the Chin state, with its capital in Peking, the Kaifeng court fled south, in 1127, and established a capital at Hangchow. Here the Southern Sung ruled, from 1128 to 1279, until the whole country was conquered by Genghis Khan and his son Kublai, who ruled over China in the Yüan Dynasty (1260–1368), when the capital was once again moved north, to Peking.

As far as the artistic life of China was concerned, the chief significance of all this movement, and of the period during which the capital was in the south, lies in the unusual prominence given to the southern style (until that time a provincial style far removed from the court) and the virtual suppression of the northern style. Although little work survives to facilitate a detailed comparison between northern and southern painting of the late

98 Emperor Hui Tsung (1082–1135), *Five-coloured Parakeet on a Branch of Apricot Blossom*. Colour on silk. The exquisite style of the Northern Sung Academy School greatly influenced painters in both China and Japan throughout later centuries.

twelfth and thirteenth centuries, such as there is suggests a continuation in the north of the traditional 'realist' school of painting often identified with it. But this style is also manifest in the south in such works of vivid observation as the *Ch'ing Ming Festival* handscroll, of Chang Tse-tuan, which stands witness to a living tradition from the north now transplanted south. This silk handscroll records, in ink, the festivities and bustle of Suchow at the time of the Spring Ch'ing Ming festival, when families gather to tend tombs. Such genre painting relates directly to the details of fishermen and village life which are found in the large northern scrolls.

99

The Southern Sung court style of landscape painting developed in a more romantic direction. But this too derived, in part, from the work of the

99 Chang Tse-tuan (late 11th–early 12th century), *Life Along the River on the Eve of the Ch'ing Ming Festival* (detail). Handscroll, ink on silk. This busy market scene is fascinating for its acute observation and is a fine example of Chinese genre painting.

northern court painters with their concern for supremacy of surface composition and elegance of drawing.

However, the use of an isolated subject, eliminating everything but the essential elements, led to a very different style of painting when applied to landscape. Faced with the problem of expressing depth within a surface composition, landscape painters turned their attention to the creation of atmospheric space: to express 'one thousand *li* of space in one foot of silk' was how they put it. The illusion of distance was achieved by touching in carefully judged tone washes and by an equally carefully judged attention to

The combination of an overhead view of buildings with an almost side-on view of figures is a convention common to both Chinese and Japanese painting.

scale, so that a distant hill seen across water sits exactly right and establishes the intervening space. The area around Hangchow, the southern capital, was a land of lakes surrounded by gentle hills, a scene far removed from the imposing peaks of the Tsin Ling mountains, south of Kaifeng, beloved of the Northern Sung landscape painters. In the hands of the Southern Sung painters, these lake-scapes became unashamedly romantic with their wide distances, low hills and silhouetted trees. Evocative of gentle sadness, evenings and half-light, they are above all else elegant paintings. In the great tradition of the Chinese landscape artists, the Southern Sung painters used

only ink. But, increasingly, they used paper rather than silk, which allowed a greater freedom of texture. Employing many of the compositional devices developed by the painters of birds and flowers of the Emperor Hui Tsung's Academy, the thirteenth-century landscape painters adopted what has been called the 'one corner' composition: shifting the balance of the picture, they were able to exploit the juxtaposition of form and space, line and mass. This compositional device, however, has inherent limitations and the pictures may seem repetitive. But the expressiveness of the brush stroke itself now became an important consideration. It was at this time that brush strokes acquired names, a development which indicates a more self-conscious brush style.

Hsia Kuei and Ma Yüan, two great masters of the later thirteenth-century court, perfected a dramatic ink style which has become associated with the 'one corner' composition, and together they typify the Southern Sung landscape style. In his *Pure and Remote Views of Hills and Streams* handscroll, Hsia Kuei painted a bravura ink painting on paper in which brushwork is as much part of the subject as is the spectacular water-scape and rocky shore. Hsia Kuei here reveals his mastery of the chopping 'axe cut' brush stroke, the dragged dry brush, the 'flying white' stroke and the subtler wet wash. Moving from stress to stress abruptly, shifting the eye from the foreground to long distance with just an evocation of the space in between, this scroll also shows the evolution in handscroll painting. The handscroll now became a more adventurous format in which the artist attempted to move the viewer in and out of the depth of the painting.

Ma Yüan and his son, Ma Lin, used the same mode of composition as Hsia Kuei, but their smooth beguiling brushwork produced a gentler kind of painting; this style of brushwork became classic, although in lesser hands it degenerated into cliché. The subject of *On a Mountain Path in Spring* is a gentleman with his servant in a garden setting – one of Ma Yüan's favourite themes. The figures, together with the trees and the rocks, take the weight of mass to one corner of the picture, but the dramatic lines of tree branches, and, more vividly, the direction of the look of the gentleman, take the eye across a misty space to the distance. In this way there is a delicately created and constant balance between the surface composition and the depth which it creates, which is not over-emphatic.

Close to the northern and southern court painters in technique, but worlds away in spirit, were the Ch'an Buddhist painters of this time. Many scholars and artists were much influenced by the asceticism and directness of the demanding teaching of this sect, which is known as Zen in Japan. The Ch'an sect had been in existence since the sixth century AD, but the thirteenth century saw a resurgence of interest in Ch'an around the Hangchow area.

100 Hsia Kuei (*fl.* 1180–1230), *Pure and Remote Views of Hills and Streams* (detail). Handscroll, ink on paper. The chopping 'axe cut' stroke is used in the modelling of the rocks, and the dragged dry and wet brush in the trees.

125

The chief quality required of the Ch'an artist was a directness of expression which stood, in some respects, for the sudden enlightenment and insight which is the experience most highly valued by the adherents of the sect. This quality was in contrast to the sophistication and artificiality admired in the court art of the time. Perhaps as a counter-balance to the self-conscious artificiality of court painting, several major artists produced paintings inspired by Ch'an beliefs. Trained as court artists and using the same astonishing sureness and control of brush, ink and tone, they added the immediacy and simplicity of vision demanded by Ch'an, to produce such masterpieces as Mu Ch'i's *Persimmons* and Liang K'ai's figure paintings.

So little is known about the personal lives of artists at this time, and still less of the monk painters, that there remains a doubt about the identity of Mu Ch'i, who may have been a Japanese monk. His paintings are not all as

101 Ma Yüan (*fl.* 1190–1225), *On a Mountain Path in Spring* (detail). Ink and light colour on silk. An album leaf in which Ma Yüan uses surface compositional devices close to Hui Tsung (Pl. 98) but adds the illusion of space and depth with the hill to the left and the flying bird.

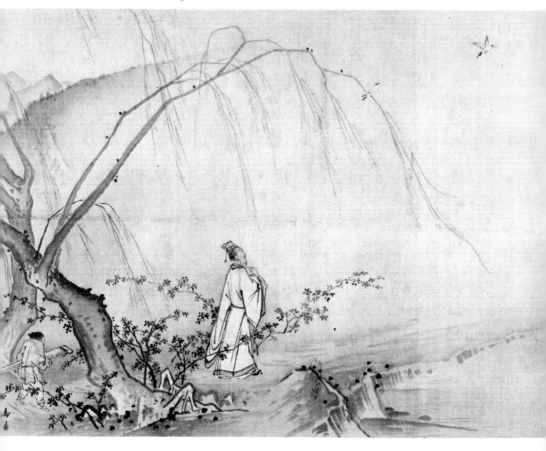

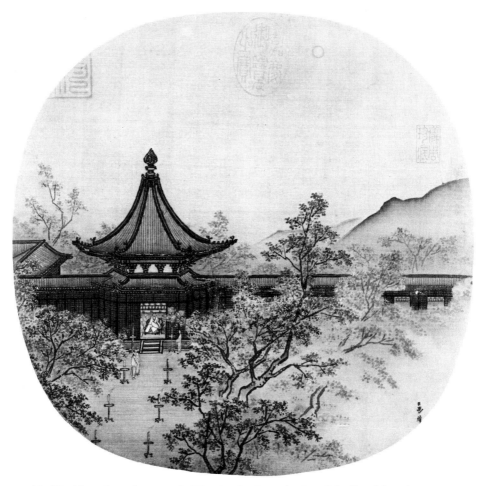

102 Ma Lin (*fl.* early 13th century), *Waiting for Guests by Lamplight*. Fan, ink and colour on silk. Atmospheric effect is vivid here, with the use of glowing colour inside the lamplit room and a faint cool white for the blossom in the twilight. The ink tone is very rich.

unusual in subject-matter as *Persimmons*, which is a monochrome painting of *104*
a subtlety in tone and composition which is very easy for the twentieth-
century Western viewer to comprehend. Mu Ch'i also painted large
Buddhist paintings which have a spiritual quality unusual in Chinese *103*
iconographic work. Mu Chi's contemporary, Liang K'ai, was also trained as
a court painter but turned to Ch'an painting. His portraits are witty and *105*
humorous, and the extraordinary verve of their ink play makes them
immediately accessible and places them in the finest tradition of Ch'an.

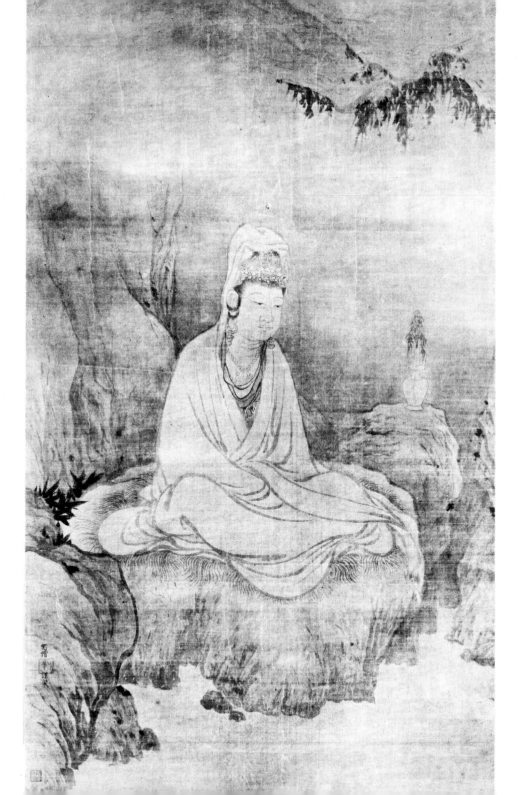

103 Mu Ch'i (active 1269) *White-robed Kuan-yin*. Ink on silk. The elegant brushwork of Hsia Kuei and Ma Yüan is here used to create a meditative painting of unusual power.

104 Mu Ch'i, *Persimmons*. Ink on paper. This small painting epitomizes the Ch'an ideal with its subtle evocation of colour in tone and its witty brushwork.

地行不
識名和
姓大以
高陽一
酒徒
卷琶壺
仙宴罷
淋漓襟
袖尚模
糊

Admiration for Southern Sung craftwork reflected the distinction between court and Ch'an taste. A third type of taste was that for export wares in all crafts. These various tastes can be seen notably in pottery. The kilns of south China grew in importance during the twelfth and thirteenth centuries, taking up the markets of the earlier northern kilns. A huge complex of kilns at Ching-te Chen, Kiangsi, was growing during the Southern Sung period. Ching-te Chen supplied white porcelain with a pale blue glaze, called Ying Ch'ing. This ware was the southern replacement for Ting ware, with which it shared decorative styles and techniques. The Ching-te Chen potters threw and turned their pots in the shapes of the silver and gold vessels fashionable at this time. The bowls ring beautifully when struck; the sides are thin and translucent, and often foliated at the rim. The foot is thick and heavy, with a thin foot rim and a typical firing scar on a ring of grit which oxidizes almost black on the base. Thirteenth-century Ying Ch'ing ware may have incised or moulded decoration. It was produced in a whole range of qualities, the finest of which would have been used at court and for high-class exports to Japan. Lower grades for more general use were also sent to Ningpo, and later to Chuan Chow on the coast to be exported in the growing trade with nearby countries. At this period China was exporting ceramics, tea and silk in exchange for gold, silver and spices from Japan and Indonesia.

106

The green glazed stonewares of Chekiang also played an important part in the export trade. By this time the market had moved from Shang Lin Hu to the more southerly Chekiang kilns around Lung Ch'uan on the Ou River. Lung Ch'uan ware has a characteristic grey body, strong and heavy but almost white. The green glaze is a distinctive blue-green and applied very thick; it has a special quality of sheen and translucency which imparts a jade-like character. The highest grade Lung Ch'uan ware both replaced the northern Ju ware at court and established a reputation of its own at a time when jade carving was highly esteemed by connoisseurs. Japanese visitors to Hangchow, monks, diplomats and traders, greatly appreciated the celadon ware and took special pieces back to Japan as treasures.

107

Japanese monks also discovered a black ware from Fukien, Chien An, being used at the Ch'an Buddhist temples at Tien Mu Shan, close to Hangchow. This was a peasant ware, local to a group of kilns in west central Fukien, whose brown-bodied dark glazed tea bowls had been adopted by the Ch'an for their ceremonies in the thirteenth century. The popularity of this

108

105 Liang K'ai (c. 1140–1210), *Ch'an Priest*. Ink on paper. Liang K'ai is a Ch'an artist of great elegance and his painting often displays the humour characteristic of Ch'an work.

106 Ying Ch'ing impressed porcelain bowl. The formal segmented style of decoration is a feature of the impressed technique; both style and technique reflect a general move towards greater elaboration. From Ching-te Chen. 13th–14th century.

107 Celadon bowl with lotus petal relief decoration. A typical product of the Lung Ch'uan group of kilns in southern Chekiang. The body is a fine pale-grey stoneware and the glaze a thick crackled blue-green with a jade-like sheen. 13th–14th century.

108 Temmoku ware tea bowl of the 'hare's fur' type, from Chien An, Fukien. The thick dark glaze runs away from the lip, which is almost unglazed, and gathers in rich rolls and drops above the foot. The 'hare's fur' effect is just visible inside the bowl. 13th–14th century.

132

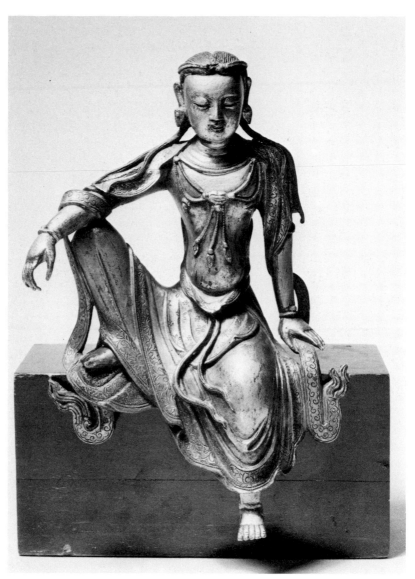

109 (*above*) Seated gilt bronze Bodhisattva. This elegant little figure has the pretty, more feminine features of the southern style of Buddhist sculpture in the Sung period.

110 (*right*) Parakeet on a cherry twig. Woven silk tapestry (*k'o ssu*). The contemporary style of bird and flower painting lent itself to reproduction in fine textiles. 13th century.

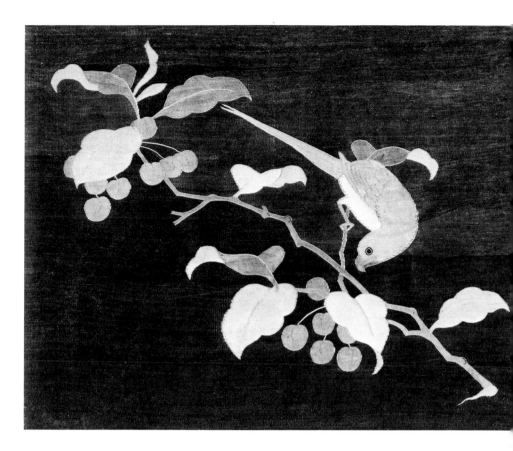

ware engendered many imitations at other kilns, each with a distinctive body but all with a streaky dark glaze. An appreciation of a sophisticated 'simplicity' is part of Sung Ch'an taste, with its respect for directness allied to elegance of technique. The Japanese monks took the tea bowls back to Japan with the ceremony; they named the bowls Temmoku, this being their pronunciation of Tien Mu Shan where they had found the bowls. This Japanese term has been adopted as a generic name for all black tea wares, which come from many different kilns.

As one would expect, refined southern crafts of bamboo and ivory carving, lacquer painting, and bronze and silk, came to the fore in the *109, 110* thirteenth century. Although examples of the more delicate materials are rare, enough has survived of jade and ivory, and particularly of porcelain, to show that a taste for the quiet southern style permeated court and *literati* circles. The *literati* remained broadly faithful to this taste from the thirteenth century onwards.

Tradition and Invention
14th–15th centuries

In 1260, the Mongols, under Ghengis Khan and more notably his son Kublai, conquered China, first sweeping out the Chin invaders of the north. By 1280 they had unified the country and had built a new capital at Peking, incorporating the Chin city. The Chinese traditional ruling class, who were settled around the old capital at Hangchow, were faced with the difficult decision of whether or not to serve a foreign ruler. For those who took up an official career, this inevitably meant a return to the north and the rediscovery of what had been the centre of Chinese culture before the Southern Sung. For those who resolved to remain outside the administration of Yüan, the new dynasty, it meant a retirement which was to last for their whole lives. There were major painters both among those who accepted the new circumstances and among those who chose to turn their backs on them. But none of these artists could be regarded as court painters in the old sense, that is, that they were attached to the court by right of their painting alone. Indeed, Chao Meng-fu, the highest official ranking painter of the period, seems to have painted chiefly in retirement. He and many of the notable painters of the time lived in the area around Hangchow known as Chiang Nan (south of the Yangtse River), which had already become a major cultural centre of China in the thirteenth century.

77

Perhaps because of the change of status forced upon many writers and painters by the painful situation of foreign domination, the Yüan period is one of individuality and inventiveness. In painting, even given the constraints of the traditions of landscape painting, some Yüan painters have come to be regarded as innovators within the classic school; they opened up the way to further evolution of the style by later painters. This group of landscape painters seem to have been engaged in creating variations on a theme. After them, the variations were treated as themes and more variations were played upon them.

This is the first period in which painters emerge as individuals and in which much is known about their lives. Enough painting has also survived to allow us an overall view of the work of particular artists. There were six artists, two from a more academic tradition and four who are traditionally known as the 'Four Great Masters of Yüan', to whom all later painters looked with great respect.

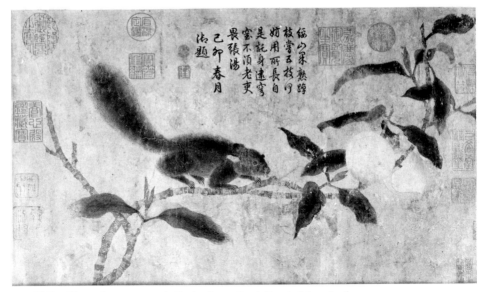

111 Ch'ien Hsuan (*c.* 1235–1301), *Squirrel on a Peach Bough*. Ink and colour on paper. This small painting, though owing much to the 12th-century bird and flower style, has a new air of movement and 'naturalness'.

Ch'ien Hsuan (*c.* 1235–1301), a scholar from Suchow who was never in fact given office, was a painter of distinction in a style which was totally in tune with his time. Ch'ien had trained in the traditional way, by studying and copying old painting and calligraphy, which would have included examples of the Southern Sung court style. Perhaps having fresh access to the old masters in the northern collections, he developed a distinguished archaistic style which was not a pale reflection of earlier prototypes, but a personal vision based on the paintings then extant of the ninth and tenth centuries. Archaism, always a creative force in Chinese art, was at this time particularly prevalent in painting. Ch'ien's painting was regarded as being close to the original prototypes and the artist himself said that he signed his pictures 'to distinguish them from imitations'. *Wang Hsi-chih feeding Geese* is a fine example of this kind of archaism. Such small, coloured paintings have great dignity and strength. The use of colour itself established a clear connection with the T'ang paintings of the 'blue and green' style. But his composition, although it owes a little to the 'one corner' Southern Sung model, is closed in and it is combined with a minute observation of every element in the painting. Even when Ch'ien uses the bird and flower style of *111* the Northern Sung, he loosens the composition to produce a more natural-seeming balance and expression of his subject.

Ch'ien Hsuan's younger contemporary, Chao Meng-fu (1254–1322), had completed his training at the start of the Yüan Dynasty (1270). He was a brilliant scholar and calligrapher. When he was called, in 1286, to Peking, he took up an official career with considerable success, rising to be secretary of the Board of War. However, he retired early, in 1295, and returned to his native Wu Hsing, bringing with him a collection of paintings which are said to have included tenth-century works. His painting, *Autumn Colours*, of the mountains of Shantung, is an unassuming but vivid account of a specific scene. It is recorded that this picture was painted for a friend who had not been able to visit the area, his old home, and so it had a special significance. There is no hint here of the artifices of the thirteenth century, but there is more than a passing reference to the brushwork and recording skills of the tenth century. Chao Meng-fu felt strongly about his place in a tradition which he saw as linking him directly with Tung Yüan and Chu Jan. Even so, he did not avoid the use of colour in his paintings. He also wrote about his paintings in a well-trained but highly personal calligraphy. Chao was much admired in his own time and seemed to be the ideal scholar-artist. But his reputation has been clouded by those who disapproved of his action in serving a foreign court. This may be the reason for the relative scarcity of his surviving work. Of his contemporaries who chose to retire from official life, Huang Kung-wang, Wu Chen, Ni Tsan and Wang Meng are grouped as the 'Four Great Masters of Yüan'. Each one has his own style, although all four artists lived in the Chiang Nan area, at a time when not only was the centre of national power far away, but the area itself was controlled by the salt-smuggler Chang Shih-ch'eng.

Huang Kung-wang (1269–1354) was a generation younger than Chao Meng-fu and came from a quite different background. Adopted into a family, he was a child prodigy. He had a short official career, but he is best known for the paintings of his old age and in particular for one ink on paper handscroll, *Wandering in the Fu Ch'un Mountains*, which inspired many later painters. The artist records that he worked on this painting for seven years during which time he made sketches and notes in the mountains and gradually built up the picture. The brush style seems absolutely assured but unselfconscious, rather like that of the older Titian; the brush strokes are laid on boldly but with subtlety of tone. The composition encompasses a whole sweep of a lake, mountain tops and wooded slopes. The spectator's eye is led to wander through the terrain and at many eye levels; foreground and background depths are varied to create a rich texture and an effect similar to that achieved by Kuo Hsi, but are executed in a brush style which is very different. A comparison of Huang's work either with the theatrical passages of Hsia Kuei or with the complex and grandiose details of Kuo Hsi

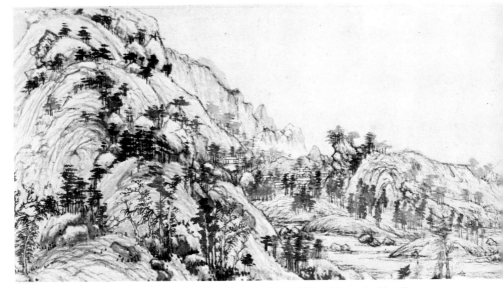

112 Huang Kung-wang (1269–1354), *Wandering in the Fu Ch'un Mountains* (detail). Handscroll, ink on paper. Comparison both with the early masters whom Huang admired (Pls 89, 90) and with the contemporary paintings by Chao Meng-fu (Pl. 77) and Ch'ien Hsuan (Pl. 111) show the strength of this master's work.

demonstrates the eclecticism of the Chinese painter. Huang is valued for his lovely brushwork and economy of means. He was also concerned with the representation of light, an aspect of landscape which artists began to explore at this time.

Wu Chen (1280–1354) was an unassuming man who earned his living as a fortune-teller and diviner. He described himself disarmingly in a colophon to one of his paintings:

I would like to have composed another 'Homecoming' ode [like Tao Yüan-ming's], but am ashamed to have no such lovely verse as 'The three paths are almost obliterated'. I would have liked to have wandered around the Yangtse and Hsiang rivers, but unfortunately hadn't the proper bearing to go about in a coat and hat of green leaves. I might have studied agriculture, but hadn't the strength needed for ploughing; I might have taken up vegetable gardening, but taxes are oppressive and the foreigners [the Mongols] would only have confiscated my land. Advancing [in public life], I could not have fulfilled any useful function; retiring, I could not have concealed myself happily in idleness. So I have lived by the Changes practising frugality and done what I pleased. Through a harmonious life I have drifted into old age. What more could I have wanted?★

★ Quoted from James Cahill, *Hills Beyond a River*, New York and Tokyo, 1976.

113 (*above*) Wu Chen (1280–1354), *Fishermen* (detail). Handscroll, ink on paper, dated 1352. The expression of space over water is similar to that of a 13th-century painting, but the softness of brushwork and the very subject-matter change the spirit of the work.

114 (*right*) Ni Tsan (1301–1374), *The Jung Hsi Studio*. Ink on paper. This is a fine example of the 'stretched' landscape composition held together by the foreground trees.

113 Wu Chen's paintings in ink on silk or paper are strongly individual. His many lakeside genre scenes of the T'ai Hu, where he lived, are painted in wet ink, usually in the middle tones which create an atmosphere of calm. Genre painting was probably one of the most popular types of painting in China and the surviving examples from Sung times up to the present day show that it could be adapted to a multitude of styles. Wu Chen worked as stylishly in bamboo painting as in genre. He clearly enjoyed working in wet ink on a fairly non-absorbent paper, which produced a smooth stroke and a full sweep, allowing full play to the calligraphic brush.

Ni Tsan (1301–1374) came from a comfortably well-off family which owned a fine house and a famous library. He was an educated man who chose not to take up the office for which he would have been fitted. During the period of national troubles, both taxation and local unrest hit his family and eventually he sold up the family estate and, to avoid having to submit to the local ruler, he and his wife lived on a boat on the lakes. It seems that his highly

114 personal landscapes, variations on the same lakeside subject, date from this period. His vision is one of calm waters and of uninhabited land in a silvery light. Painted in light ink on paper, Ni Tsan's paintings are executed with a light, staccato brushwork and in a very narrow range of tone. The artist has a sure eye for expressing space across water. He uses a vertical hanging scroll format and he is the finest exponent of the 'stretched' composition: whereas the eleventh-century landscape painter bound his painting to the edges of the

屋角東春風多杏花小齋容膝
庚年華金檢耀水池魚戲彩
細林澗竹斜查～清談霏玉屑
蕭～角髮岸鳥紗而今不二韓
焦濱市上懸盡來之諱甲寅三
月四日僕歸翁復撿郎畐未索
聯詩贈雪仁仲醫師且錫山
子文枕鄉匕客膝齋則仁仲燕
居大坮旭月持歸故鄉登斯齋
持巵酒辰斯屬為仁仲壽當
逐吾志也雲林子識

壬子歲七月五日雲林生寫

frame and related one eye level to another by interlocking units within the composition, Ni Tsan and other fourteenth-century painters expanded the space between these units, daring almost to split the composition horizontally, but tying it by the use of vertical elements, such as a tall tree in the foreground, to unite the surface.

The fourth of the Yüan masters was Wang Meng, a grand-nephew of Chao Meng-fu. It is possible that he knew his uncle's collection of old master paintings. Wang Meng was arguably the most inventive of this group of fourteenth-century painters. Nevertheless, he used a tenth-century type of composition for his big paintings, building his mountain scenes with multiple eye levels and using a *tour de force* perspective construction to produce a receding mountain ridge beside an open expanse of water. Wang Meng was also a master of complex brushwork, modelling his forms all over in tiny *ts'un* (this technical term, which derives from the word for the wrinkles on the back of the hand, refers to strokes which express both texture and modelling). After a brief official career between 1354 and 1368, Wang Meng retired to the mountains near Suchow. He was later called to the court of Hung Wu (1368–98), who was the first Emperor of the Ming Dynasty. But shortly after, purged by Hung Wu, together with several *literati* of whom the new Emperor was very suspicious, Wang Meng was thrown into prison where he died.

Although life for the painter-official was not straightforward, nor in some cases even safe, there was a rich patronage available at court and among the growing merchant class. This affluence is evident in the domestic culture of the minor arts. The fourteenth century saw much enriched decorative art: the introduction of underglaze painting on porcelain, in cobalt and copper, the increased use of carved and painted lacquer, and a distinctive use of metalwork. All these crafts, whether they were carried out in north or south China, show a move towards ornate decoration carried out on more substantial forms. Even the pottery shapes produced by the Lung Ch'uan kiln, which was a kiln in decline, changed at this time, and incised decoration was reintroduced; potting became heavier and the glaze denser. The kilns at Ching-te Chen, on the other hand, were in the ascendant and expanding fast, as were the kilns in Fukien and Kwangtung, mainly owing to increased overseas trade. With the taste for decoration clearly growing, the decorators at Ching-te Chen experimented with both cobalt and copper on the white

115

116–118

115 Wang Meng (1308–1385), *Thatched Halls on Mount T'ai.* Ink and colour on paper. An eccentric composition in which the waterfall to the left and the valley to the right come dangerously close to the edge of the picture. The central 'spine' of the composition grows from the trees and up the mountain ridges.

142

116 Iron underglaze decorated stoneware dish. This large piece is a development of the Tzu Chou style (see Pl. 97). Perhaps from Chi Chow, Kiangsi. 14th century.

porcelain body, covered by a pale, transparent blue Ying Ch'ing glaze. The motifs used in the early Ching-te Chen decorated ware are of birds and flowers in the main zone, with various flower scroll motifs in the borders. The arrangement of decoration is, interestingly, entirely traditional, that is, arranged in horizontal bands or concentric rings. Of the two metallic oxides used in underglaze decoration, copper and cobalt, copper proved to be much the most difficult to control and was quite quickly abandoned; but, once its

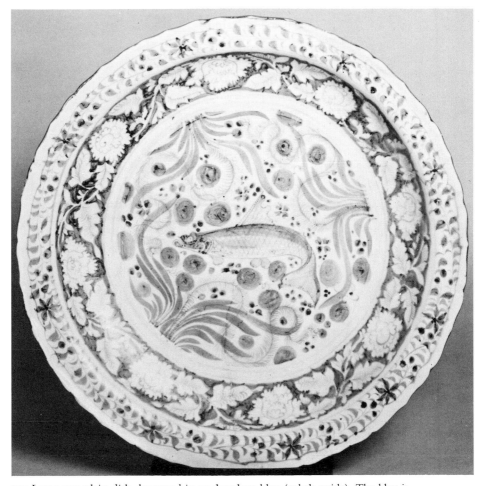

117 Large porcelain dish decorated in underglaze blue (cobalt oxide). The blue is painted on to the porcelain body and then covered with a Ying Ch'ing glaze. From Ching-te Chen. Late 14th century.

tendency to run with the glaze and to rise through the latter had been conquered, cobalt became the favourite colour, and a rich blue is typical of the fourteenth-century Ching-te Chen decorated ware. This experimental, decorated ware is contemporary with a monochrome white ware, characteristically potted more heavily than the thirteenth-century pieces from the same kiln, in a style known as 'shu fu', after two characters often found included in the ornate slip trail decoration. The 'shu fu' glaze, although

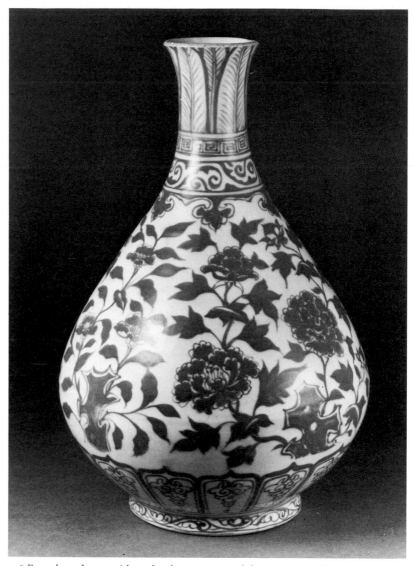

118 Pear-shaped vase with underglaze copper-red decoration. At this early date the floral decoration often seems to grow from the foot of the vase. The lip is slightly cut down. From Ching-te Chen. 14th century.

119 Large Ying Ch'ing porcelain figure of a seated Kuan-yin. The torso is moulded, and the hair, jewellery and drapery modelled separately. From Ching-te Chen. Dated 1298 or 1299.

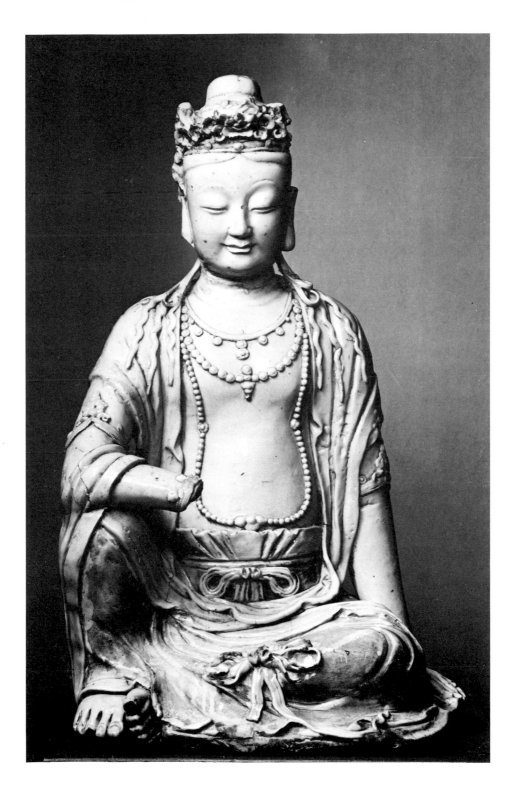

more opaque than the Ying Ch'ing glaze from the same kiln, was also of a bluish tinge, unlike another white ware of the period called 'sweet' white, which is almost pure white. A few new shapes, such as the monk's-cap jug and the stem-cup, were introduced, but it is the underglaze decoration, both in metallic oxide and in slip trail, which distinguishes fourteenth-century porcelain. Grand Buddhist figurines were another innovation of the Ching-te Chen kilns.

119

Lacquer must have been a prominent craft from a very early period. But while the surface of painted lacquer is strong and impermeable, once it is cracked or damaged by over-exposure to light, deterioration is fast in either wet or dry conditions. Since the tradition of extensive, careful burial of objects had become less common, very little lacquer has survived, and it is difficult to follow the varying styles of this craft. However, several examples of Yüan Dynasty lacquer have been preserved in China and Japan, mostly boxes and dishes of foliate shapes derived, apparently, from gold and silver wares. Lacquer was made in black and red with the occasional use of gold for inlay and signature. This strange material is the resin of *rhus vernificera*, the 'Lacquer Tree', which is native to east China. The resin is tapped from the living tree and collected as a slow-flowing liquid which oxidizes to an opaque whitish colour and which will dry only in a humid atmosphere. Lacquer workers use a matrix, usually of finely turned light wood, on to which successive coats of lacquer are painted very thinly. Each coat is polished smooth. Carbon, cinnabar and ochre are used for colouring and are mixed into the lacquer. When the lacquer is dry and very hard it may be carved, just like wood, and the surface burnished to a glossy finish. The full thickness required for carving has to be painstakingly built up from many hundreds of coats of lacquer before carving can be carried out. The ornate

137

carved lacquer of the Ming and Ch'ing Dynasties was later made in exactly the same way.

Fourteenth-century craftwork has a richness and generosity of scale in decoration, and both decorative and expressive painting is also freed from the mannerism of the Southern Sung. A broadening of style in all media and a widening of the tradition on which painting was based enlivened the visual arts, opening the way for many new styles to flourish.

Eclecticism and Innovation
15th–17th centuries

When Peking was chosen by the Yung Lo Emperor (1403–24) as his capital, in 1403, the building of the Forbidden City, and all the other palaces, tombs and Imperial temples in and near Peking, was started. The Forbidden City, as the palace of the Emperor and his administration was called, was laid out to include, and enlarge, the rectangular palace area of the previous Chin and Yüan Dynasties. The grand plan, which included ceremonial, religious, administrative and domestic quarters, was approved by Yung Lo and, although much of the building now standing is of seventeenth-century and eighteenth-century date, the lay-out is typical of a Ming palace. The ceremonial buildings are oriented in series down a central north–south axis, facing south. This axis is also aligned with the south gate of the city wall. When empty, the huge courtyards and terraces before each of the ceremonial halls are almost oppressively imposing; they were used as meeting areas for large gatherings of officials. The walled enclosure surrounding the central halls contains smaller halls also used for ceremonial and administrative offices, and the outer box, just within the walls of the city, contains the courtyards, each with a garden, where members of the Imperial family lived. Temples and altars for the use of the Imperial family are sited within the city walls and in the south–eastern corner. All the buildings are constructed in the traditional style of wooden beams and pillars. The wide tiled roofs are supported on elaborately bracketed eaves and cross-beams. Used from the first century AD, bracketing had grown and spread to take the progressively wider roofs, but by the Ming period it had also become a decorative feature and the details of the woodwork were picked out in colour. The construction of the roof was simplified and the *ang* lever had disappeared. The roofs of the Forbidden City are of yellow glazed tiles. The profile of the roofs is typically northern in the restraint of the curve of the roof ridge, which is much more pronounced in the south. Roof ridge ends are embellished with dragon finials and the hip ridges are now also decorated with animal tiles. From the fifteenth century architectural techniques and design were static; it is only in details of finials and decoration that originality was shown.

Although Peking became the administrative centre of the country, to which professional artists and craftsmen were summoned, it was not the

*120–
124*

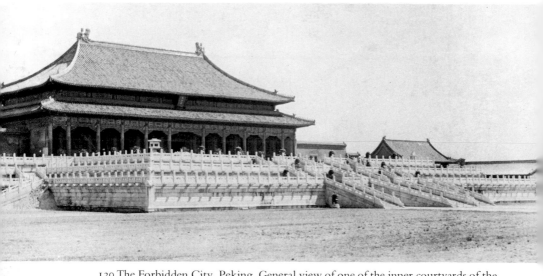

120 The Forbidden City, Peking. General view of one of the inner courtyards of the Palace. 15th-century foundation.

121 The Forbidden City, Peking. View of the canal and covered way leading to the side of the main halls. 15th-century foundation.

122 The Temple of Heaven, near Peking. This circular building with violet-blue tiled roof and brilliantly painted woodwork faces the Altar of Heaven at which the Emperor performed seasonal rituals. 15th–century foundation.

cultural centre; the Chiang Nan area remained the favourite haunt of painters and writers. Suchow, Yangchow and Nanking were rich centres which thrived on the silk, tea and salt trades; here private fortunes were made and rich families established. Away from the capital, painters and writers, often retired from public service, congregated in towns such as Suchow, in houses with marvellously designed courtyard gardens. The courtyard garden, designed to be viewed through a framed window opening, was developed into a fine art in the sixteenth and seventeenth centuries. The essential feature of this type of garden was that although it was possible to have a general view of the whole garden from a balcony, one usually walked around the garden in a covered corridor, looking through lattice windows which framed the view, often of a carefully placed rock or tree. The garden was seen, thus, as a series of colourful pictures, set in motion as one moved.

134

123 Interior of the ceremonial hall at the Ming tombs outside Peking. Erected in the 15th century, this massive building is one of the largest wooden structures known. Dark wooden pillars rise from a marble floor to the painted wooden ceiling; the roof is of yellow tiles.

The general effect is of being inside a painting which changes as one walks in it. The element of composition of each still is created by the frame of the lattice window, and it is magical; the lattice surface pattern within the frame further enhances the effect by fragmenting the composition enclosed and by emphasizing the contrast of surface and depth. Such contrasts were well understood by painters and indeed the ink paintings of the scholar-painter may be commentaries on the multiple compositions which the artist experienced in his own garden. Lack of colour here was no loss; it tended rather to allow the artist to emphasize line, texture and composition.

Courtyard gardens, however, were only one of many types of garden popular at this time. Large, park-like gardens were also constructed in the Nanking area while rich families with plentiful land laid out less formal, much wilder parks on their estates (such an estate was the subject of many

124 Marble camels on the Spirit Way, a road flanked by animal sculpture which leads to the Ming tombs at Nanking. The first two Ming emperors were buried at Nanking, where the tomb site, though similar, is smaller than that at Peking.

paintings by the fifteenth-century artist, Shen Chou, whose work is discussed below).

When, in 1368, the first court of the Ming Dynasty was set up by the Emperor Hung Wu in Nanking, the Emperor assembled a number of painters in an attempt to institute an Academy there. The stay of these painters at Nanking, however, was usually short, due to the factionalism and the conspiracies which were characteristic of the Hung Wu court and which extended to the artists themselves. Even after the court moved to Peking, in 1403, it did not prove to be a congenial place for many painters, and it was never again possible for an emperor to establish an Academy.

One of the greatest of the early Ming court artists in the mid-fifteenth century was Tai Chin, who came from Ch'ien T'ang, in Chekiang. He was an effortlessly fluent painter who used a large format and a style partly

derived from the thirteenth-century romantic style, but his work was also close to the fluid painting of Wu Chen. His large landscape, *Returning Home at Evening*, is constructed on the lines of a Southern Sung landscape, using wide illusions of space and a misty distance; the detail of the figures at the garden door makes a delightful small picture in itself. This picture is painted in the liquid ink style used to a similar effect by Ma Yüan, in the thirteenth century, by Wu Chen, in the fourteenth century, and by Wang Fu in the very early Ming period. Tai Chin painted only for a short time at the court, and he quickly retired to his home in Chekiang. The first syllable of the name of this province was adopted as the name of a school – the Che School – of which Tai Chin was regarded as the leader. When reference is made to painting of the Che School, it is to a general style of painting which is regarded as 'professional' and which carries with it a pejorative judgment of court artists as servants who painted to order. So, regardless of their place of origin, painters who went to court in the fifteenth century are grouped under the Che School. Although their work can be quite different in character, what they share is a fine brush style which is both flamboyant and self-assured. Wu Wei (1459–1508), from Hupei, painted mostly scrolls of fishermen in genre style. Lin Liang (last half of the fifteenth century), from Kwangtung, painted hunting birds, eagles and their prey, and was to have an influence on the Kano School in Japan. Lu Chih (last half of the fifteenth century), from Ningpo, was the most successful of all the court artists: he set up a workshop and produced a huge output of paintings of domestic birds, such as ducks and geese. These decorative Ming paintings are not only generous in scale, but also varied in style and taste. But their range of subjects is limited to kittens and puppies, well dressed little children in idyllic garden surroundings, songbirds among flowering trees, and magnificent phoenix and pheasants.

Another school of painters calling themselves Wu School grouped themselves around Shen Chou (1427–1509), who came from Wu Hsien (Suchow) where his family had an estate. His great-grandfather had been a friend of Wang Meng and it is likely that the family possessed a notable collection of paintings and calligraphy. Shen Chou was a cultivated man who never took up an official career. He was a serious painter and one of the finest eclectics in a tradition which was based upon eclecticism. As a young man he experimented with the styles of the eleventh and fourteenth centuries; he proved an interesting commentator on these styles but his own individuality was never submerged – his eclecticism was never merely archaistic. In this sense he was a true Confucian in his attitudes to his teachers, for he worked within the bounds of tradition until the moment when he felt able to break away and paint entirely in his own style. Fortunately, good

125

126

138

125 Tai Chin (1388–1452), *Returning Home at Evening* (detail). Hanging scroll, ink and slight colour on silk. The scale of this large painting imparts a new dimension to a brush style which is clearly related to the 13th century (see Pls 101, 102).

126 (*right*) Wang Fu (1362–1416), *Farewell Meeting at Feng Ch'eng*. Ink on paper. Painted in a brush style which relates both to Wu Chen (Pl. 113) and to Ni Tsan (Pl. 114), this one-sided composition is very typical of a 15th-century mode.

127 (*far right*) Shen Chou (1427–1509), *Poet on a Clifftop*. Album leaf, ink on paper. The painter/poet has projected himself, and by extension the viewer, into the painting. This is one of the earliest instances of an inscription intended as part of the composition.

156

白雲如帶東山腰
磴飛空細路遙㩳倚
杖藜舒眺望欲因鳴
澗谷吹簫　沈周

examples of works painted at different stages of his life have survived, so that
his development as an artist can be fully traced through his actual work. This
development is further confirmed by the evidence of his own writings.

Shen Chou painted many subjects; among his favourites were small
landscapes of the estate on which he spent all his life. In *Walking with a Staff in
the Mountains*, now in the Palace Museum, Taiwan, he used a light brush
style; the landscape is constructed of bare rocks and trees reminiscent of Ni
Tsan's style. However, the composition as a whole is compressed so that its
'stretch' is lost, and with it the sense of space over water. Moreover, in
contrast to Ni Tsan's pure landscapes, which lack any trace of human
presence, there is a figure walking in the middle distance, facing into the
landscape. The figure of a man is often present in Shen Chou's paintings; its
purpose is to make the viewer identify himself with the figure and so become
drawn right into the picture. This is achieved by the scale of the figure and by
its placing within the landscape. Figures had appeared in landscape paintings
before, notably in Ma Yüan's work, but their role had never been so *101*
deliberate. In another work by Shen Chou, in the Nelson Gallery, Kansas *127*

City, consisting of an album leaf depicting a flute player on a cliff top, the little figure draws the viewer into the painting in a similar way. Here the artist's intentions are reinforced by the accompanying poem. Since the thirteenth century explanatory notes had been written on paintings, recording the circumstances of the execution of the work and giving the date and the name of the painter; colophons also were added by owners and by other painters to enlarge upon the subject or to comment on the painting. But in the Ming Dynasty it became the custom for the artist to write a poem which was complementary to the painting. The poem for the Nelson Gallery picture reads as follows:

White clouds encircle the mountain waist like a sash,
Stone steps mount high into the void where the narrow path leads far.
Alone, leaning on my rustic staff, I gaze idly into the distance.
My longing for the notes of a flute is answered in the murmurings of the
gorge.

Shen Chou's evocation surely aims to transport the viewer into the open space high up. This little painting, quite informal and strong, epitomizes Shen Chou in his mature style, direct and vivid. He used both ink and colour with a freedom common at this time. His mature style demonstrates also the studied 'amateurism' of the scholar-painter, as he attempted to avoid the facility of brush and colour of the 'professional' decorative painters.

Shen Chou had one famous pupil, Wen Cheng-ming (1470–1559), who, although he had an official career, retired early to devote himself to painting. Wen Cheng-ming's early work was eclectic and he painted in many styles. As commentaries on the styles of old masters, his paintings are also interesting because they give clues to a general movement towards colour which seems to have been taking place at this time. Thus when he painted in Ni Tsan's wintry style, Wen Cheng-ming followed the old master's composition closely, but he changed the whole spirit of the scene by the use of atmospheric colour and by setting his picture in a different season: his landscape is of a lovely, spring day. Wen Cheng-ming was abandoning the traditional browns, greens and blues as accents to the composition and feeling his way towards the use of more realistic colours in his landscapes. This development, whose further implication was that colour might be used to create recession in landscape, was almost incompatible with traditional techniques of composition. Wen Cheng-ming was not alone in

128 Wen Cheng-ming (1470–1559), *Lofty Leisure Beneath a Sheer Cliff* (detail). Large hanging scroll, ink and colour on paper. The richness of foliage, expressed in a growing vocabulary of brush strokes, results in a striking surface texture enriched by colour.

129 (*above*) Chou Ch'en (*fl.* late 15th century), *Taoist Scholar Dreaming of Immortality* (detail). Handscroll, ink and slight colour on paper. This is the beginning, right-hand, part of the scroll; the scholar's dream of himself appears in the sky to the left.

130 (*right*) Ch'iu Ying (*c.* 1494–*c.* 1552), *Fishing Boat by a Willow Bank.* Colour on silk. Using a high view and delicate composition, the artist achieves a most poetic and decorative effect.

experimenting along these lines; his descendants for the next two generations followed his example and many other artists of the sixteenth century, including Chou Ch'en, explored these new areas of pictorial representation.

129

One of the most delightful painters who followed Wen Cheng-ming's example was Ch'iu Ying (first half of the sixteenth century), a painter from Suchow. He was a professional painter, in the sense that he trained as a decorator and painted for a living. Without having a scholarly background,

130

Ch'iu Ying was an accomplished eclectic who used an archaistic blue and green style, ink monochrome and also full colour. He had no inhibitions about subject or style, and his sheer painterly genius carried him through,

often bringing him very close to the prettiness so dreaded by the classic landscape traditionalists. Ch'iu Ying's figure paintings of courtly scenes, which are of great delicacy, have been much copied. His figures in landscapes and his pure landscape paintings are free from the constraints of his scholarly contemporaries and they demonstrate the possibilities of the Wu School when given full freedom of development. Another painter, who does not fit into a tidy category, was T'ang Yin (1470–1524), again from Suchow. A brilliant scholar, whose career was ruined at the outset by an examination scandal, T'ang Yin painted as a professional artist. Although he was not a great innovator, he was a painter of such elegance that he won the respect and admiration of his contemporaries, even if the more conservative were a little suspicious of his suave brushwork. Also renowned at this period was the painter and illustrator, Ch'en Hung-shou.

131

The sixteenth century was a period of great vitality in all the arts. Following developments in painting, colour also became a prominent feature of many of the applied arts. In ceramics, besides the rich blue and white decorated porcelains, overglaze colours brought a brightness previously known only in the low-fired burial wares. Ching-te Chen decorators used the low-fired glazes on porcelain in a secondary firing to produce all-over decoration in red, green and yellow. Ching-te Chen was a well established centre of Imperial production, but it also supplied most of the decorated porcelain of the country. As markets developed, kilns in the south-east grew rich on the export trade. Styles changed slowly through the Ming Dynasty from the delicate formalism of the fifteenth century to a greater naturalism of floral motifs. By the sixteenth century the 'picture' motif derived from woodblock prints became well known; two or three different shades of blue were being used; and it became customary to finish all decorative schemes with a selection of borders. Three-colour and five-colour polychrome styles followed the motifs already accepted in Ching-te Chen blue and white. The potters of Hopei produced Fa Hua, a stoneware with boldly drawn decoration, usually in slip trail, over which purple, turquoise and yellow glazes make a rich effect. Enamel was fired on metalwork using the *cloisonné* technique. Here opaque glaze-like material is laid in fields divided by bands of metal (*cloisons*) soldered onto the surface of the vessel. The whole object is then fired and burnished, resulting in a decoration of jewel-like richness. In some cases of great Imperial wealth, as in the tomb treasure of the Emperor Wan Li (1573–1619), semi-precious stones were set in filigree metal, and fixed over plain porcelain or jade vessels. Rich silks and rugs, opulently carved red lacquer, and heavy gilt bronze vessels all contributed to the furnishing of the houses of the collectors for whom the coloured paintings were also made.

140

132

141

137

138

162

131 Ch'en Hung-shou (1599–1652), *Lady Hsuan Giving Instruction in the Classics* (detail). Colour on silk. This eccentric artist often adopted a witty archaistic style. Comparison with Pl. 68 shows some of the references.

163

At this same time, scholars and literary men became particularly concerned with questions of aesthetics and with literary criticism. They applied themselves to reviewing the progress of literature and poetry from the T'ang period in the tenth century down to their own time, and they saw this as an orderly progression, with a classical revival occurring about 1500. They put forward criteria for quality among which *tun-wu*, a Ch'an Buddhist concept meaning 'sudden awakening', was valued above learning. Scholars interested in painting carried out a similar review. Tung Ch'i-ch'ang (1555–1636) and his colleague Mo Shih-lung (1540–1587) worked on the history of Chinese painting. Mo Shih-lung died before this work was completed, but Tung, who was a Ch'an Buddhist and a very successful official, went on to produce a critique of painting which has dominated Chinese aesthetic thinking until today. His book, *Hua Shuo (Talking of Painting)*, contains a division of Chinese painting into historic and stylistic periods, as well as remarks on connoisseurship and on the classification of paintings.

The most distinctive part of Tung Ch'i-ch'ang's book concerns his theory according to which north and south are seen as representing diametrically opposed schools of landscape painting. This distinction, on which his whole classification of painting was based, can perhaps be most simply understood by an analogy with the northern and southern sects of Ch'an Buddhism. In the late seventh century AD, a schism occurred within the sect and one branch broke away, rejecting sutra and study, ritual and all outward show; this sect then went to the south, leaving the northern sect with the court. Tung, accordingly, divides paintings between those which are concerned with poetic insight and what he called 'transformation', and those which are superficial and decorative, classifying them respectively as southern and northern. The distinction was clear in his own time and his classification underlines a scholarly disapproval of decorative and showy art. As his sympathies clearly lay with the southern school, Tung's ideas on the nature of southern painting are more fully developed and more interesting. The concept of 'transformation' encompasses both the painter's expression of observed reality and also, within the general theory of the transmission of a tradition, the transformation of one painter's vision by another – the very essence of eclecticism. This last concept could lead to a very strict adherence to tradition. But Tung warned against such a strait-jacket in a passage entitled 'Conformity and Detachment': 'Even a great master of painting

132 Standing Kuan-yin carrying a basket of fish. White porcelain with a slightly ivory-tinted glaze from Te Hua, Fukien (Blanc de Chine ware). 17th century.

must start from imitation. In time there will be virtuosity and with virtuosity will come spontaneity. Once the method is mastered and digested by the painter he can go in and out of the method at will with his own variations and he can be completely free from his models.' And on the notion of 'transformation' between observed reality and depiction, the primary artistic transformation, he said, most vividly: 'painting is no equal to mountains and water for the wonder of scenery; but mountains and water are no equal to painting for the sheer marvels of brush and ink'. Tung predictably claimed for the southern school a direct line from Wang Wei of T'ang, through the tenth-century landscape masters, the Yüan scholars and the Wu School of Ming. As a painter himself, Tung was, in his larger works, an analyst. In his *133* dry paintings, he explored and dissected composition and brushwork. Such works seem, at least in part, to be study exercises and they comment on the work of the Yüan masters in particular. Tung's album leaves are much more direct and painted in the accomplished style of a gentleman artist of the period.

This process of analysis and classification, indeed the attempt to trace a history of painting parallel to that of literature, was to have an immense influence in succeeding centuries. Perhaps it aimed at making artists pause in the gathering momentum towards freedom and even eccentricity in style, but it also encouraged an academicism against which many artists were to react strongly.

133 Tung Ch'i-ch'ang (1555–1636), *Landscape*. Ink on paper. Such a landscape is an academic artist's comment on the work of several 14th-century and earlier painters (see Pls 112, 114).

Individualism and Eccentricity
17th–18th centuries

The growing complexity of society at the end of the sixteenth century was reflected in an enriched cultural life in which heterogeneous tastes supported a wide variety of artists and craftsmen: the presence of foreigners at court and increasing affluence, which made the merchants independent of the court and of the official class, were only two of the many factors which nurtured artistic diversity. Individuality also began to be considered an important quality in a painter; indeed, a small group of artists were even known as the 'Individualists'.

One of the best of these artists was Chu Ta, also known as Pa Ta Shan Jen (1626–1705). He was a relation of members of the Ming royal house and at the change of dynasty he retired to live in a monastery. He painted in the Ch'an School. He was something of a recluse and an eccentric, and it is said that he became dumb and may even have suffered from epilepsy. His ink paintings of birds, fish and flowers bear the stamp of his individual style; his brushwork and composition communicate directly to the twentieth-century viewer; his style is witty and requires no further explanation. Pa Ta Shan Jen's composition is in the Ch'an tradition of Mu Ch'i and Liang K'ai, subtle and yet very strong. The bravura of his work appealed to the Japanese and his style has become virtually synonymous with Zen painting in that country. However, he also painted landscapes, usually in ink on satin or coarse paper, and it is in this genre that he comes very close to Tung Ch'i-ch'ang. But whereas Tung was preoccupied with finding solutions to compositional problems, Pa Ta Shan Jen used the mass and line of a landscape to produce imaginative 'transformations' of great strength. In his day Pa Ta Shan Jen was a connoisseur's artist, and his style has been influential up to the present day in both China and Japan.

Shih T'ao or Tao Ch'i (1630–1707) was also related to the Ming royal family, and he too retired to live the quiet life of a monk, painter and scholar in the Yangchow area. He wrote a famous treatise, *Hua Yu Lu* (*Collection of Sayings on Paintings*), which is a brilliant exposition of a painter's task. His work stands almost at the opposite pole to Tung Ch'i-ch'ang's and he was at some pains to counteract what he considered the older artist's academicism. He emphasized the need for clear vision and direct communication, and eschewed being categorized: he said he did not know to which school of

135

134 The Wang Shi Yüan garden, Suchow. A small courtyard garden seen from a
doorway. The covered way to the right with its tile lattice windows provides
different views of the trees and rocks against the white wall. 16th century. (See p. 151)

135 (*left*) Pa Ta Shan Jen (Chu Ja) (1626–1705), *Landscape in the Manner of Tung Yüan.* Ink on paper. This hanging scroll should be compared with Pl. 133, for although many of the references are similar, Pa Ta Shan Jen has in addition the grace and vitality of a great Ch'an painter.

136 (*above*) Shih T'ao (1630–1707), *The Peach Blossom Spring.* This is the right-hand end of a small handscroll, in ink on colour over paper. The traveller makes his way out of the idyllic valley into the grey world beyond.

painting he belonged, but that he was himself the school. Basing himself on the Yüan masters and following Shen Chou, Shih T'ao painted imaginative landscape and genre pictures. He used colour to create atmosphere and light, particularly with his coloured *tien*, the dots used by painters as accents and texture strokes; when these are painted in pale pink and blue over each other they create the effect of a haze of light. He also used colour under his ink paintings; this allowed a combination of ink and colour compositions, a solution to the problem raised by the polychromatic works of the previous century. Shih T'ao invented new techniques to serve his vision, so that sometimes his brushwork seems wild and his composition eccentric. Such was the vitality of his invention that to this day painters look to his work for inspiration.

The third of the Individualist painters was K'un Ts'an, also a monk about whom very little is known, and from whose work only a few landscapes and album leaves survive. His large compositions tend to be sprawling and

137 Red lacquer covered box carved with a design of camellia sprays. Generous composition and deep smooth cutting distinguish Ming lacquerwork. Later Ch'ing pieces become much more complex and sharp edged. First half of 15th century. (See p. 162)

138 Pien Wen-chin (*fl.* 1400–1430), *Three Friends and One Hundred Birds*. Ink and colour on silk. Generosity of decoration is evident in this large hanging scroll which is an example of the Ming development of the bird and flower tradition. (See pp. 154, 162)

139 K'un Ts'an (c. 1610–1693), *Autumn Landscape*. Ink and slight colour on paper. The atmospheric effect of the distance is enhanced by the colour.

anecdotal. The structure does not have any of the tightness of other classic-style painters, and the various focal episodes of his large pictures are divided by misty, undefined passages; each focus thus becomes a small independent composition. K'un Ts'an used colour in a personal way in his landscapes: in the distance, over the hills, there is often a sunset painted in full colour, although the foreground is usually executed in greys and browns. This is a rare treatment of transient light effects and an innovation which seems to lead towards watercolour paintings of landscape, in full colours.

These three great Individualist artists initiated a movement in painting outside established modes. None of them worked in an official capacity, nor were they professional artists, although we do find Shih T'ao complaining about being required to paint on satin, which he disliked. The Individualists were regarded as connoisseurs' painters, but they were also highly regarded by court and commercial painters, although not by the court itself. Shih T'ao in particular was in correspondence and close contact with the major artists of his day.

As mentioned before, society in China at the start of the Ch'ing Dynasty was becoming more diverse, and many kinds of patronage encouraged a variety of styles. The court and the more conventional official class admired the work of a group known as the Four Wangs. These four men, all by the surname Wang, but not all related, span two generations and formed the centre of a movement which derived from the Wu School and from Tung Ch'i-ch'ang. Wang Shih-min (1592–1680) held a high official position until the fall of the Ming Dynasty, when he retired to live at T'ai Ts'ang, in

Kiangsu. The majority of his works are large, densely composed landscapes, often coloured. While not innovative, in the sense that Shih T'ao was, Wang Shih-min painted magnificent scrolls on the scale of the old masters, of whom he particularly admired Huang Kung-wang. His manipulation of eye levels and surface balance are fairly traditional, but his work is not archaistic. A follower of Tung Ch'i-ch'ang, Wang Shih-min seems to have reached the final stage in the process, described by Tung, of 'slipping in and out of the method at will'. His contemporary, but no relation, was Wang Chien (1598–1677), who also painted imposing landscapes in the same style. These two men were admired by the Manchu Ch'ing court as great exponents of a tradition and culture with which the Manchus were not yet entirely at home. Wang Chien introduced Wang Hui (1632–1717) to Wang Shih-min, who took the younger man on as a pupil. This young man, also no relation, had a naturally beautiful brush style which gave charm to his work. His compositions, although within the tradition of his teacher, are striking; he painted landscapes in an exaggeratedly tall and thin scroll format. His friends Yun Shou-p'ing and Wu Li (often included in the Four Wang group) worked in a more decorative vein, making free use of colour. Yun Shou-p'ing painted flowers in what is known as the 'boneless' style, that is, without outline. Wu Li painted idyllic summer landscapes in the style of Wen Cheng-ming. Yun Shou-p'ing and Wu Li also collaborated together on paintings, in a manner traditional amongst scholar-painters: one would paint the rocks and another the trees or bamboo. Such collaborative work became a form of social painting, and it played an important role in the scholar-painters' lives. Informally, fans and album leaves were painted during social gatherings of scholars, who would also compose poems and paint together.

The fourth of the Four Wangs, Wang Yüan-ch'i (1642–1715), also worked at the K'ang Hsi court. He was a grandson of Wang Shih-min. He held high court office and was in charge of the Imperial collections of painting and calligraphy. In spite of his court commitments, Wang Yüan-ch'i was a highly inventive painter within the landscape tradition. His distinctive feature is his manner of expressing volume and depth in almost Cubist terms within the traditional moving eye level composition. The comparison of Wang Yüan-ch'i's landscape with that of Pa Ta Shan Jen is interesting: the calligraphic style of the earlier painter contrasts with the painting of volume by the eighteenth-century artist. This is clear in the landscape *View of Mount Hua*, where Wang seems to reach towards his more *142* Cubist style, which, however, Chinese artists were never to develop any further. He used touches of colour as a slight indication of atmosphere and light, and also to strengthen the surface composition, in a manner reminiscent of Cézanne.

140 Moon flask of blue and white porcelain. Free and delicate painting of birds and flowers gradually superseded the heavier and more conventional motifs of the 14th century (see Pls 117, 118). From Ching-te Chen. 15th century. (See p. 162)

141 Overglaze decorated porcelain bowl. Green and red low-fired glaze colours painted over the porcelain glaze and then refired. From Ching-te Chen. 16th century. (See p. 162)

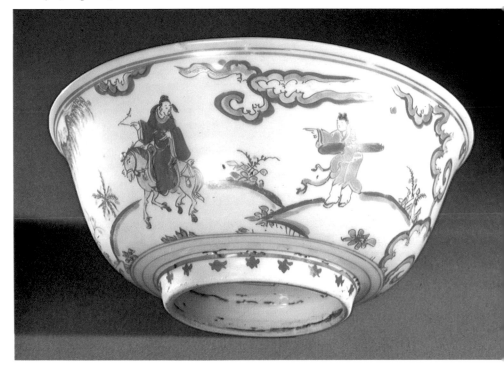

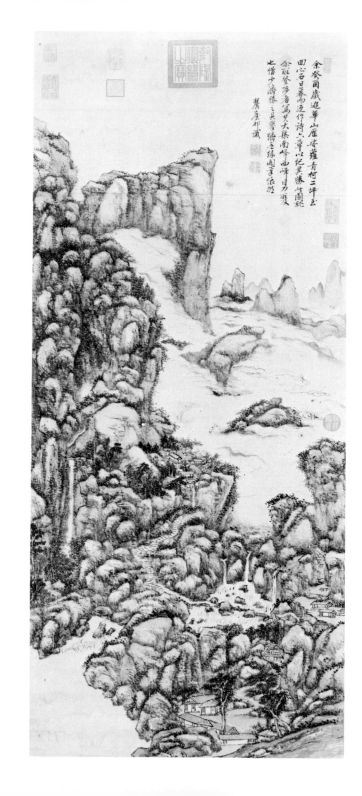

The younger group of the Four Wangs worked at the court of the K'ang Hsi Emperor, the third of the Manchu rulers of the Ch'ing Dynasty. K'ang Hsi had come to the throne as a child and was educated as a Chinese, but he retained some of the characteristic energy of a Manchu. He gathered around him a remarkable court which included painters, poets and calligraphers. These artists practised the traditional Chinese arts which were an acquired taste for the Manchus, whose own taste and traditions found expression in the decorative arts. Following these traditions, the Emperor encouraged the setting up of workshops within the palace compound to house expert craftsmen who made enamels, jade carvings, embroideries and overglaze decorated porcelain. Although drawn from the diverse major craft centres in China, these palace craftsmen did reflect something of the special taste of the Manchu court.

Ching-te Chen and the Imperial porcelain factories in Kiangsi had suffered during the disturbances caused by the change of dynasty. But by the time of the reign of the Emperor K'ang Hsi, the kilns were working again and producing fine quality blue and white wares. These were painted with *145* landscape and figure scenes, finely drawn in a manner similar to that of the late seventeenth-century and early eighteenth-century landscape painters. The pots from this period became collector's items, especially appealing to those with an academic taste. The style used developed initially from woodblock illustrations and was refined by the late seventeenth century to a calligraphic style broadly known as the 'K'ang Hsi style'. In overglaze decoration of porcelain, a more varied palette was used with the addition of the tints of the five overglaze colours of the Ming. This ware, called *famille verte* by Europeans, was decorated in the same refined manner as the blue and *143* white wares. The body of *famille verte* ware, with its clear white glaze, was treated as the equivalent to silk on which artists sometimes painted. The decorators of these pots painted on them ever more delicately in the style of contemporary bird and flower or landscape painting.

The new stylistic tendency in decorated wares, which soon included enamel on metal, was towards the use of a wider range of colours and of *146* more delicate drawing: rose-pink and white colours (pink from colloidal gold and white from arsenic) were introduced from Europe and they completed a palette known in the West as *famille rose*. Parallel with the *144* developing taste for pretty decoration was the ever-present use of archaistic

142 Wang Yüan-ch'i (1642–1715), *View of Mount Hua*. Ink and light colours on paper. Here the mist takes the place of a river, and the breakdown of the land mass into boulders gives a greater sense of volume. The high overview of the near distance allows an almost fixed eye-level.

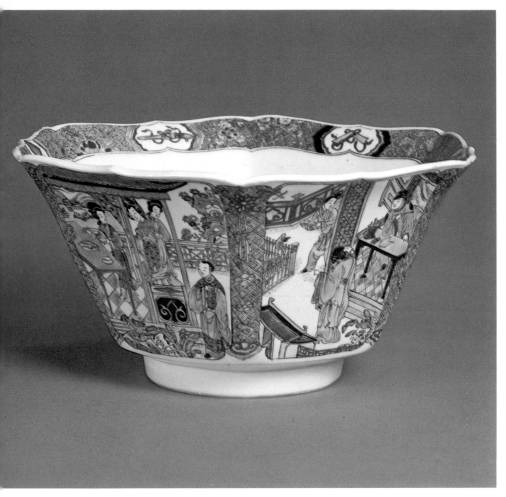

143 *Famille verte* foliated porcelain bowl. The full five-colour palette is used for the overglaze decoration of ladies in a garden. From Ching-te Chen. Early 18th century.

144 Small porcelain vase decorated in *famille rose* colours of the quality known as Ku Yüeh Hsuan. This piece is thought to have been decorated in the Palace workshops, although the body was made in Ching-te Chen. Mid-18th century.

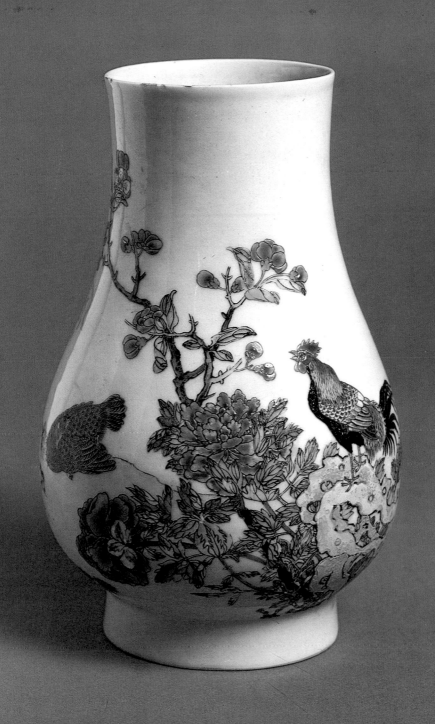

145 Porcelain vase in the form of a European glass bottle, decorated with underglaze blue. From Ching-te Chen. Mid- to late 17th century.

design. This was particularly strong during the Yung Cheng reign (1723–35) when it took the form of very fine quality Sung-style stoneware (of the Ju and Kuan type), and of inlaid bronze work. The combination of more colourful decoration and sober archaistic designs was in accord with eighteenth-century European taste. As a result, craftwork from China became part of a growing trade with Europe, where a fascination with all things Oriental led to the flowering of Chinoiserie.

The K'ang Hsi palace in Peking was rebuilt and fully painted in bright colours, as it is today, and its gardens were laid out. The Manchus loved bright colours and this influenced court costume and the development of Ch'ing styles of embroidery. Jade carving was of high quality and it became

146 Bronze cup and saucer decorated with 'Canton' enamel. The technique of firing enamel painting on metal was popular both at the court and for export. Such strikingly foreign decoration, derived from a European print, reflects the contemporary court taste for the exotic. 18th century.

increasingly flamboyant towards the reign of the Ch'ien Lung Emperor (1736–95). Once again semi-precious stones were used in inlay, in a style close to that of the Mughul jade workers. Indeed, there is a tendency in all the applied arts of this period towards exoticism, either through the use of more elaborate decoration or, more subtly, through the introduction of strange and unfamiliar forms. This was perhaps the result of the introduction of European workmen to the court, who brought about a sort of Chinoiserie in reverse.

There had been Jesuits at the Chinese court since 1601, when Matteo Ricci was attached to the Wan Li court. K'ang Hsi received delegations of foreigners and allowed a group of Jesuits to settle in Peking. He showed interest in the European painted enamels and decorated articles – mirrors, clocks and trinkets – which were presented to him. And he required his own craftsmen to produce similar work in the workshops set up in the north-west of the palace compound. There were also a number of Jesuit painters at court,

the most notable of whom was Giuseppe Castiglione (1688–1766), better known by his Chinese name of Lang Shih-ning. Castiglione had trained in Italy as an architect and painter; he became a valued servant of the Peking court where, by right of the favour shown him as a painter, he had the unenviable position of acting as intercessor for the Catholic Church in China in times of persecution. Castiglione or Lang Shih-ning adopted certain Chinese characteristics in his painting: he made use of the proportions of the scroll format and in his bird and flower paintings he employed compositional techniques current at the time. His drawing, however, was
147 Italian, as was his use of colour, light and shade, modelling and linear perspective, all of which seemed exotic and fascinating to the Chinese. His style became popular at court and was adopted by several Chinese painters. The result was a new 'realism' in painting which was at odds with all that Shih T'ao, Pa Ta Shan Jen or the Four Wangs stood for. Nevertheless, this type of realism became rooted in Chinese tradition and it further generated a school of decorative painting in the eighteenth and nineteenth centuries.

 Outside court circles, life was rich and independent in spirit. In flourishing districts such as Yangchow, Suchow and Nanking, artists and craftsmen found a ready market. A group of overtly commercially-minded painters, who were yet of the educated class, made their appearance in these centres. Advertising their work for sale and producing considerable quantities of small paintings, they made a good living from their work. These artists were grouped under the name of Eccentrics and were at some pains to create a memorable personal style. Although none of them was of the stature of Shih T'ao or Pa Ta Shan Jen, they were all to some extent innovators. Mei Ch'ing (1623–1697) was a friend and admirer of Shih T'ao. Using a brush stroke
148 reminiscent of the older man, he painted evocative fragments of windswept, remote landscapes. Hua Yen (1682–1755) painted horses and figures in
149 misty, windy weather, in much the same spirit. The effect of realistic immediacy, so rare in Chinese paintings, created by the evocation of weather, gives these eighteenth-century paintings a quality which is much out of character with the sense of timelessness sought by the classical painters.

147 (*above right*) Lang Shih-ning (Castiglione) (1688–1766), *Kazaks Presenting Tribute Horses to the Ch'ien Lung Emperor* (detail). Handscroll, ink and colour on paper. Another example of court taste, with its mixture of European and Chinese styles.

148 (*below right*) Mei Ch'ing (1623–1697), *Landscape in the Style of Ching Hao and Kuan T'ung*. Album leaf, ink and colour on paper. In the style of true romantic painting; all but the necessary elements are eliminated to produce a slight but vivid work.

高山流水搨名園
林香遮逕綠鳥雀喧
好友攜來遠命
酌須忘此處勝桃
源
倣荊關筆意
豐澤揚清平題

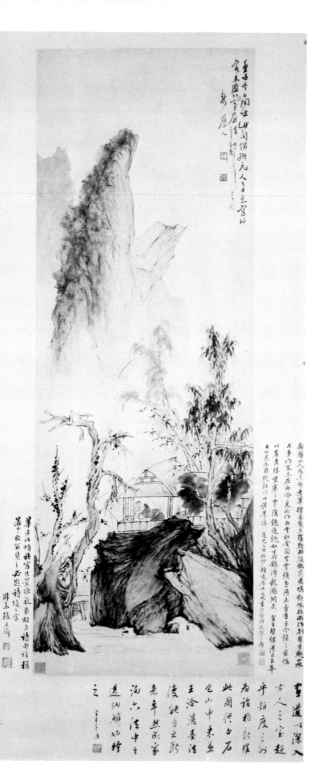

149 (*left*) Hua Yen (1682–1755), *Conversation in Autumn*. Ink and colour on paper, dated 1732. This also is a selective composition which takes the viewer back to Wang Fu (Pl. 126) and Pa Ta Shan Jen (Pl. 135), both in the composition and in the treatment of trees and rocks.

150 (*above*) Kao Ch'i-p'ei (*c.* 1672–1754), *The Four Seasons* (detail). Handscroll, ink and colour on paper. Drawn with a fingernail specially grown and used like a pen nib, a technique which Kao made his own towards the end of his life. The plum blossom and *ling-chih* fungus stand for spring.

Kao Ch'i-p'ei (*c.* 1672–1754), a Manchu who came south with the invasion, was a successful landscape painter who first worked in a meticulous, traditional style. Kao is recorded as worrying about his own originality, a quality presumably required of painters, for commercial reasons. Such unprecedented emphasis on originality makes one think that artists at this time were in a situation a little similar of that of the twentieth-century Western artist. Many other painters of the Chiang Nan area sought to break away from the old order, which had been gently eroded since the sixteenth century. Painters now exploited eccentricity of both subject and technique, while craftsmen exploited the appeal of technical pyrotechnics and weirdness of forms. In this climate, the solid scholar/patron/artist relationship, which had been the foundation of the artistic culture of China, seems to have lost its vitality and with it the capacity to create further. By the nineteenth century, as the fortunes of the state and private business declined, the position of the arts was in some disarray. By then, painters and craftsmen had become accustomed to supplying a rich but uninformed market, in which an eye-catching quality seemed all-important.

150

187

CHAPTER TWELVE
Conformity and Confidence
19th–20th centuries

Following the period of vitality and heightened creativity in painting and the applied arts, which was described in the previous chapter, artist and patron alike seemed to lose confidence by the beginning of the nineteenth century. The artist found himself in a situation of excessive dependence on a market or a patron. The Ch'ing court of the nineteenth century was not one of cultural distinction, and it provided little inspired patronage. Craftsmen too produced work of mixed quality and little originality; the general tendency was towards repetition, or mere elaboration. At this low ebb in the arts, even the scholar-painters seemed to lose confidence and to turn to a style of painting which, while traditional, tried too hard to conjure up some vitality by making use of emphatic brushwork and heavy ink.

157 There were, however, certain individuals whose work had strength and quality. One such was Jen Po-nien (1840–1895) who came from Chekiang and moved to Shanghai where he became one of the leading members of the White Lotus Society of painters. He painted bird and flower pictures in ink and colour on paper or silk. His distinctive style is recognized by a staccato brush style and by abrupt movement in his compositions. The compositions themselves are of traditional Ming style, balanced by strong diagonals and by the stabbing brushwork. Jen Po-nien's colour is rich and decorative and it gives an added appeal to his work. In lesser hands, Jen Po-nien's manner produced a bland style of spurious energy characterized by the use of bright colour and heavy ink tones.

At the end of the nineteenth century, during the reigns of the Kuang Hsu Emperor and, later, under the influence of the Empress Dowager Tzu Hsi, there was a short revival of the arts at court marked by active patronage and extensive palace building, notably the building of the present Summer Palace. The revival of decorative arts was in the style of the late eighteenth century (late Ch'ien Lung period), but lacked the finesse of the earlier period;
152 in porcelain decoration, for instance, an emphatic black line was used, giving the polychrome overglaze decoration a heavy and sometimes garish

151 Light metal hairpin with tremblant flower decoration set with pearls, semi-precious stone and kingfisher feather. Part of a hair ornament which might have been worn with a gown in the style of Pl. 153.

188

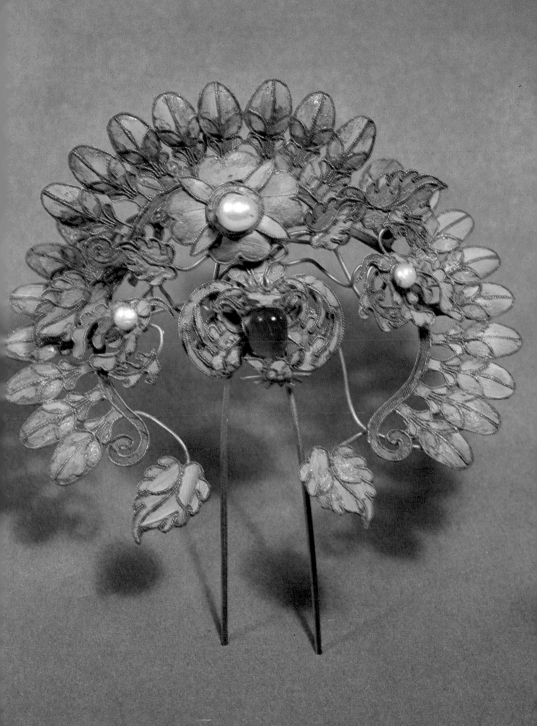

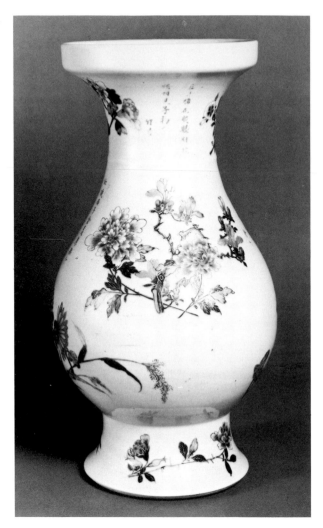

152 Porcelain vase with pink, gold and black decoration. Both the shape and the decoration of this piece are characteristic of the late 19th and early 20th century. From Ching-te Chen.

appearance. Much of the Chinese art seen in English country houses dates from this period. Bronze work too was heavy, archaistic in style and often of rough workmanship, while lacquer and ivory carvings were elaborate and ornate. Textiles and costumes made use of the newly introduced aniline dyes and were complemented by flamboyant jewellery. Excessive attention to

153
151

190

153 Silk gown with a design of butterflies and flowers, made for the Empress Tzu Hsi. This richly embroidered informal robe would have been worn over and indeed under other silk gowns and jackets. Late 19th or early 20th century.

technical accomplishment was not balanced by the discerning taste of preceding centuries, and the resulting work, while representing a technical *tour de force*, was over-executed and clumsy by comparison.

In the early twentieth century painters joined together in societies, one of the most influential being the White Lotus Society of Shanghai, mentioned

154 (*left*) Fu Pao-shih (1904–1965), *Mountain Landscape*. Ink and colour on paper, dated 1944. The surface of the paper is roughened and much of the ink texture is due to an uneven absorbency and spread. (See p. 198)

155 (*above*) An appreciation of Fu Pao-shih. Calligraphy by the writer and scholar Kuo Mo-jo (d. 1979). This is a fine example of modern calligraphy, reading from left to right horizontally. The composition of the page is considered, and the scale and weight of characters is emphasized towards the foot of the page.

156 Wu Ch'ang-shih (1844–1927), *Rocks and Flowers*. Ink and colour on paper, dated 1918. A somewhat over-blown composition with rich ink and bright colour in a style popular today.

157 Jen Po-nien (1840–1895), *Hibiscus and Flying Kingfishers*. Ink and colour on paper, dated 1894. A small painting in 'boneless' style, i.e. without outlines.

above. Wu Ch'ang-shih (1844–1927) was one of the leading members of the 156
society at this time. In many ways he was a close follower of Jen Po-nien, his 157
older contemporary. His personal style of heavy and strong brushwork, rich
colour and strong calligraphy seems to epitomize the turn-of-the-century
style. His use of a Ch'an style in his ink works, and his method of
composition in his flower paintings, often in large format, influenced many
later painters. A younger contemporary of his, Huang Ping-hung
(1864–1955), came from Anhui, but moved to Shanghai in 1908. He painted

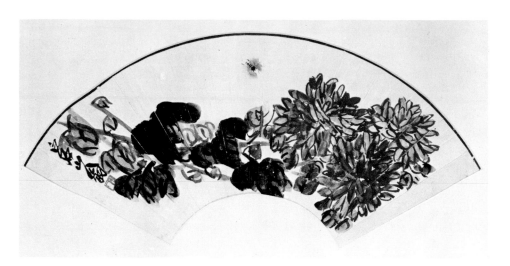

158 Ch'i Pai-shih (1863–1957), *Chrysanthemum and Bee*. An unmounted fan painted in colour on paper. Although this work dates from the artist's later years, the style is still close to that of Wu Ch'ang-shih (Pl. 156).

landscapes in ink, and in ink and colour. His work is executed in a free and self-assured manner and his composition is derived from the Wu School tradition; he often makes use in his paintings of cloud passages which break the transitions from middle to back ground. Huang seemed to be the natural successor to K'un Ts'an. These two painters generated styles which persisted through the experiments which came later. Ch'i Pai-shih (1863–1957) must also be mentioned here, as he was their contemporary and a close follower of Wu Ch'ang-shih. Ch'i came from the Changsha area and he was of very humble origins. He made his reputation as a bird and flower painter and he also painted insects, which made him a legend in his lifetime. He was a skilled professional painter by training, painting portraits and household decorations. He was self-educated and he developed his personal style after he had moved to Peking; this style was varied, sometimes combining exquisitely painted insects with bold Ch'an-style painting.

158

As the Imperial system broke down and successive political changes were taking place, many diverse influences were at work in China. Not only was Western culture imported, but Chinese artists started travelling abroad, to Japan and to the West, especially to France and Germany. Some of these painters made reputations overseas, as did Hsu Pei-hung (1896–1953), who painted in Paris under the name of Ju Peon. Most of these travellers returned home in the 1930s and many European-inspired experiments were tried out in China. Western-style art schools, where life-drawing and oil-painting were taught, were set up in Shanghai, Nanking and Peking, and still-life

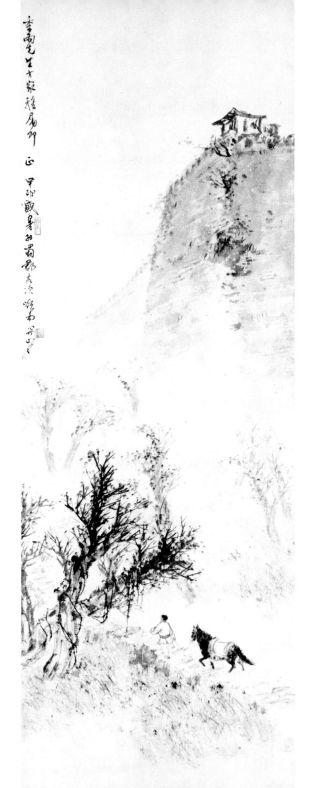

159 Kuan Shan-yüeh (contemporary), *Man with Horse on Steps*. Pale colour and ink on paper, dated 1934. The picture employs a fixed perspective relieved by mist to enhance the overpowering city wall.

197

painting and huge history paintings of the Water Margin stories were undertaken. For the present, at least, this Westernizing movement must be seen as short-lived and as having left little impression. The Chinese painters who went to Japan returned with styles and techniques much closer to their own, but with a new sense of freedom in their use of papers and texture.

Ch'i Pai-shih may be taken as representative of those artists who stayed in China developing a style based partly on Ch'an, partly on more academic models, but one rooted in eighteenth- and nineteenth-century traditions of painting. Of the artists who travelled abroad, Hsu Pei-hung experimented with a hybrid style, part Western-academic, part Chinese, which, however, has not developed any further. Lin Feng-mien (born 1901), who also travelled to Paris, was more influenced by Matisse and the Western colourists; his style is also hybrid, but distinctive and personal. Fu Pao-shih (1904–1965), who went to Japan, developed a wide range of styles ranging from T'ang figure painting to a more personal landscape style evolving out of the Shih T'ao style – this is the style which has most influenced the work of the major artists of the mid-twentieth century. His great contemporary and collaborator was the Kwangtung artist, Kuan Shan-yüeh. Li K'o-jan is one of the most popular painters of the present day and his work shows many of the features of mid-twentieth-century art: the use of strong line and of a solidly balanced composition, and also of decorative colour. This style owes much to a vogue for woodblock prints in the 1920s and 1930s. At that time, societies were formed, inspired by the popular enthusiasm for the art of woodblock cutting and printing; prints became an important medium partly because of their use as political tools and partly through the rejuvenation of the craft through the introduction of a foreign woodblock style. The Chinese had a well-established and highly skilled tradition of woodblock printing, but a new style, influenced by German prints, and particularly by the work of Georg Grosz and Käthe Kollwitz, was avidly taken up during the 1930s. In the wake of this new woodblock style, certain elements of Western composition found their way into Chinese painting, changing the traditional composition completely and resulting in a four-square proportion and a static quality quite new to Chinese art.

With so much innovation and experimentation in the arts taking place everywhere else in the world, it is interesting that Chinese painting, on the whole, has remained self-sufficient within its own traditions. It has not

160 Li K'o-jan (contemporary), *Landscape Based on Chairman Mao's Poem*. Ink and slight colour on paper, 1960s. The heavy ink style is very characteristic of the artist. The blocking-in of the rectangular frame and the very high view derive from print design techniques.

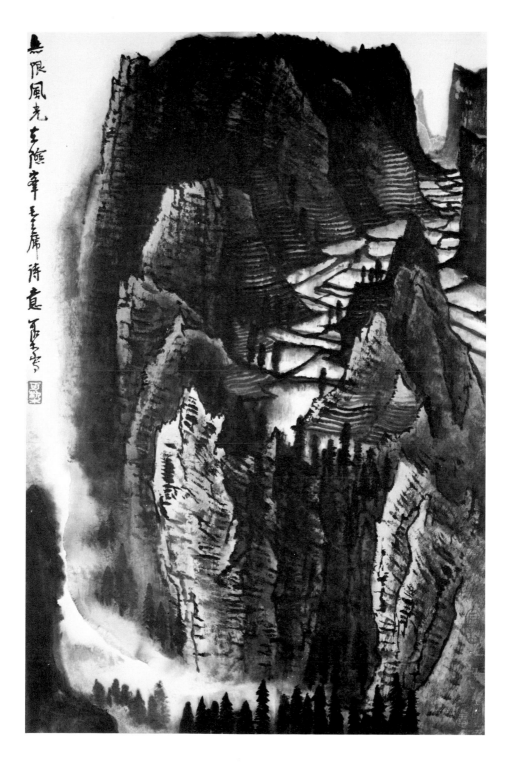

followed, for example, the same course as Japanese painting, to which, in some ways, it is closely related: there seems, for the present, to be no place in Chinese painting for pure abstraction. Outside China, some Chinese artists have painted abstract works successfully. But the weight of a long tradition of art within the country seems to be greater than that of international art trends. Lui Shou-kwan, a traditionally trained Cantonese painter working in Hong Kong, has struggled with the problems involved in finding his own style, and he moved naturally towards abstraction; but the moment he achieved it he found that he lost impetus in his painting and he has had, repeatedly, to return to a representational theme to regain momentum. This experience serves perhaps as a general comment on a situation and a sensibility which earlier painters had confronted: Chinese painting has sought a balance between abstraction and representation for many centuries and therein lies much of its fascination.

161

161 Lui Shou-kwan (d. 1977), *Island Landscape*. Ink on paper, dated 1961. While retaining much from classical tradition, this semi-abstraction of the island landscape of Hong Kong demonstrates the balance sought by Chinese artists between abstraction and representation.

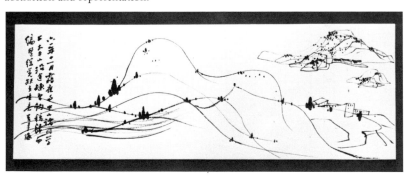

Selected Bibliography

General

R. Dawson (ed.), *The Legacy of China*, Oxford, 1964
A. Herrmann, *An Historical Atlas of China*, new ed., Edinburgh, 1966
Sherman E. Lee, *A History of Far Eastern Art*, revised ed., New York, 1974 and London, 1975
L. Sickman and A. Soper, *The Art and Architecture of China*, 3rd ed., Harmondsworth, 1968
M. Sullivan, *The Arts of China*, revised ed., Berkeley, Los Angeles and London, 1977
W. Watson, *Style in the Arts of China*, Harmondsworth and Baltimore, 1974
W. Willetts, *Foundations of Chinese Art*, London and New York, 1965

Early Periods

K.C. Chang, *The Archaeology of Ancient China*, 3rd ed., New Haven, 1977
T.K. Cheng, *Archaeology in China*, 4 vols, Cambridge and Toronto, 1959–66
J. Rawson, *Ancient China: Art and Archaeology*, London, 1980
W. Watson, *Archaeology in China*, London, 1960
—, *Early Civilisation in China*, London and New York, 1966
—, *Cultural Frontiers in Ancient East Asia*, Edinburgh, 1971

Journals: *Wen Wu*, Peking (monthly)
Kaogu, Peking (monthly)
Kaogu Xuebao, Peking (quarterly)

Bronzes

W. Watson, *Ancient Chinese Bronzes*, London and Vermont, 1962

Ceramics

H. Garner, *Oriental Blue and White*, London, 1954
G. St G. Gompertz, *Chinese Celadon Wares*, London, 1958
Soame Jenyns, *Ming Pottery and Porcelain*, London, 1953 and New York, 1954
—, *Later Chinese Porcelain: The Ch'ing Dynasty 1644–1912*, 4th ed., London, 1971
D. Lion-Goldschmidt, *Ming Porcelain*, London and New York, 1978
M. Medley, *The Chinese Potter*, Oxford and New York, 1976
—, *Yüan Porcelain and Stoneware*, London, 1974
S. Valenstein, *A Handbook of Chinese Ceramics*, New York, 1975
N. Wood, *Oriental Glazes*, London and New York, 1978

Painting

J. Cahill, *Chinese Painting*, Geneva, 1960
—, *Hills Beyond a River: Chinese Painting of the Yüan Dynasty*, New York and Tokyo, 1976
—, *Parting at the Shore: Chinese Painting of the Early and Middle Ming*, New York and Tokyo, 1978
M. and S. Fu, *Studies in Connoisseurship: Chinese Paintings in the Arthur M. Sackler Collection*, Princeton, 1973
O. Sirén, *Chinese Painting*, 7 vols, London and New York, 1956–58
M. Sullivan, *The Three Perfections: Chinese Painting, Poetry and Calligraphy*, London, 1974
—, *Chinese Art in the 20th Century*, Berkeley and London, 1959

Sculpture

T. Akiyama, *Arts of China*, Vol. II: *Buddhist Cave Temples*, Tokyo and Palo Alto, 1969

Lacquer and Enamel

M. Beurdeley, D. Lion-Goldschmidt, S. Jenyns and W. Watson, *Chinese Art*, 3 vols, London, 1963–65
H. Garner, *Chinese and Japanese Cloisonné Enamels*, London and Vermont, 1962
—, Chinese Lacquer, London, 1979

Architecture etc.

A. Boyd, *Chinese Architecture and Town Planning 1500 BC–AD 1911*, Chicago and London, 1962
M. Keswick, *The Chinese Garden*, London and New York, 1978

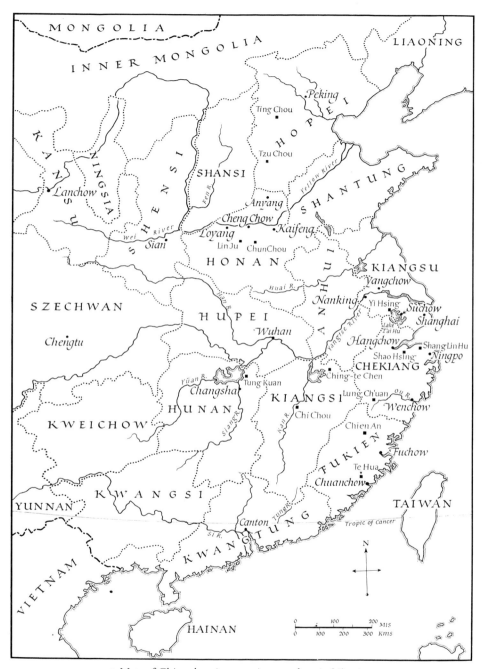

1 Map of China showing provinces and main kiln sites.

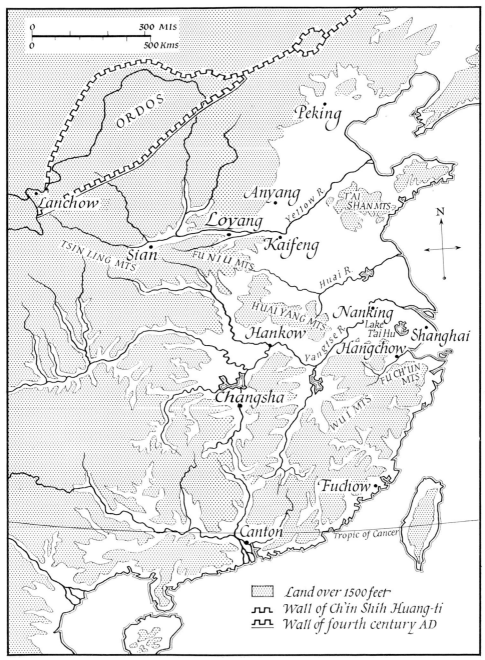

2 Relief map of China.

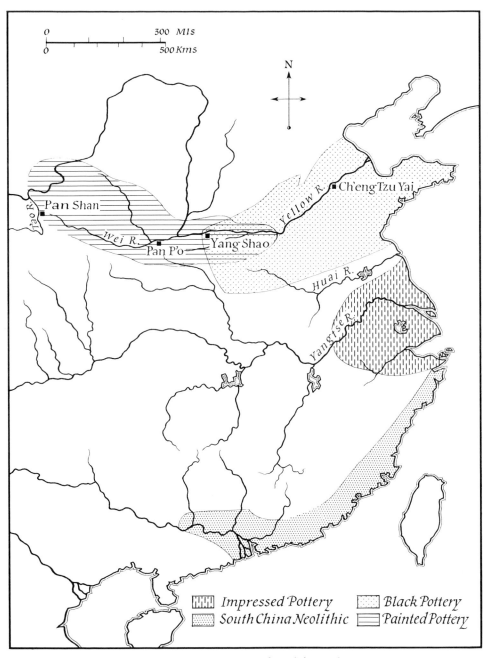

N

0 300 MIs
0 500 Kms

Pan Shan

Ch'engTzuYai

Yellow R.

Tao R.

Wei R.

Pan P'o

Yang Shao

Huai R.

Yangtse R.

Impressed Pottery **Black Pottery**
South China Neolithic **Painted Pottery**

3 Map showing main areas of Neolithic settlement.

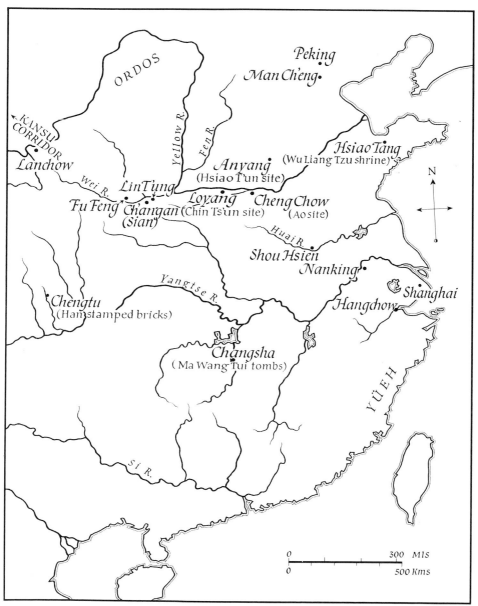

ORDOS

Peking

Man Ch'eng

KANSU CORRIDOR

Yellow R.

Fen R.

Hsiao Tang
(Wu Liang Tzu shrine)

Lanchow

Wei R.

Anyang
(Hsiao T'un site)

N

LinTung

Loyang
(Chin Ts'un site)

Cheng Chow
(Ao site)

Fu Feng Ch'angan
(Sian)

Huai R.

Shou Hsien

Nanking

Chengtu
(Han stamped bricks)

Yangtse R.

Shanghai

Hangchow

Changsha
(Ma Wang Tui tombs)

YÜEH

Si R.

| 0 | | 300 MIS |
| 0 | | 500 Kms |

4 Map showing Bronze Age and Han Dynasty sites.

5 (*overleaf*) Map showing Buddhist cave temple sites.

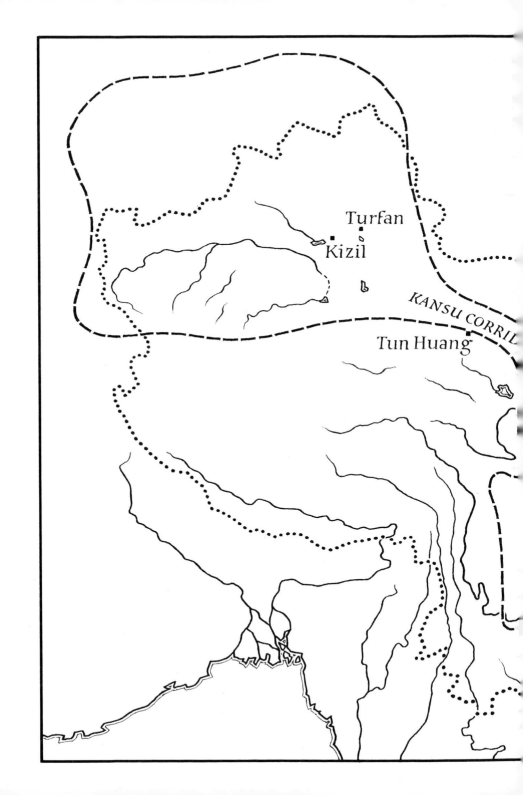

Turfan

Kizil

KANSU CORRIL

Tun Huang

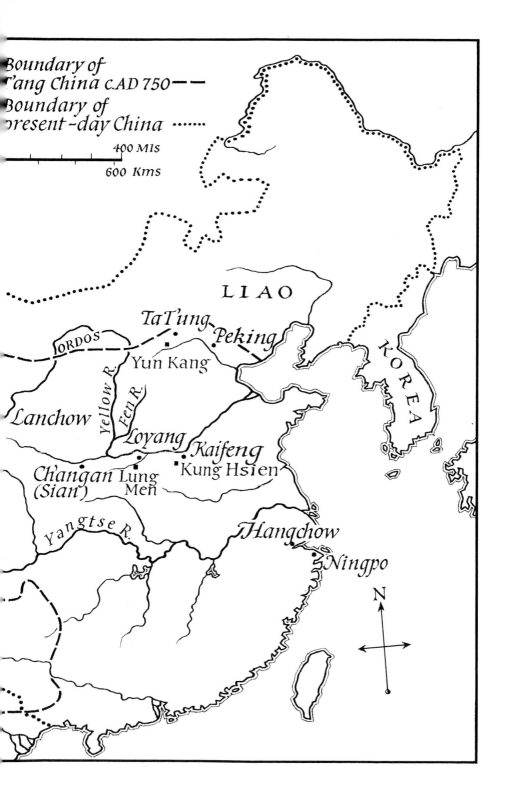

Boundary of
T'ang China c.AD 750 ———
Boundary of
present-day China ·······

400 MIs
600 Kms

L I A O

TaT'ung
Peking

ORDOS

Yun Kang

Yellow R.

Fen R.

Lanchow

Loyang
Kaifeng

Ch'angan
(Sian)
Lung
Men
Kung Hsien

Yangtse R.

KOREA

Hangchow
Ningpo

N

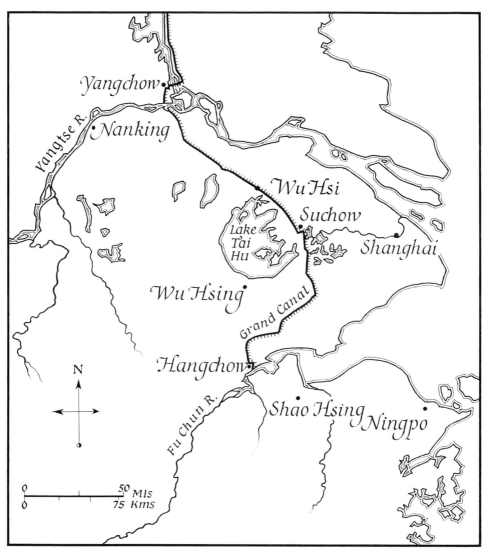

6 Map of the Chiang Nan region.

List of Illustrations

Measurements are given in inches followed by centimetres, height preceding width preceding depth, unless otherwise indicated

(27·9). Ashmolean Museum, Oxford.

35 Ordos style bronze plaque showing tiger and tree. 4th–3rd century BC. 2½ × 3⅞ (6·2 × 9·9). British Museum, London.

36 Li script with heavy serif, in ink on wooden strip. From Yumen, Kansu. AD. 100. 4¾ × 2½ (12 × 6·5). British Museum, London.

37 Pottery burial jars from sites in the Kansu region. 3rd–2nd millennium BC. British Museum, London.

38 Bronze vessel, chüeh. 13th–12th century BC. H. 8½ (21·6). Ashmolean Museum, Oxford.

39 Painted brick from the frieze of a tomb near Loyang (detail). Han. 7½ × 13¾ (19 × 35). Museum of Fine Arts, Boston.

40 Drawing of funerary banner from the Ma Wang Tui tombs, Changsha. Mid-2nd century BC. People's Republic of China.

41 Lower portion of banner from the Ma Wang Tui tombs, Changsha. Mid-2nd century BC. People's Republic of China.

42 Bronze mirror back with cosmic motifs. Han. D. 5½ (14). Barlow Collection, University of Sussex. Photo Jeff Teasdale.

43 Stone relief carving of a concert in a palace. From a funerary chapel at Ching Ping Hsien, Shantung. c. AD. 114. Metropolitan Museum of Art, New York (Rogers Fund, 1920).

44 Battle on a bridge (detail). Rubbing of a stone relief from the Wu Liang Tzu shrine, Shantung. AD. 147–168. H. 30¾ (78). Photo courtesy School of Oriental and African Studies, London.

45 Rubbing of a stamped brick from Chengtu, Szechwan, showing hunting and reaping scenes. Late Han. H. 16½ (42). People's Republic of China.

46 Stamped brick from Chengtu, Szechwan, showing a teacher with students. Late Han. Szechwan Provincial Museum.

47 Grey earthenware standing tomb figure of a servant. Probably Han. H. 30 (76·2). Ashmolean Museum, Oxford.

48 Unglazed pottery tomb model of a farmhouse. From Canton. Han. H. 9¼ (23·5). Ashmolean Museum, Oxford.

49 Pair of cast bronze wrestlers or acrobats. Late Chou or early Han. 6 × 6 (15·3 × 15·3). British Museum, London.

50 Gilt bronze mirror box, lien. Han. D. of lid 7 (17·8). Victoria and Albert Museum, London.

51 Bronze hill censer with gold and silver inlays. From the tomb of Prince Liu Sheng, Man Ch'eng, Hopei. Late 2nd century BC. H. 10¼ (26). People's Republic of China.

52 Gilt bronze oil lamp in the form of a kneeling servant girl. From the tomb of Princess Tou Wan, Man Ch'eng, Hopei. c. 2nd century BC. H. 18⅞ (48). People's Republic of China.

53 Large stoneware storage jar with incised decoration and green glaze. Han. H. 23 (58·4). Ashmolean Museum, Oxford.

54 Bronze horse poised on a flying swallow. From Wu-wei, Kansu. 2nd century BC. 13⅝ × 17¾ (35·4 × 45). People's Republic of China.

55 Projection and plans of the Horyuji, Nara, Japan. 7th century. From R.T. Paine and A. Soper, The Art and Architecture of Japan, Harmondsworth, 1974.

56 Section and elevation of the Fo Kuang Ssu hall on Mount Wu T'ai. Mid-9th century. From L. Sickman and A. Soper, The Art and Architecture of China, Harmondsworth, 1968.

57 Detail of bracketing and eaves of the Fo Kuang Ssu. From L. Sickman and A. Soper. The Art and Architecture of China, Harmondsworth, 1968.

58 Interior of cave no. 428, Tun Huang, Kansu. 5th century.

59 General view of part of the caves at Yun Kang, Shensi. Photo courtesy Lawrence Sickman.

60 Colossal red sandstone Buddha with attendant Buddha, Yun Kang. H. of colossal Buddha 45 ft (13·7 m). c. 460–470. Photo British Museum, London.

61 Seated Buddha with Bodhisattva at the Si Ku Ssu, Yun Kang. 460–494. Photo Werner Forman Archive.

62 Detail of a relief from cave 6, Yun Kang. Second half of 5th century. Photo Werner Forman Archive.

63 Grey limestone carving of a celestial musician. Probably from Lung Men, Honan. Early 6th century. H. 25¼ (64·1). Victoria and Albert Museum, London.

64 The Paradise of Amitabha. Silk painting from Tung Huang. 8th century. 54·7 × 40 (139 × 101·7). British Museum, London.

65 Detail from the murals in the tomb chamber of Princess Yung T'ai, near Ch'angan. 706. H. 75½ (192).

66 The colossal Buddha at the Feng Hsien Ssu, Lung Men, Honan. 672 and 675. H. of Buddha 50 ft (15·2 m). Photo Werner Forman Archive.

67 Central lotus boss of the Lien Hua Tung, Lung Men. 6th century. Photo Werner Forman Archive.

68 The Emperor Ming Huang Travelling in Shu. Colour on silk. Later copy of 8th-century original. 21¾ × 31 (55·9 × 81). Collection of National Palace Museum, Taipei, Taiwan, Republic of China.

69 Standing Buddha with attendants at the Ping Yang Tung, Lung Men. c. 523. Photo Werner Forman Archive.

70 Colossal marble standing Amitabha Buddha. Found at Hsiang-pei near Ting Chou, Hopei. 585. H. 216 (548·6). British Museum, London.

71 Headless marble statue of a Bodhisattva. From Lung-yen-shan, Pao-ting, Hopei. *c.* 670. H. 73 (185·4).

72 Detail of incised carving on a limestone sarcophagus. *c.* 525. 24½ × 88 (62·2 × 223·5). Nelson Gallery-Atkins Museum, Kansas City, Missouri.

73 Ku K'ai-chih (*c.* 344–*c.* 406), *The Nymph of the Lo River* (detail). Handscroll, ink and colour on silk. Later copy. H. 21⅛ (53·6). British Museum, London.

74 Ku K'ai-chih (*c.* 344–*c.* 406), *Admonitions of the Instructress to the Court Ladies* (detail). Handscroll, red and black ink on silk. 9⅞ × 136⅝ (25 × 347). British Museum, London.

75 Three-colour lead glazed earthenware dish. 8th century. D. 14 (35½). Victoria and Albert Museum, London.

76 Ju ware vase with copper rim. 12th century. H. 9¾ (25). Percival David Foundation of Chinese Art, London.

77 Chao Meng-fu (1254–1322), *Autumn Colours on the Ch'iao and Hua Mountains* (detail). Handscroll, ink and light colour on paper. 1295. H. 11⅛ (28·4). Collection of National Palace Museum, Taipei, Taiwan, Republic of China.

78 Rubbing of incised decoration from the sarcophagus of the Princess Yung T'ai tomb, Ch'angan. 706. 53½ × 31⅞ (136 × 81).

79 Bodhisattva flying on a cloud. Ink painting on hemp. 8th century. 52 × 54 (132 × 137·2). Shosoin, Nara, Japan.

80 Yüeh ware water pot. From Shang Lin Hu, Chekiang. 10th century. H. 3¼ (8·3). Ashmolean Museum, Oxford.

81 Northern white ware indented jar. Possibly from the Ting Chou region. 10th century. H 8½ (21·6). Ashmolean Museum, Oxford.

82 Pair of shallow silver bowls and covers with chased and gilt decoration. *c.* 750–850. D. 9½ (24·1). Seattle Art Museum (Eugene Fuller Memorial Collection).

83 Bronze mirror back decorated in silver and covered with a thin sheet of gold. Mid-8th century. Courtesy of Smithsonian Institution, Freer Gallery of Art, Washington D.C.

84 Stoneware pilgrim flask with brown glaze and moulded decoration. Mid-8th century. 8⅝ × 7½ (21·9 × 19). Victoria and Albert Museum, London.

85 Fragment of woven silk with a design of wine drinkers. From Astana, near Turfan, Sinkiang. 8th century. L. 5 (12·8). People's Republic of China.

86 Earthenware tomb model of a saddled camel with cream, green and yellow glazes. 8th century. H. 32½ (82·5). British Museum, London.

87 Detail of lacquer landscape painting on the face of a *p'i-pa*, a type of lute. 8th century. W. approx. 8¾ (22·2). Shosoin, Nara, Japan.

88 Tung Yüan (*fl.* 947–970), *Festival for Evoking Rain*. Ink and slight colour on silk. 61¾ × 63½ (156·8 × 161·3). Collection of National Palace Museum, Taipei, Taiwan, Republic of China.

89 Chu Jan (*fl. c.* 960–980), *Seeking the Tao in the Autumn Mountains*. Ink on silk. 61½ × 30¾ (156·2 × 78·1). Collection of National Palace Museum, Taipei, Taiwan, Republic of China.

90 Fan K'uan (*c.* 950–1050), *Travelling in Streams and Mountains*. Ink and slight colour on silk. 61 × 29¼ (154·9 × 74·3). Collection of National Palace Museum, Taipei, Taiwan, Republic of China.

91 Kuo Hsi (*c.* 1020–1090), *Early Spring*. Ink and slight colour on silk. 62¼ × 42⅝ (158·1 × 108·7). Collection of National Palace Museum, Taipei, Taiwan, Republic of China.

92 Hsu Tao-ning (*fl.* 11th century), *Fishing in a Mountain Stream* (detail). Handscroll, ink on silk. 19 × 82½ (48·3 × 209·6). Nelson Gallery-Atkins Museum, Kansas City, Missouri.

93 Su Shih (1036–1101), *Cold Provisions Day*. Ink on paper. Detail of poem composed and written by Su Shih.

94 Shallow foliated Ting ware bowl. 11th–12th century. D. 8 (20·3). Ashmolean Museum, Oxford.

95 Chun ware dish of pale-blue glazed buff stoneware. 12th century. D. 6¾ (17·1). Ashmolean Museum, Oxford.

96 Pear-shaped stoneware vase with an almost black glaze. Probably from Honan. 12th–13th century. H. 10⅝ (27). Ashmolean Museum, Oxford.

97 Tzu Chou stoneware pillow. 12th century 6 × 17 × 6¾ (15·2 × 43·2 × 17·1). Victoria and Albert Museum, London.

98 Emperor Hui Tsung (1082–1135), *Five-coloured Parakeet on a Branch of Apricot Blossom*. Handscroll, colour on silk. H. 20⅞ (53). Museum of Fine Arts, Boston (Maria Antoinette Evans Fund).

99 Chang Tse-tuan (late 11th–early 12th century), *Life Along the River on the Eve of the Ch'ing Ming Festival* (detail). Handscroll, ink and slight colour on silk. H. 10 (25·5). Collection of Palace Museum, Peking.

100 Hsia Kuei (*fl.* 1180–1230), *Pure and Remote Views of Hills and Streams* (detail). Handscroll, ink on paper. H. 18¼ (46·5). Collection of National Palace

Museum, Taipei, Taiwan, Republic of China.

101 Ma Yüan (*fl.* 1190–1225), *On a Mountain Path in Spring* (detail). Album leaf, ink and light colour on silk. H. 10¾ (27·4). Collection of National Palace Museum, Taipei, Taiwan, Republic of China.

102 Ma Lin (*fl.* early 13th century), *Waiting for Guests by Lamplight*. Album leaf, ink and colour on silk. 9¾ × 9⅞ (24·8 × 25). Collection of National Palace Museum, Taipei, Taiwan, Republic of China.

103 Mu Ch'i (active 1269), *White-robed Kuan-yin*. Ink on silk. 56 × 38 (142×96). Daitokuji, Kyoto. Photo courtesy School of Oriental and African Studies, London.

104 Mu Ch'i (active 1269), *Persimmons*. Ink on paper. 15 × 14¼ (36·2 × 38·1). Daitokuji, Kyoto.

105 Liang K'ai (*c.* 1140–1210), *Ch'an Priest*. Ink on paper. 19¼ × 10⅞ (48·7×27·6). Collection of National Palace Museum, Taipei, Taiwan, Republic of China.

106 Ying Ch'ing impressed porcelain bowl. From Ching-te Chen. 13th–14th century. D. 6¾ (17·1). Ashmolean Museum, Oxford.

107 Lung Ch'uan celadon bowl with lotus petal relief decoration. 13th–14th century. D. 5¾ (14·6). Ashmolean Museum, Oxford.

108 Temmoku ware tea bowl of the 'hare's fur' type. From Chien An, Fukien. 13th–14th century. D. 4 (10·2). Ashmolean Museum, Oxford.

109 Gilt bronze Bodhisattva. Sung. H. 7½ (19). Ashmolean Museum, Oxford.

110 Parakeet on a cherry twig. Woven silk tapestry (*k'o ssu*). 13th century. 10 × 12 (25·4 × 30·5). Museum of Fine Arts, Boston.

111 Ch'ien Hsuan (*c.* 1235–1301), *Squirrel on a Peach Bough*. Ink and colour on paper. 10¼ × 17¼ (26 × 43·8). Collection of National Palace Museum, Taipei, Taiwan, Republic of China.

112 Huang Kung-wang (1269–1354), *Wandering in the Fu Ch'un Mountains* (detail). Handscroll, ink on paper. 1350. H. 13 (33). Collection of National Palace Museum, Taipei, Taiwan. Republic of China.

113 Wu Chen (1280–1354), *Fishermen*. Handscroll, ink on paper. 1352. 12¾ × 211⅞ (32·5 × 562·2). Courtesy of Smithsonian Institution, Freer Gallery of Art, Washington D.C.

114 Ni Tsan (1301–1374), *The Jung Hsi Studio*. Ink on paper. 28¾ × 13¾ (73×34·9). Collection of National Palace Museum, Taipei, Taiwan, Republic of China.

115 Wang Meng (1308–1385), *Thatched Halls on Mount T'ai*. Ink and colour on paper. 43⅞ × 13¾ (111·4×34·8). Collection of National Palace Museum, Taipei, Taiwan, Republic of China.

116 Iron underglaze decorated stoneware dish.

Perhaps from Chi Chow, Kiangsi. 14th century. D. 18 (45·7). Ashmolean Museum, Oxford.

117 Large porcelain dish decorated in underglaze blue. From Ching-te Chen. Late 14th century. D. 18¼ (46·4). Ashmolean Museum, Oxford.

118 Pear-shaped vase with underglaze copper-red decoration. From Ching-te Chen. 14th century. H. 12 (30·5). Ashmolean Museum, Oxford.

119 Ying Ch'ing porcelain figure of a seated Kuan-yin. From Ching-te Chen. 1298 or 1299. 20¼ × 12 × 7¾ (51·4 × 30·5 × 19·7). Nelson Gallery-Atkins Museum, Kansas City, Missouri.

120 The Forbidden City, Peking. General view of one of the inner courtyards of the Palace. 15th-century foundation. Photo Werner Forman Archive.

121 The Forbidden City, Peking. View of the canal and covered way leading to the side of the main halls. 15th-century foundation. Photo Werner Forman Archive.

122 The Temple of Heaven, near Peking. Late Ch'ing period. Photo Russell A. Thompson.

123 Interior of the ceremonial hall at the Ming Tombs outside Peking. 15th-century foundation. Photo Werner Forman Archive.

124 Marble camels on the Spirit Way, a road leading to the Ming Tombs at Nanking. Photo Werner Forman Archive.

125 Tai Chin (1388–1452), *Returning Home at Evening* (detail). Hanging scroll, ink and slight colour on silk. 73⅞ × 36⅛ (187×92). Collection of National Palace Museum, Taipei, Taiwan, Republic of China.

126 Wang Fu (1362–1416), *Farewell Meeting at Feng Ch'eng*. Ink on paper. 36 × 12¼ (91·4 × 31). Collection of National Palace Museum, Taipei, Taiwan, Republic of China.

127 Shen Chou (1427–1509), *Poet on a Clifftop* Album leaf, ink on paper. 15¼ × 23¾ (38·7 × 60·3). Nelson Gallery-Atkins Museum, Kansas City, Missouri.

128 Wen Cheng-ming (1470–1559), *Lofty Leisure Beneath a Sheer Cliff* (detail). Large hanging scroll, ink and colour on paper. 58⅝ × 70 (148·9 × 177·9). Collection of National Palace Museum, Taipei, Taiwan, Republic of China.

129 Chou Chen (*fl.* late 15th century), *Taoist Scholar Dreaming of Immortality* (detail). Handscroll, ink and slight colour on paper. H. 11⅛ (28·3). Courtesy of Smithsonian Institution, Freer Gallery of Art, Washington D.C.

130 Ch'iu Ying (*c.* 1494–*c.* 1552), *Fishing Boat by a Willow Bank*. Colour on silk. 40½ × 18½ (102·9 × 47·2). Collection of National Palace Museum, Taipei,

Taiwan, Republic of China.

131 Ch'en Hung-shou (1599–1652), *Lady Hsuan Giving Instruction in the Classics* (detail). Colour on silk. 68⅜ × 21⅞ (188 × 55·6). Cleveland Museum of Art (Purchase Mr and Mrs William H. Marlatt Fund).

132 White porcelain figure of a Kuan-yin carrying a basket of fish. From Te Hua, Fukien. 17th century. H. 16 (40·6). Ashmolean Museum, Oxford.

133 Tung Ch'i-ch'ang (1555–1636), *Landscape*. Ink on paper. 37⅝ × 16¼ (95·5 × 41·3). British Museum, London.

134 The Wang Shi Yüan garden, Suchow. Photo Peter Hayden.

135 Pa Ta Shan Jen (Chu Ja) (1626–1705), *Landscape in the Manner of Tung Yüan*. Ink on paper. 70⅞ × 36⅞ (180 × 93·5). Östasiatiska Museet, Stockholm.

136 Shih T'ao (1630–1707), *The Peach Blossom Spring* (detail). Handscroll, ink on colour over paper. 9⅞ × 62¼ (25 × 157·8). Courtesy of Smithsonian Institution, Freer Gallery of Art, Washington D.C.

137 Red lacquer covered box carved with a design of camellia sprays. First half of 15th century. D. 8¾ (22·2). Victoria and Albert Museum, London.

138 Pien Wen-chin (fl. c. 1400–30), *Three Friends and One Hundred Birds*. Ink and colour on silk. 1413. 59½ × 30¾ (151·3 × 78·1). Collection of National Palace Museum, Taipei, Taiwan, Republic of China.

139 K'un Ts'an (c. 1610–1693), *Autumn Landscape*. Handscroll, ink and slight colour on paper. 1666. 12⅜ × 25¼ (31·4 × 64·1). British Museum, London.

140 Moon flask of blue and white porcelain. From Ching-te Chen. 15th century. H. 12⅛ (30·7). Percival David Foundation of Chinese Art, London.

141 Overglaze decorated porcelain bowl. From Ching-te Chen. 16th century. D. 8¾ (22). Percival David Foundation of Chinese Art, London.

142 Wang Yüan-ch'i (1642–1715), *View of Mount Hua*. Ink and light colours on paper. 1693. 45⅝ × 19½ (115·9 × 49·7). Collection of National Palace Museum, Taipei, Taiwan, Republic of China.

143 *Famille verte* foliated porcelain bowl. From Ching-te Chen. Early 18th century. D. 6½ (16·5). Ashmolean Museum, Oxford.

144 Small porcelain vase decorated in *famille rose* colours. Mid-18th century. H. 7 (17·8). Ashmolean Museum, Oxford.

145 Blue and white porcelain vase in the form of a European glass bottle. From Ching-te Chen. Mid- to late 17th century. H. 9½ (24·1). Ashmolean Museum, Oxford.

146 Bronze cup and saucer decorated with 'Canton' enamel. 18th century. D. of saucer 5¾ (14·6).

Ashmolean Museum, Oxford.

147 Giuseppe Castiglione (1688–1766), *Kazaks Presenting Tribute Horses to the Ch'ien Lung Emperor* (detail). Handscroll, ink and colour on paper. 17¾ × 105⅛ (45 × 267). Musée Guimet, Paris. Photo Musées Nationaux, Paris.

148 Mei Ch'ing (1623–1697), *Landscape in the Style of Ching Hao and Kuan T'ung*. Album leaf, ink and colour on paper. 11¼ × 17¼ (28·6 × 44). Cleveland Museum of Art (Purchase John L. Severance Fund).

149 Hua Yen (1682–1755), *Conversation in Autumn*. Ink and colour on paper. 1732. 45⅜ × 15⅝ (115·3 × 39·7). Cleveland Museum of Art (Purchase John L. Severance Fund).

150 Kao Ch'i-p'ei (c. 1672–1754), *The Four Seasons* (detail). Handscroll, ink and colour on paper. H. 8¾ (22·2). Ashmolean Museum, Oxford.

151 Light metal hairpin set with pearls, semi-precious stone and kingfisher feather. H. 3 (7·6). Ashmolean Museum, Oxford.

152 Porcelain vase with pink, gold and black decoration. From Ching-te Chen. Late 19th or early 20th century. H. 16½ (41·9). Ashmolean Museum, Oxford.

153 Silk gown with a desigh of butterflies and flowers, made for the Empress Tzu Hsi. Late 19th or early 20th century. Royal Ontario Museum, Toronto.

154 Fu Pao-shih (1904–1965), *Mountain Landscape*. Ink and colour on paper. 1944. 43⅛ × 24⅛ (109·5 × 61·3). Ashmolean Museum, Oxford.

155 An appreciation of Fu Pao-shih. Calligraphy by Kuo Mo jo (d. 1979).

156 Wu Ch'ang-shih (1844–1927), *Rocks and Flowers*. Ink and colour on paper. 1918. 61¾ × 31½ (157 × 80). Private Collection.

157 Jen Po-nien (1840–1895), *Hibiscus and Flying Kingfishers*. Ink and colour on paper. 1894. 25⅞ × 18⅛ (65·6 × 46). Ashmolean Museum, Oxford.

158 Ch'i Pai-shih (1863–1957), *Chrysanthemum and Bee*. Unmounted fan, colour on paper. 7½ × 22 (19 × 55·9). Ashmolean Museum, Oxford.

159 Kuan Shan-yüeh (contemporary), *Man with Horse on Steps*. Pale colour and ink on paper. 1934. 44 × 15⅛ (111·8 × 38·4). Ashmolean Museum, Oxford.

160 Li K'o-jan (b. 1907), *Landscape Based on Chairman Mao's Poem*. Ink and slight colour on paper. 1960s. 27½ × 18¼ (70 × 46.25). C. A. Drenowatz Collection, Museum Rietberg, Zurich.

161 Lui Shou-kwan (d. 1977), *Island Landscape*. Ink on paper. 1961. 11 × 32¼ (27·9 × 81·9). Private Collection.

Index